1998

Book Illustration and Decoration

Book Illustration and Decoration

A Guide to Research

Compiled by VITO J. BRENNI

Art Reference Collection, Number 1

GREENWOOD PRESS
Westport, Connecticut • London, England

Library of Congress Cataloging in Publication Data

Brenni, Vito Joseph, 1923-
 Book illustration and decoration.

 (Art reference collection ; no. 1 ISSN 0193-
6867)
 Includes indexes.
 1. Illustration of books—Bibliography.
2. Book ornamentation—Bibliography. I. Title.
II. Series.
Z5956.I44B7 [NC960] 016'.74164
ISBN 0-313-22340-8 (lib. bdg.) 80-1701

Library of Congress Catalog Card Number: 80-1701
ISBN: 0-313-22340-8
ISSN: 0193-6867

First published in 1980

Greenwood Press
A division of Congressional Information Service, Inc.
88 Post Road West, Westport, Connecticut 06881

Printed in the United States of America

10 9 8 7 6 5 4 3 2 1

CONTENTS

PREFACE

The literature on book illustration and decoration is so extensive that to attempt a complete bibliography would be a very ambitious enterprise. A more modest undertaking would be a selective list that the student and researcher can use to find publications containing a wide range of information on the history and technique of book illustration and decoration and the many topics that relate to them. This is the aim of the present work. It contains over two thousand citations of published books, pamphlets, essays in books, periodical articles, and theses. Exhibit and sales catalogs, as well as library catalogs and other lists of illustrated books, are included if they contain essays and/or illustrations. Many articles on minor aspects of the subject are excluded, as are all writings on individual illustrators and books.

The bibliography is concerned primarily with illustration and decoration inside the book, on the pages rather than the cover. The reader will want to refer to bibliographies on binding for binding illustration and decoration. The bibliography includes all periods and all countries. In general, geographic areas smaller than a country have been omitted.

The bibliography begins with a selection of reference works that a researcher may find useful for locating publications and information on illustration, decoration, engraving, printing, and symbolism in art. These titles are the more general reference works on these subjects. Many reference works on specific subjects are given in their appropriate sections in this bibliography.

Chapter 2 includes the general works on book decoration and those fairly general publications on such topics as type ornamentation, initial letters, title pages, and book edges. For publications on book decoration in certain historical periods and in particular countries, the reader needs to search the index or refer to the logical location in subsequent sections of this work where illustration and book decoration are treated together.

Many manuals on illustration are included for information on the technique of illustration in certain periods and countries. Some of these manuals are old, while others were published as recently as the last ten years. New and revised editions have been noted. A separate list of titles on the history of methods of illustration follows the manuals.

The history of book illustration is divided into five periods: ancient and medieval, the fifteenth and sixteenth centuries, the seventeenth and eighteenth centuries, the nineteenth century, and the twentieth century. The an-

cient and medieval section contains separate headings on schools of illumination and manuscript ornamentation. This section needs to be used for studies on Greek and Roman illustration, as well as the separate pages on Greece and Italy in the next large division of the bibliography.

By far the largest portion of this work is on book illustration and decoration in individual countries. More than fifty-four countries are included as well as separate lists for Hebraic and Islamic illustration. Some of the countries are subdivided by chronological period for the convenience of the researcher. The pages for the United States include a separate list of publications on the history of methods of illustration in that country. Throughout this whole geographic section a number of titles are included that are more for general background information than for specific information on the subjects of this bibliography. This is also true for some of the other divisions of the bibliography, especially chapters 5 and 7.

The science and technology division contains general works on the history of scientific illustration and separate lists of titles on botanical and zoological illustration. The botanical list has a separate group of titles on flower painting and drawing.

Titles on book illustration in four other subject areas follow scientific illustration: medicine, music, geography, and history. Herbals is a subdivision of medical illustration. In the section on geography and history, most of the titles are about decoration and illustrations on the title pages and maps in atlases.

The bibliography concludes with a full author index and a detailed subject index. Besides the names of the writers of the publications, the first index has entries for editors, translators, and authors of prefaces, introductions, and notes. The subject index contains cross-references.

The entries in the bibliography were published between the sixteenth century and the 1970s. For each publication author, title, full imprint, and pages are given. Illustrations, plates, and facsimiles complete the description. Some entries have notes concerning editions, introductions, and special features, such as appendices and lists of illustrators and their books.

Throughout the work the compiler realized how much he depended on the book and periodical collections in art museums and university libraries in the East and Midwest. He would like to thank the librarians for the help, the courtesy, and the forbearance which they so generously gave to a bibliographer who made heavy and frequent use of the collections for several years. A special note of gratitude goes to the librarians in art, special collections, and interlibrary loan at Michigan State University and the University of Michigan for their assistance and interest during those years when he had almost continuous access to the rich collections in these two large universities. The compiler would also like to acknowledge the suggestions and encouragement which Pamela J. Parry, editor of this art reference series, and Marilyn Brownstein, acquisitions editor of Greenwood Press, gave during the final stages of the manuscript.

Book Illustration and Decoration

REFERENCE WORKS

Bibliographies

(The word "illus." is used in the bibliographic description for
many titles containing illustrations.)

1. Berlin, Staatliche Kunstbibliothek. Katalog der Ornamentstichsamm-
lung. Berlin, Verlag für Kunstwissenschaft, 1939. 782p.

2. Bland, David. A bibliography of book illustration. London, 1955.
15p. (National Book League pamphlet)

3. Bourcard, Gustave. Graveurs et gravures, France et étranger.
Essai de bibliographie 1540-1910. Paris, Floury, 1910. 320p.

4. Colin, Paul. La gravure et les graveurs. Brussels, G. Van Oest,
1916-18. 2 vols.

5. "Engravings and other print media: bibliography." (In Encyclopedia
of world art. N.Y., McGraw-Hill, 1961. vol. 4, columns 782-85).

6. Guilmard, Désiré. Les maîtres ornementistes, dessinateurs, peintres,
architectes, sculpteurs et graveurs. Paris, E. Plon, 1880-81. 500p.
and an atlas of 180 plates.

7. Levis, Howard C. A descriptive bibliography of the most important
books in the English language relating to the art and history of engrav-
ing and the collecting of prints. London, Ellis, 1912. 571p. Supple-
ment and index, 1913. 141p.

8. Shaw, Renata V. Picture searching; techniques and tools. N.Y.,
Special Library Association, 1973. 65p.

9. St. Bride Foundation. Catalog of the technical reference library of
works on printing and the allied arts. London, Printed for the
Governors, 1919. 999p.

10. Steeves, H. Alan. "Index to graphic arts printing processes."
Bulletin of the New York Public Library 47:323-44, Apr. 1943.

Dictionaries and Encyclopedias

11. Allen, Edward M. Harper's dictionary of the graphic arts. N.Y., Harper, 1963. 295p.

12. Arneudo, Giuseppe. Dizionario esegetico, tecnico, e storico per le arti grafiche. Torino, 1913-25. 3 vols.

13. Audin, Maurice. "Glossaire abrégé de la langue graphique." (In Histoire de l'imprimerie. Paris, A. J. Picard, 1972. p.413-46)

14. Baker, William H. A dictionary of engraving (particularly of the modern commercial processes) together with terms used in related branches... Cleveland, The Author, 1908. 108p.

15. Birkenmajer, Aleksander et al., eds. Encyklopedia wiedzy o ksiaze. Wroclaw, 1971. 2874 columns.

16. Collins, F. Howard. Authors' and printers' dictionary. 10th ed. London, G. Cumberlege, Oxford Univ. Press, 1956. 442p.

17. Glaister, Geoffrey. Glossary of the book; terms used in paper-making, printing, bookbinding and publishing. With notes on illuminated manuscripts, bibliophiles, private presses, and printing societies. London, Allen and Unwin, 1960. 484p. illus.

 The American edition by World Publishing Co. has the title An encyclopedia of the book.

18. Jacobi, Charles T. The printers' vocabulary: a collection of some 2500 technical terms, phrases, abbreviations, and other expressions relating to letter-press printing... London, Chiswick Press, 1888. 168p.

19. Lexikon des Buchwesens. Hrsg. von Joachim Kirchner. Stuttgart, Hiersemann, 1952-56. 4 vols. illus.

20. Lexikon des gesamten Buchwesens. Hrsg. von Karl Löffler und Joachim Kirchner unter Mitwirkung von Wilhelm Olbrich. Leipzig, Hiersemann, 1935-37. 3 vols.

21. Peters, Jean, ed. The bookman's glossary. 5th ed. N.Y., Bowker, 1975. 169p.

22. Quick, John. Artists' and illustrators' encyclopedia. N.Y., McGraw-Hill, 1969. 273p.

23. Savage, William. A dictionary of the art of printing. London, Longman, Brown, Green, and Longmans, 1841. 815p.

24. Stevenson, George A. Graphic arts encyclopedia. N.Y., McGraw-Hill, 1968. 492p. illus. 2d ed., 1978.

25. Timperley, Charles H. Dictionary of printers and printing. London, Johnson, 1839. 996p.

26. Waldo, Alexander. Illustrierte Encyklopädie der graphischen Kunst
und der verwandten Zweige. Leipzig, The Author, 1884. 911p.

Handbooks

27. Berry, W. Turner and Poole, H. Edmund. Annals of printing;
a chronological encyclopedia from the earliest times to the present.
London, Blandford, 1966. 315p.

28. Billoux, René. Encyclopédie chronologique des arts graphiques.
Paris, 1943. 305p.

Previously published under the title of Chronologie des arts
graphiques.

29. Clair, Colin. A chronology of printing. London, Cassell, 1969.
228p.

30. Greenhood, David and Gentry, Helen. Chronology of books and print-
ing. rev. ed. N.Y., Macmillan, 1936. 186p.

31. Harper, Francis P. Colored plate books and their values.
Princeton, N.J., F. P. Harper, 1913. 215p.

Biographies

32. Bartsch, Adam von. Le peintre graveur. new ed. Leipzig,
J. A. Barth, 1808-54. 21 vols in 17.

A supplement by Rudolph Wiegel was published in 1843.

33. Bénézit, Emmanuel. Dictionnaire critique et documentaire des pein-
tres, sculpteurs, dessinateurs et graveurs de tous les temps et tous les
pays par un groupe d'écrivains spécialistes français et étrangers. new
ed. Paris, Grund, 1956-61; 1948-55. 8 vols.

34. Bradley, John W. A dictionary of miniaturists, illuminators,
calligraphers, and copyists with references to their works and notices
of their patron from the establishment of Christianity to the eighteenth
century. London, Quaritch, 1887-89. 3 vols.

35. Bryan, Michael. Dictionary of painters and engravers. 4th ed. rev.
and enlarged under the supervision of G. C. Williamson. London, G. Bell,
1903-05. 5 vols.

36. Foster, Joshua J. Dictionary of miniatures 1525-1850. Ed. by
Ethel M. Foster. London, Philip Allan, 1926. 330p.

37. Kindlers Malerei Lexikon. Ed. by Germain Bazin et al. Zurich,
Kindler Verlag, 1964-71. 6 vols.

38. Latimer, Louise P. Illustrators, a finding list. Boston, Faxon,
1929. 47p. (Useful reference series, no. 39)

39. Le Blanc, Charles. Manuel de l'amateur d'estampes, contenant le dic-
tionnaire des graveurs de toutes les nations. Paris, 1854-90. 4 vols.

40. Passavant, Johann D. Le peintre-graveur. Contenant l'histoire de la gravure sur bois, sur métal, et au burin jusque vers la fin du xvi siècle. Leipzig, R. Weigel, 1860-64. 6 vols. in 3.

41. Strutt, Joseph. A biographical dictionary containing an historical account of all the engravers from the earliest period of the art of engraving to the present time and a short list of their most esteemed works. London, 1785-86. 2 vols.

42. Thieme, Ulrich and Becker, Felix. Allgemeines Lexikon der bildenden Künstler von der Antike bis zur Gegenwart. Leipzig, Seemann, 1907-50. 37 vols.

43. Vollmer, Hans. Allgemeines Lexikon der bildenden Künstler des xx. Jahrhunderts. Leipzig, Seemann, 1953-62. 6 vols.

44. Who's who in art. Havant, Art Trade Press, 1927-

Symbolism in Art

45. Aurenhammer, Hans. Lexikon des christlichen Ikonographie. Vienna, Hollinek, 1959-.

46. Bhattacharyya, Benoytosh. Indian Buddhist iconography, mainly based on the Sadhanamala and cognate texts of rituals. 2d ed. Calcutta, Mukhopadhyay, 1958. 478p. illus.

47. Gopinatha Rau, T. A. Elements of Hindu iconography. Madras, Law Printing House, 1914-16. 2 vols in 4. illus.

48. Hall, James. Dictionary of subjects and symbols in art. London, J. Murray, 1974. 545p. illus.

49. Henkel, Arthur and Schöne, Albrecht, eds. Emblemata: Handbuch zur Sinnbildkunst des xvi und xvii Jahrhunderts. Stuttgart, J. B. Metzler, 1956. 2196 columns. illus. Supplement, 1976.

50. Künstle, Karl. Iconographie der christlichen Kunst in zwei Bänden. Freiburg i Breisgau, 1926-28. 2 vols. 672 illus.

51. Lexikon der christlichen Ikonographie. Ed. by E. Kirschbaum in Zusammenarbeit mit G. Bandmann et al. Rome, Herder, 1968-73. vol. 1-

52. Marle, Raimond van. Iconographie de l'art profane au moyen âge et à la renaissance, et la décoration des demeures. La Haye, 1931-32. 2 vols. illus. plates.

53. Réau, Louis. Iconographie de l'art chrétien. Paris, Presses Universitaires de France, 1955-59. 3 vols. plates.

54. Seyn, Eugène de. Dictionnaire des attributs, allégories, emblèmes et symboles. By Eug. Droulers. [pseud.] Turnhout, Belgique, Brepols, 1949. 281p. illus.

55. Tervarent, Guy de. Attributs et symboles dans l'art profane, 1450-1600. Geneva, Droz, 1958-64. 3 vols. plates.

56. Typotius, Jacobus. Symbola divina et humana pontificum imperatorum regum. Prague, 1601-03. 3 vols.

57. Williams, Charles A. Encyclopedia of Chinese symbolism and art motives. N.Y., Julian, 1960. 468p.

 A re-issue of Outlines of Chinese symbolism and art motives (1931, rev. 1932).

BOOK DECORATION

General Works

58. Bossert, Helmuth T. An encyclopedia of colour decoration from the
earliest times to the middle of the xixth century. N.Y., Weyhe, 1928.
34p. 120 colored plates.

59. Crane, Walter. Of the decorative illustration of books old and new.
2d ed. London, G. Bell, 1901. 337p.

60. Evans, Joan. Pattern; a study of ornament in western Europe from
1180 to 1900. Oxford, Clarendon Press, 1931. 2 vols.

61. Guillot, Ernest. Eléments d'un ornementation du xvie au xviiie
siècle, tirés des manuscrits, des imprimés, des estampes de la
Bibliothèque Nationale et des monuments historiques de l'époque. Paris,
Turgis, 1899.

62. Hamlin, Alfred D. A history of ornament. N.Y., Century, 1916,
1923. 2 vols. illus. 92 plates.

63. Heubner, Ludwig. "Book ornamentation and illustration."
Publishers' weekly 100:892-95, Sept. 11, 1926.

 Reprinted from Der Verlag of Berlin, Nov. 1925.

64. Hurm-Wien, Otto et al. "Schrift als ornament." Buch und Schrift
2:9-118. 1928.

65. Jessen, Peter. Der Ornamentstich Geschichte der Vorlagen des
Kunsthandwerks seit dem Mittelalter. Berlin, Verlag für Kunstwissen-
schaft, 1920. 384p.

66. Johnson, Henry L. Historic design in printing. Reproductions of
book covers, borders, initials, decorations, printers' marks and
devices. Boston, Graphic Arts Co., 1925. 193p. plates.

67. Jones, Owen. The grammar of ornament. London, B. Quaritch, 1910.
157p. 100 plates.

68. Lambert, F. C. "Photography as an aid to the decoration of a book."
Penrose annual 4:57-61. 1898.

69. McMurtrie, Douglas C. Book decoration. Pelham, N.Y., Bridgman,
1928. 63p. illus. facs.

70. Morison, Stanley S. and Jackson, Holbrook. "Decoration in printing." (In A brief survey of printing history and practice. N.Y., Knopf, 1923. p.67-74.)

71. New York Public Library. Cuts, borders, and ornaments. Selected from the Robinson-Pforzheimer typographical collection in the New York Public Library. N.Y., 1962. 44 leaves of illus.

72. Nordenfalk, Carl. "The beginning of book decoration." (In Essays in honor of G. Swarzenski. Chicago, Henry Regnery, 1951. p.9-20.)

73. Pächt, Otto. "Notes and observations on the origin of humanistic book decoration." (In Gordon, D. J., ed. Fritz Saxl 1890-1948; a volume of memorial essays. London, Nelson, 1957. p.184-94.)

74. Pennell, Joseph. "Pen drawing for book decoration." (In Pen drawing and pen draughtsmen. London, Macmillan, 1889. p.251-71.)

75. Savage, William. Practical hints on decorative printing, with illustrations engraved on wood and printed in colours at the type press. London, 1822. 118p. 49 plates.

76. Speltz, Alexander. Styles of ornament, exhibited in designs, and arranged in historical order, with descriptive text.... Tr. from the 2d German edition by David O'Conor. N.Y., E. Weyhe, 1910. 647p. illus.

Type Ornamentation

77. Cagniard, Espérance. Epreuve-spécimen des ornements anciens. [Rouen] The Author, n.d. (c.1850). 264 specimens.

Contains reproductions of Renaissance typographical ornaments.

78. "A grammar of type ornament." Monotype recorder 42, no. 1:3-18. 1960.

79. Gray, Nicolete. xixth century ornamented types and title-pages. London, Faber and Faber, 1938. 213p. new ed., 1976.

80. Hutchings, Reginald S. A manual of decorated typefaces. N.Y., Hastings House, 1965. 96p.

81. McMurtrie, Douglas C. The earliest use of type ornament? Chicago, Privately Printed, 1933. 6p.

82. Meynell, Francis. "Typographic flowers." Signature no. 7:42-50, Nov. 1937.

83. _____ and Morison, Stanley. "Printers' flowers and arabesques." Fleuron no. 1:1-44. 1923.

84. Morison, Stanley. "Decorated types." Fleuron no. 6:95-130, 1928.

85. Ryder, John. "Printers' flowers." Book collector 5:19-27, Spring 1956.

86. Warde, Frederic. Printers ornaments applied to the composition of decorative borders, panels and patterns. London, Lanston Monotype Corp., 1928. 114p.

87. Weiler, Joseph. "Development of the typographic ornament." Print 9:29-36, June-July 1954.

Initial Letters

88. Carrick, Edward. "Book decoration versus book illustration, with a plea for initial letters." Penrose annual 33:60-65. 1931.

89. Dwiggins, William A. Form letters: illustrator to author. N.Y., W. E. Rudge, 1930. xvi numbered leaves.

90. Gutbrod, Jürgen. Die Initiale in Handschriften des achten bis dreizehnten Jahrhunderts. Stuttgart, W. Kohlhammer, 1965. 207p. illus. facs.

91. Jennings, Oscar. Early woodcut initials, containing over thirteen hundred reproductions of ornamental letters of the fifteenth and sixteenth centuries. London, Methuen, 1908. 287p. facs.

92. Johnson, Alfred F. Decorative initial letters. London, Cresset Press, 1931. 247p.

93. Lehner, Ernst. Alphabets and ornaments. N.Y., Dover, 1952. 256p.

94. Nesbitt, Alexander. Decorative alphabets and initials. N.Y., Dover, 1959. 192p.

95. Pollard, Alfred W. "Some pictorial and heraldic initials." Bibliographica 3:232-52. 1897.

96. Schardt, Alois J. Das Initial; Phantasie und Buchstabenmalerei des frühen Mittelalters. Berlin, 1938. 180p. illus. plates.

97. Smith, Percy J. "Initial letters in the printed book." Fleuron no. 1:61-92. 1923.

Title Pages

98. De Vinne, Theodore L. The practice of typography: a treatise on title pages. N.Y., Century, 1920. 485p. facs.

99. Johnson, Alfred F. One hundred title-pages 1500-1800, selected and arranged with an introduction and notes. N.Y., Appleton, 1928. 100 plates.

100. Nesbitt, Alexander. 200 decorative title pages. N.Y., Dover, 1964. unpaged.

100a. Schottenloher, Karl. "Der Holzchnitt-Titel im Buch der Frühdruck-zeit." Buch und Schrift 2:17-24. 1928.

101. Simon, Oliver. "The title-page." Fleuron no. 1:93-110. 1923.

102. Strange, Edward F. "The composition of a decorative title-page."
Ars typographica 1:23-27, Summer 1918.

Book Edges

103. Davenport, Cyril J. "The decoration of book edges."
Bibliographica 2:385-407. 1896.

104. Dutter, Vera E. "The ancient art of fore-edge painting."
American artist 33:56-57. Jan. 1969.

105. Nixon, H. M. "Edges ancient and modern." Times literary supple-
ment, June 29, 1967. p.588.

106. Weber, Carl J. Fore-edge painting; an historical survey of a
curious art in book decoration. Irvington-on-Hudson, N.Y., Harvey House,
1966. 223p.

107. _____. A thousand and one fore-edge paintings. Waterville,
Me., Colby College, 1949. 194p.

3

MANUALS OF ILLUSTRATION AND OTHER WRITINGS ON TECHNIQUE

General Works

108. Bersier, Jean E. La gravure: les procédés, l'histoire. Paris, La Table Ronde, 1947. 278p. illus. plates.

109. Bickford, John. New media in printmaking. N.Y., Watson-Guptill, 1976. 176p.

110. Biggs, John R. Illustration and reproduction. London, Blandford Press, 1950. 240p.

111. Brunner, Felix. Handbuch der Druckgraphik. Teufen, Niggli, 1962. 379p. illus. (some in color). 2d ed. 1964.

112. Curwen, Harold. Processes of graphic reproduction in printing. 4th ed. Rev. by Charles Mayo. London, Faber and Faber, 1963. 171p.

113. Esteve Botey, Francisco. El grabado en la ilustración del libro. Las gráficas artísticas y las fotomecánicas. Madrid, 1948. 2 pts., 378, 35p. plates.

114. Fielding, Theodore H. The art of engraving, with the various modes of operation. London, Ackerman, 1841. 109p.

115. Gamble, Charles W. Modern illustration processes. 3d ed. London, Pitman, 1933. 409p.

116. Hayter, Stanley. New ways of gravure. rev. ed. London, Oxford Univ. Press, 1966. 298p.

117. Hinton, A. Horsley. A handbook of illustration. London, Dawbarn and Ward, 1895. 120p.

118. Klemin, Diana. The illustrated book; its art and craft. N.Y., C. N. Potter, 1970. 159p.

119. Konow, Jurgen von. Om grafik. Malmo, Allhems Forlag, 1955c1956. 266p. illus. colored plates.

120. Lamb, Lynton. Drawing for illustration. London, Oxford Univ. Press, 1962. 211p. many illus. plates.

121. Lewis, John. A handbook of type and illustration. London, Faber and Faber, 1956. 203p.

122. Martindale, Percy H. Engraving, old and modern. London, H. Cranton, 1928. 208p. illus. plates.

123. Meglin, Nick. The art of humorous illustration. N.Y., Watson-Guptill, 1973. 160p.

124. Monet, A. L. Procédés de reproductions graphiques appliqués à l'imprimerie. Paris, 1888. 343p.

125. Pennell, Joseph. The illustration of books; a manual for the use of students. N.Y., Century, 1896. 168p.

126. Perrot, Aristide N. Nouveau manuel complet du graver. new ed. by M. F. Malepeyre. Paris, Roret, 1865. 348p. (First ed. in 1830.)

127. Peterdi, Gaber. Printmaking: methods old and new. rev. ed. N.Y., Macmillan, 1971. 342p.

128. Pitz, Henry C. The practice of illustration. N.Y., Watson-Guptill, 1947. 146p.

129. Rhein, Erich. Die Kunst des manuellen Bildrucks. 2d ed. Ravensburg, Maier, 1958. 240p. illus. plates.

130. Sotriffer, Kristian. Printmaking; history and technique. Tr. from the German by Francisca Garvie. N.Y., McGraw-Hill, 1968. 143p. 19 colored plates, 78 monochrome plates, and 21 line illustrations.

131. Stone, Bernard and Eckstein, Arthur. Preparing art for printing. N.Y., Reinhold, 1965. 199p.

132. Wood, Henry T. Modern methods of illustrating books. London, E. Stock, 1887. 260p.

Illumination

133. De arte illuminandi: e altri trattati sulla technica della miniatura medievale [a cura di] Franco Brunello. Vicenza, N. Pozza, 1975. 268p. (Italian and Latin)

134. Bell, Louis. The art of illumination. N.Y., McGraw-Hill, 1912. 353p.

135. Bradley, John W. A manual of illumination on paper and vellum. London, Winsor and Newton, 1860. 76p.

136. Delamotte, Freeman G. A primer of the art of illumination for the use of beginners. London, C. Lockwood, 1860. 43p. 2d ed., 1925.

137. Humphreys, Henry N. The art of illumination and missal painting. London, H. G. Bohn, 1849. 64p. plates.

138. Jewitt, Edwin. Manual of illuminated and missal painting. London, 1859. 47p.

139. Johnston, Edward. Writing and illuminating and lettering with dia-
grams and illustrations by the author and Noel Rooke. London, 1906.
510p. 220 illus. 24 plates.

140. Shaw, Henry. A handbook of the art of illumination as practiced
during the middle ages. London, Bell and Daldy, 1866. 66p.

Wood Engraving

141. Beedham, R. John. Wood-engraving. With introduction and appendix
by Eric Gill. 6th ed. London, Faber and Faber, 1946. 57p.

142. Biggs, John R. The craft of woodcuts. N.Y., Sterling, 1963. 63p.

143. Brown, William N. Wood engraving; a practical and easy introduc-
tion to the study of the art. With numerous illustrations. 3d ed.
London, C. Lockwood, 1899. 70p.

144. Chatto, William A. and Jackson, John. A treatise on wood engrav-
ing, historical and practical. With upwards of three hundred illustra-
tions engraved on wood, by John Jackson. London, C. Knight, 1839. 749p.
2d ed., 1861; new ed., 1881.

145. Emerson, William A. Handbook of wood engraving. new ed. Boston,
Lee and Shepard, 1881. 95p.

146. Gilks, Thomas. The art of wood engraving; a practical handbook.
3d ed. London, Winsor and Newton, 1871. 38p. (First published in 1866.)

147. Grupe, E. Y. Instruction in the art of photographing on wood.
Leominster, Mass., F. N. Boutwell, 1882. 13p.

148. Laliberté, Norman and Mogelon, Alex. Twentieth century woodcuts;
history and modern techniques. N.Y., Van Nostrand Reinhold, 1971. 111p.

149. Leighton, Clare V. Wood-engraving and woodcuts. London, Studio,
1932. 96p.

150. Linton, William J. Wood engraving: a manual of instruction.
London, G. Bell, 1884. 127p.

151. Müller, Hans A. How I make woodcuts and wood engravings. N.Y.,
American Artists Group, 1945. 96p.

152. Ness, Evaline. "The artist at work: woodcut illustration."
Horn book 40:520-22, Oct. 1964.

153. Papillon, Jean M. Traité historique et pratique de la gravure en
bois. Paris, P. G. Simon, 1766. 3 vols. in 2. plates.

154. Platt, John E. Colour woodcuts; a handbook of reproductions and a
handbook of method. London, Pitman, 1938. 53p. illus. plates.

155. Rothenstein, Michael. Frontiers of printmaking; new aspects of
relief printing. N.Y., Reinhold, 1966. 144p.

156. Schasler, Max A. Die Schule der Holzschneidekunst; Geschichte, Technik, und Aesthetik. Leipzig, J. Weber, 1866. 295p. illus.

157. Servolini, Luigi. Tecnica della xilografia. Milan, Bartollozzi, 1935. 257p.

158. Sternberg, Harry. Woodcut. Photography by Ted Davies. N.Y., Pitman, 1962. unpaged. illus.

Etching, Aquatint, and Other Engraving Techniques

159. Banister, Manly. Etching and other intaglio techniques. N.Y., Sterling, 1969. 128p.

160. Bishop, Thomas. The etcher's guide. Phila., Janentzky, 1879. 22p.

161. Bosse, Abraham. Traité des manières de graver en taille douce sur l'airin. Paris, 1645. 75p. 16 plates.

The 1665 ed. is much enlarged with 140p. and 67 plates. Later editions were published in 1745 and 1758.

162. Bradley, Bob. "A new technique for gravure etching." Penrose annual 70:73-80. 1977/78.

163. Brunsden, John. The technique of etching and engraving. N.Y., Reinhold, 1965. 152p.

164. Edmondson, Leonard. Etching. N.Y., Van Nostrand Reinhold, 1973. 136p.

165. Faithorne, William. The art of graveing and etching. London, Faithorne, 1662. 48p.

166. Green, J. H. (bookseller). The complete aquatinter; being the whole process of etching and engraving in aquatint. Hartfield, Printed by W. Morphew, 1801. 23p.

167. Gross, Anthony. Etching, engraving and intaglio printing. London, Oxford Univ. Press, 1970. 172p.

168. Hamerton, Philip G. The etcher's handbook. London, C. Roberson, 1871. 84p.

169. Lalanne, Maxime. A treatise on etching. Authorized American edition translated from the 2d French edition by S. R. Koehler. With an introductory chapter and notes by the translator. Boston, Estes and Lauriat, 1880. 79p.

170. Lumsden, Ernest S. The art of etching. Phila., Lippincott, 1925. 376p.

171. Morrow, Benjamin F. The art of aquatint. N.Y., Pitman, 1935. 140p. 45 illus.

172. Plowman, George T. Manual of etching; a handbook for the beginner.
N.Y., Dodd, Mead, 1924. 94p.

173. Poortenaar, Jan. Etskunst; techniek en geschiedenis. Amsterdam,
J. H. de Bussy, 1930. 216p. illus. plates.

174. Reed, Earl H. Etching; a practical treatise. N.Y., Putnam, 1914.
148p.

175. Singer, Hans W. and Strang, William. Etching, engraving and other
methods of printing pictures. London, Paul, Trench, Trübner, 1897. 228p.

176. Strang, David. The printing of etchings and engravings. With an
introduction by Martin Hardie. N.Y., Dodd, 1930. 218p.

177. Victoria and Albert Museum, London. Dept. of Engraving, Illustra-
tion and Design. Tools and materials used in etching and engraving; a
descriptive catalogue of a collection exhibited in the Museum. 3d ed.
London, 1914. 18p.

178. Wright, John B. Etching and engraving; techniques and the modern
trend. London, Studio, 1953. 240p. illus.

Lithography

179. Antreasin, Garo Z. and Adams, Clinton. The Tamarind book of
lithography; art and techniques. Los Angeles, Tamarind Lithography
Workshop, 1971. 463p.

180. Audsley, George A. The art of chromolithography. N.Y., Scribner,
1883. 24p. 44 plates.

181. Bouchot, Henri. La lithographie. Paris, 1895. 296p. illus.

182. Browne, Warren C. Practical textbook of lithography. N.Y.,
The National Lithographer, 1912. 231p.

183. Cumming, David. Handbook of lithography; a practical treatise for
all who are interested in the process. London, A. and C. Black, 1904.
248p.

184. Doyen, Camillo. Trattato di litografica storico, teorico, practico
ed economico. Turin, F. Casanova, 1877. 296p.

185. Engelmann, Godefroi. Manuel du dessinateur lithographe. Paris,
1822. 91p.

186. _____. Traité de lithographie. Mulhouse, 1839. 467p.

187. Fritz, Georg, ed. Handbuch der Lithographie und des Steindruckes.
Halle, W. Knapp, 1898-1901. 3 fasc. in 1 vol.

188. Goodman, Joseph. Practical modern metalithography. Letchworth,
England, Garden City Press, 1914. 230p.

189. Griffits, Thomas E. The rudiments of lithography. London, Faber and Faber, 1956. 95p.

190. Hartrick, Archibald S. Lithography as a fine art. London, Oxford Univ. Press, 1932. 83p.

191. Hullmandel, Charles J. The art of drawing on stone, giving a full explanation of the various styles of the different methods to be employed to ensure success.... London, The Author, 1824. 92p.

192. Jones, Stanley. Lithography for artists. London, Oxford Univ. Press, 1967. 78p.

193. Knigin, Michael and Zimiles, Murray. The technique of fine art lithography. N.Y., Van Nostrand Reinhold, 1970. 143p.

194. Krueger, Otto F. Die lithographischen Verfahren und der Offstdruck. 3d ed. Leipzig, 1949. 278p.

195. Lieure, Jules. La lithographie artistique et ses diverses techniques; les techniques, leur évolution. Paris, J. Dauguin, 1939. 104p.

196. Lorilleux, Ch. et Cie. Traité de lithographie. Paris, 1889. 380p.

197. Rhodes, Henry J. The art of lithography; a complete practical manual of planographic printing. 2d ed. London, Scott, Greenwood, 1924. 328p. 120 illus.

198. Richmond, W. D. The grammar of lithography; a practical guide for the artist and printer. Ed. and revised with an introduction by the editor of the Printing times and lithographer. 2d ed. London, Wyman, 1880. 254p.

199. Senefelder, Alois. The invention of lithography. Tr. by J. W. Muller. London, Fuchs and Lang Manufacturing Co., 1911. 229p.

200. _____. Vollständiges Lehrbuch ... der Steindruckerey ... verfasst und herausgegeben von dem Erfinder der Lithographie. Munich, C. Thienemann, 1818. 120p.

201. Vicary, Richard. Manual of lithography. N.Y., Scribner, 1976. 152p.

202. Ward, Lynd. "The artist at work; doing a book in lithography." Horn book 40:34-41, Feb. 1964.

203. Wengenroth, Stow. Making a lithograph. N.Y., Studio, 1937. 79p. illus.

Photomechanical Processes

204. Ammonds, Charles C. Photoengraving; principles and practice. London, Pitman, 1966. 307p.

205. Burton, William K. Practical guide to photographic and photo-mechanical printing. London, Marion, 1887. 355p. (rev. in 1898, 1907, and 1928.)

206. Cartwright, Herbert M. Photogravure; a textbook on the machine and hand printed processes. Boston, American Photographic Publishing Co., 1930. 142p.

207. _____ and MacKay, Robert. Rotogravure; a survey of European and American methods. Lyndon, Ky., MacKay Publishing Co., 1956. 303p.

208. Courmont, Emile. La photogravure; histoire et technique. Paris, Gauthier-Villars, 1947. 249p.

209. Fithian, A. W. Practical collotype. London, Iliffe, Sons and Sturmey, 1901. 90p.

210. Flader, Louis and Mertle, J. S. Modern photoengraving; a practical textbook on latest American procedures. Chicago, Modern Photoengravers Publishers, 1948. 334p.

211. Horgan, Stephen H. Photo-engraving primer. Boston, American Photographic Publishing Co., 1920. 81p.

212. Huson, Thomas. Huson on photo-aquatint and photogravure; a practical treatise with illustrations and a photo-aquatint plate by Thomas Huson. London, Published for "The Photogram, 1d.", by Dawbarn and Ward, 1897. 116p.

213. Kirkbride, Joseph. Engraving for illustration; historical and practical notes. N.Y., Van Nostrand, 1903. 72p.

214. Lewis, John and Smith, Edwin. The graphic reproduction and photography of works of art. London, Cowell, 1969. 144p.

215. Nicholson, David. Photo-offset lithography. N.Y., Chemical Publishing Co., 1941. 154p.

216. Sipley, Louis W. The photomechanical halftone. Phila., American Museum of Photography, 1958. 62p.

217. Schnauss, Julius. Collotype and photo-lithography. Tr. by E. C. Middleton. London, Iliffe, Sons and Sturmey, 1889. 170p.

218. Smith, William J. et al. Photo-engraving in relief. 2d ed. London, Pitman, 1947. 309p.

219. Tissandier, Gaston. History and handbook of photography. Tr. from the French of Gaston Tissandier. London, Low, Marston, Low and Searle, 1876. 326p.

220. Verfasser, Julius. The half-tone process; a practical manual of photo-engraving in half-tone on zinc, copper and brass. 3d ed. London, Iliffe, Sons and Sturmey, 1904. 292p.

221. Vidal, Léon. Traité pratique de photogravure. Paris, 1900. 445p. plates.

222. _____. Traité pratique de photolithographie. Paris, 1893. 419p.

223. Wallis, Frederick and Howitt, H. Photo-litho in monochrome and colour. London, Pitman, 1963. 284p.

224. Wilkinson, W. T. Photo-engraving, photo-lithography, collotype, and photogravure. 5th ed. London, Morland, Judd, 1894. 169p.

225. Willy, Clifford M. Practical photolithography. 4th ed. Ed. and rev. by G. E. Messenger. London, Pitman, 1952. 240p.

226. Wilson, Thomas A. The practice of collotype. London, Chapman and Hall, 1935. 96p.

227. Wood, Franklin. Photogravure. London, Pitman, 1949. 62p. plates.

Color Printing

228. Biegeleisen, Jacob I. The complete book of silk screen printing production. N.Y., Dover, 1963. 253p.

229. _____ and Busenbark, E. The silk screen printing process. N.Y., McGraw-Hill, 1938. 206p. 2d ed., 1941.

230. _____ and Cohn, Max. Silk screen stenciling as a fine art. Introduction by Rockwell Kent. N.Y., McGraw-Hill, 1942. 179p.

231. Burch, Robert M. Colour printing and colour printers with a chapter on modern processes by W. Gamble. N.Y., Baker and Taylor, 1910. 280p. illus.

232. Cartwright, Herbert M. and MacKay, Robert. Rotogravure; a survey of European and American methods. Lyndon, Ky., MacKay Publishing Co., 1956. 303p.

233. Clemence, Will. The beginner's book of screen process printing. London, Blandford Press, 1970. 88p. 17p. of illustration.

234. Fithian, A. W. Practical collotype. London, Iliffe, Sons and Sturmey, 1901. 90p.

235. Hunt, Robert W. The reproduction of colour. London, Fountain Press, 1957. 205p. plates.

236. Kinsey, Anthony. Introducing screen printing. N.Y., Watson-Guptill, 1968. 95p.

237. Ligeron, R. La gravure originale en couleurs. 2d ed. Paris, Lefranc, 1924. 173p.

238. Noble, Frederick. The principles and practice of colour printing.
London, Office of "Printers Register," 1881. 174p.

239. Rasmusen, Henry N. Printmaking with monotype. Phila., Chilton Co.,
1960. 182p.

240. Richmond, W. D. Colour and colour printing as applied to lithog-
raphy, containing an introduction to the study of colour, an account of
the general and special qualities of pigments employed, their manufacture
into printing inks, and the principles involved in their application.
London, Wyman, 1885. 169p.

241. Schnauss, Julius. Collotype and photo-lithography. Tr. by E. C.
Middleton. London, Iliffe, Sons and Sturmey, 1889. 170p.

242. Shokler, Harry. Artist's manual for silk screen print making.
N.Y., American Artists Group, 1946. 170p. illus. plates.

243. Sternberg, Harry. Silk screen color printing. N.Y., McGraw-Hill,
1942. 73p.

244. Wallis, Frederick and Howitt, H. Photo-lithography in monochrome
and colour. London, Pitman, 1963. 284p.

HISTORY OF METHODS
OF ILLUSTRATION

General Works on Engraving

245. Adhémar, Jean et al. La gravure. Paris, Presses Universitaires de France, 1972. 128p.

246. Bock, Elfried. Geschichte der graphischen Kunst von ihren Anfängen bis zur Gegenwart. Berlin, Propyläen-Verlag, 1930. 716p. (Propyläen Kunstgeschichte, Ergänsungsband.)

247. British Museum. Dept. of Prints and Drawings. A guide to the processes and schools of engraving with notes on some of the most important masters. 3d ed. London, W. Clowes, 1933. 52p. 4th ed., 1952.

248. Cleaver, James. A history of graphic art. N.Y., Philosophy Library, 1963. 282p.

249. Delen, Adrien J. De graphischen Kunsten door de eeuwen heen. Antwerp, Standard-Boekhandel, 1956. 279p.

250. Focillon, Henri. Les maîtres de l'estampe. Paris, H. Laurens, 1930. 233p.

251. Getlein, Frank and Getlein, Dorothy. The bite of the print; satire and irony in woodcuts, engravings, etchings, lithographs and serigraphs. N.Y., C. N. Potter, 1963. 272p.

252. Gusman, Pierre. La gravure sur bois et d'épargne sur métal du xive au xxe siècle. Paris, Roger et Chernoviz, 1916. 299p.

253. Harrop, Dorothy A. "Engraving." (In Encyclopedia of library and information science. Ed. by Allen Kent et al. N.Y., Marcel Dekker, 1972. vol. 8, p.105-16.)

254. Hind, Arthur M. History of engraving and etching. 3d ed. London, Constable, 1923. 487p.

255. _____. A short history of engraving and etching for the use of collectors and students [with] full bibliography and classified list and index of engravers. 2d ed. London, Constable, 1911. 473p.

256. Kristeller, Paul. Kupferstich und Holzschnitt in vier Jahrhunderten, mit 259 Abbildung. Berlin, B. Cassirer, 1905. 595p. 2d ed., 1911; 3d ed., 1921; 4th ed., 1922.

257. Laran, Jean et al. L'estampe. Paris, Presses Universitaires de France, 1959. 2 vols. (vol. 2 contains plates).

258. Melot, M. "Gravure." (In Encyclopaedia universalis. vol. 7, 1970, p.988-93.)

259. Petrucci, Carlo A. "Engravings and other print media: historical account: the western world." (In Encyclopedia of world art. N.Y., McGraw-Hill, 1961. vol. 4, columns 759-75.)

260. Singer, Hans W. Geschichte des Kupferstichs. Leipzig, 1895. 286p. illus.

Wood Engraving

261. Bliss, Douglas P. A history of wood engraving. London, Dent, 1928. 263p.

262. Bucherer, Max and Ehlotzky, Fritz. Der Original-Holzschnitt; eine Einführing in sein Wesen und seine Technik. Munich, E. Reinhardt, 1922. 103p.

263. Cundall, Joseph. A brief history of wood-engraving from its invention. London, S. Low, Marston, 1895. 132p.

264. De Vinne, Theodore L. "The growth of wood-cut printing." Scribner's monthly 19:860-74, Apr. 1880.

265. Firmin-Didot, Ambroise. Essai typographique et bibliographique sur l'histoire de la gravure sur bois. Paris, Firmin-Didot Frères, 1851. paginé col. 557-922. (Extrait de l'Encyclopédie moderne, tome xxvi.)

266. Furst, Herbert E. "The modern woodcut." Print collector's quarterly 8:151-70, July-Oct. 1921.

267. _____. The modern woodcut; a study of the evolution of the craft. London, John Lane, 1924. 271p. many illus.

268. Hind, Arthur M. An introduction to a history of woodcut, with a detailed survey of work done in the fifteenth century. London, Constable, 1935. 2 vols.

269. Lindley, Kenneth A. The woodblock engravers. N.Y., Drake Publishers, 1970. 128p.

270. Linton, William J. The masters of wood engraving. New Haven, Conn., The Author, 1889. 229p.

271. McMurtrie, Douglas C. "The block books"; (In The book; the story of printing and bookmaking. 3d ed. London, Oxford Univ. Press, 1943. p.114-22.)

272. McMurtrie, Douglas C. "Early European woodcuts." (In The book; the story of printing and bookmaking. 3d ed. London, Oxford Univ. Press, 1943. p.101-13.)

273. _____. "Woodcut book illustration." (In The book; the story of printing and bookmaking. 3d ed. London, Oxford Univ. Press, 1943. p.239-63.)

274. Musper, Heinrich T. Der Holzschnitt in fünf Jahrhunderten. Stuttgart, W. Kohlhammer, 1964. 400p.

275. Papillon, Jean-Baptiste M. Traité historique et pratique de la gravure en bois. Paris, P. G. Simon, 1766. 3 vols in 2. plates.

276. Pilinski, Adam, ed. Monuments de la xylographie reproduits en facsimilé. Précédés de notices par G. Pawlowski. Paris, A. Pilinski et fils, 1882-86. 8 vols.

277. Portland, Oregon. Art Museum. Masterworks in wood: the woodcut print from the 15th to the early 20th century. Exhibition Jan. 21 through Feb. 22, 1976. Portland, 1976. unpaged. many illus.

 "Notes on the exhibition" by William H. Givler.

278. Reiner, Imre. Woodcut and wood engraving; a contribution to the history of the art. Tr. by Cecil Palmer. London, Public Publishing Co., 1947. 111p.

279. Salaman, Malcolm C. The new woodcut. London, Studio, 1930. 176p. illus. plates.

 Contains about 200 reproductions of woodcuts and engravings from 16 countries.

280. Woodberry, George E. A history of wood-engraving. N.Y., Harper, 1883. 221p.

Mezzotint, Etching, Aquatint, and Photoengraving

281. Chelsum, James. A history of the art of engraving in mezzotint. Winchester, Printed by J. Robbins and sold by J. and T. Egerton, London, 1786. 100p.

282. Courmont, Emile. La photogravure; histoire et technique. Paris, Gauthier-Villars, 1947. 249p.

283. Davenport, Cyril J. Mezzotints. London, Methuen, 1904. 207p.

284. Hagedorn, Leo H. "The first century of photo-engraving." Penrose annual 19:189-97. 1917.

285. Herkomer, Hubert von. Etching and mezzotint engraving; lectures delivered at Oxford. London, Macmillan, 1892. 107p. 12 plates.

286. Hind, Arthur M. History of engraving and etching. 3d ed.
London, Constable, 1923. 487p.

287. Koehler, Sylvester R. Etching; an outline of its technical
processes and its history. N.Y., Cassell, 1885. 238p.

288. Laborde, Léon de. Histoire de la gravure en manière noire.
Paris, Impr. de J. Didot l'aîné, 1839. 413p.

289. Leisching, Julius. Schabkunst: ihre Technik und Geschichte in
ihren Hauptwerken von xvii. zum xx. Jahrhundert. Vienna, A. Wolf,
1913. 98p.

290. Poortenaar, Jan. Etskunst; techniek en geschiedenis. Amsterdam,
J. H. de Bussy, 1930. 216p.

291. Prideaux, Sarah T. Aquatint engraving; a chapter in the history
of book illustration. London, Duckworth, 1909. 434p.

> Appendices, p.325-408. Appendix A: "Books published before
> 1830 with aquatint plates." Appendix B: "Bibliographical
> notices of engravers. Appendix F: "Alphabetic list of
> aquatint engravers with the books illustrated by them."

292. Whitman, Alfred. The masters of mezzotint; the men and their
work. London, G. Bell, 1898. 95p. 60 plates.

Lithography

293. Bild vom Stein; die Entwicklung der Lithographie von Senefelder
bis heute. Munich, Prestel-Verlag, 1961. illus.

> A valuable catalog with extensive and scholarly notes.

294. Grolier Club, N.Y. Catalogue of an exhibition illustrative of a
centenary of artistic lithography 1796-1896, at the Grolier Club ...
March the sixth to March the twenty-eighth MDCCC. Ed. by Frank
Weitenkampf. N.Y., 1896. 73p.

295. Marthold, Jules de. Histoire de la lithographie. Paris,
L.-H. May, 1898. 64p.

296. Peignot, Gabriel. Essai historique sur la lithographie. Paris,
Renouart, 1819. 61p.

297. Weber, Wilhelm. History of lithography. Tr. from the German.
London, Thames and Hudson, 1966. 259p.

> This is a translation of Saxa Loquuntur-Steine reden:
> Geschichte der Lithographie, I: von den Anfängen bis 1900.
> Heidelberg, 1961.

HISTORY OF BOOK ILLUSTRATION FROM ANCIENT TIMES TO THE PRESENT DAY

General Works

298. Audin, Marius. Histoire de l'imprimerie par l'image. Tome 111: Esthétique du livre. Paris, H. Jonquieres, 1929.

299. Barberi, Francesco. "Derivazioni di frontespizi." (In Contributi alla storia del libro italiana; miscellanea in onore di Lamberto Donati. Florence, Olschki, 1969. p.27-52.)

300. _____. "Graphic arts: illustration." (In Encyclopedia of world art. N.Y., McGraw-Hill, 1962. Vol. 6, columns 687-96.)

301. Bland, David. The illustration of books. 3d ed. London, Faber and Faber, 1962. 200p. illus.

302. _____. A history of book illustration; the illuminated manuscript and the printed book. 2d rev. ed. Berkeley, Univ. of Calif. Press, 1969. 459p. illus.

303. Bouchot, Henri F. The printed book; its history, illustration and adornment from the days of Gutenberg to the present time. Tr. and enlarged by Edward C. Bigmore. London, Grevel, 1887. 312p.

304. Buchkunst; beiträge zur Entwicklung der graphischen Künste und der Kunst im Buche. Leipzig, Staatl. Academie für Graphische Künste und Buchgewerbe, 1931-

305. Dunikowska, Irena, ed. "Illustratorstwo." (In Birkenmajer, Alexander, ed. Encyklopedia wiedzy o ksiazce. Wroclaw, 1971. columns 956-80.)

306. Ellis, Richard W. Book illustration; a survey of its history and development shown by the work of various artists together with critical comments. Kingsport, Tenn., Kingsport Press, 1952. 76p.

307. Evans, Hilary and Evans, Mary. Sources of illustration 1500-1900. N.Y., Hastings House, 1972. 162p. illus.

308. Good, Harry G. "The "first" illustrated school-books." Journal of educational research 35:338-43, Jan. 1942.

309. Guter, Josef. "Fünfhundert Jahre Fabelillustration." Antiquariat 22, No. 4:6-7. 1972.

310. Gutenberg-Museum, Mainz. Tausend Jahre Buchillustration. [Zur Freier des 50 jährigen Bestehens des Gutenberg-Museums. Den Text schrieben H. Presser und D. Meinecke.] Mainz, 1950. 48p. illus.

311. Lacassin, Francis. Pour un neuvième art, la bande dessinée. Paris, Union Générale d'Editions, 1971. 511p.

312. Lehmann-Haupt, Hellmut. In search of the frontispiece. Garden Club of America bulletin, 7th series, no. 9, 1940. (not verified.)

313. Lewis, John. Anatomy of printing; the influence of art and history on its design. N.Y., Watson-Guptill, 1970. 228p. illus.

314. MacRobert, Thomas M. Fine illustrations in western European printed books. London, H. M. Stationery Office, 1969. 23p. 125 plates (Victoria and Albert Museum. Large picture book, no. 38.)

315. Major, A. Hyatt. Prints and people; a social history of printed pictures. N.Y., Metropolitan Museum of Art (distributed by N.Y. Graphic Society), 1971. unpaged. 752 illus.

316. Paris. Bibliothèque Nationale. Le livre. Paris, 1972. 225p. 32 illus. (exhibit catalog.)

317. _____. Le livre dans la vie quotidienne. Paris, 1975. 179p. plates.

318. Peterson, Ann C. "Illustrations." (In Encyclopedia of library and information science. Ed. by Allen Kent et al. N.Y., Marcel Dekker, 1974. vol. 11, p.218-63.)

319. Pollard, Alfred W. Fine books. London, Methuen, 1912. 331p.

320. Poortenaar, Jan. The art of the book and its illustration. Phila., Lippincott, 1935. 182p. plates.

321. Ratta, Cesare. L'arte del libro e della revista. Bologna, 1927-28. 2 vols. 500 plates.

322. Simon, Howard. 500 years of art in illustration from Albrecht Dürer to Rockwell Kent. Cleveland, World Publishing Co., 1942. 476p.

323. Steinberg, S. H. "Book illustration." (In Five hundred years of printing. 2d ed. Harmondsworth, Middlesex (England), Penguin Books, 1961. p.153-61.)

324. Thomas, Alan G. Fine books. London, Weidenfeld and Nicolson, 1967. 120p.

325. Unger, Arthur W. Die Herstellung von Buchern Illustrationen, Akzidenzen. 3d ed. Halle A. S., W. Knapp, 1910. 511p. 62p. of illustration and 77 plates.

326. Wechsler, Herman J. Great prints and printmakers. N. Y., H. N. Abrams, 1967. 244p. illus. 100 plates.

327. Weitenkampf, Frank. The illustrated book. Cambridge, Mass.,
Harvard Univ. Press, 1938. 314p. illus.

328. Zigrosser, Carl. The book of fine prints; an anthology of
printed pictures and introduction to the study of graphic art in the
West and the East. N.Y., Crown, 1937. 499p. 555 illustrations.

Early History to Fifteenth Century

Reference Works

329. Aeschlimann, Erhard and Ancona, Paolo d'. Dictionnaire des
miniaturistes du moyen âge et de la renaissance. 2d ed. Milan,
U. Hoepli, 1949. 239p. 155 plates.

330. Donati, Lamberto. Bibliografia della miniatura. Florence,
L. Olschki, 1972. 2 vols.

331. Valentine, Lucia N. Ornament in medieval manuscripts: a glossary.
London, Faber and Faber, 1965. 108p.

General Works

332. Ancona, Paolo d' and Aeschlimann, Erardo. Art of illumination;
an anthology of manuscripts from the sixth to the sixteenth century.
London, Phaidon, 1969. 235p. illus.

333. Beissel, Le P. Stephan. Vaticanische Miniaturen; manuscrits
choisis de la Bibliothèque du Vatican. Fribourg, B. Herder, 1893.
59p. and plates. (In German and French.)

334. Berenson, Bernhard. Studies in medieval painting. New Haven,
Yale Univ. Press, 1930. 146p. plates.

335. Bethe, Erich. Buch und Bild im Altertum. Leipzig, Harrassowitz,
1945. 148p.

336. Bland, David. "Medieval illumination in the West." (In
A history of book illustration. Cleveland, World Publishing Co., 1958.
p.40-83.)

337. Boeckler, Albert. Abendländische Miniatures bis zum Ausgang der
romanischen Zeit. Berlin, Walter De Gruyter, 1930. 133p. and 106
plates.

338. Bradley, John W. Illustrated manuscripts. London, Methuen, 1905.
290p.

339. British Museum. Illuminated manuscripts in the British Museum.
Miniatures, borders, and initials reproduced in gold and colors. With
descriptive text by Sir George F. Warner. Series 1-4, 4 parts. London,
1900-04. folio with 60 plates.

340. Burlington Fine Arts Club, London. Exhibition of illuminated
manuscripts. London, 1908. 129p. plates.

 Contains an introduction by Sydney C. Cockerell.

341. Colding, Torben H. Aspects of miniature painting: its origins
and development. Copenhagen, Munksgaard, 1953. 218p.

342. Couderc, Camille. Les enluminures des manuscrits du moyen-âge du
vie au xve siècle, de la Bibliothèque Nationale. Paris, Editions de
la Gazette des Beaux Arts, 1927. 118p.

343. Diringer, David. The hand-produced book. N.Y., Philosophical
Library, 1953. 603p. illus.

344. _____. The illuminated book, its history and production.
New ed., revised and augmented with the assistance of Dr. Reinhold
Regensburger. London, Faber and Faber, 1967. 514p. illus.

345. _____. "Miniatures and illumination: the European West, 6th
to the 11th centuries." (In Encyclopedia of world art. N.Y., McGraw-
Hill, 1965. vol. 10, columns 141-71.)

346. Donati, Lamberto. Il non finito nel libro illustrato antico.
Florence, L. Olschki, 1973. 272p. illus.

347. Ehl, Heinrich. Buchmalerei des frühen Mittelalters. Berlin,
Furche-Kunster-verlag, 1925. 26p.

348. Formaggio, Dino and Basso, Carlo, eds. A book of miniatures.
Tr. by Peggy Craig. N.Y., Tudor, 1962. 143p. 132 illus.

349. Harvard University Library. Illuminated and calligraphic manu-
scripts; an exhibition held at the Fogg Art Museum and Houghton Library,
Feb. 14-Apr. 1, 1955. Cambridge, 1955. 45p. 80 plates.

350. Hassall, Averil G. and Hassall, William O. Treasures from the
Bodleian Library. N.Y., Columbia Univ. Press, 1976. 160p. 36 full
color plates.

351. Herbert, John A. Illuminated manuscripts. 2d ed. London,
Methuen, 1911. 355p.

352. Humphreys, Henry N. The illuminated books of the middle ages.
London, Longman, Brown, Green, Longmans, 1849. 15p. 34 leaves. 40
plates.

353. James, Montague R. A descriptive catalog of the Latin manuscripts
in the John Rylands Library at Manchester. Manchester, at the Univer-
sity Press, 1921. 2 vols. (vol. 2 has plates.)

354. Kobell, Louise von. Kunstvolle Miniaturen und Initialen aus
Handschriften des 4. bis 16. Jahrhunderts. Munich, J. Albert, 1890.
108p. plates.

355. Kraus, H. P. (firm) Fifty medieval and renaissance manuscripts. N.Y., n.d. 199 illus. (84 in color). (catalog 88.)

356. _____. Illustrated books from the xvth and xvith centuries. N.Y., n.d. 148p. 115 reproductions of woodcuts. (catalog 121.)

357. Mandel, Gabriele. Les manuscrits à peintures. Paris, Pont Royal (Del Duca-Laffont), 1964. 54p. 176 plates.

358. Miner, Dorothy. "Illuminated books of the Middle Ages and the Renaissance." Print 6, no. 3:29-60. 1949.

359. Mitchell, Sabrina. Medieval manuscript painting. N.Y., Viking, 1964. 176p.

360. Moid, Abdul. "Illumination." (In Encyclopedia of library and information science. Ed. by Allen Kent et al. N.Y., Marcel Dekker, 1974. vol. 11, p.196-219.)

361. Molinier, Auguste M. Les manuscrits et les miniatures. Paris, Hachette, 1892. 333p.

362. Monumenta codicum manu scriptorum; an exhibition catalog of manuscripts of the 6th to the 17th centuries. N.Y., H. P. Kraus, 1974. 164p. 125 illus. in black and white; 63 colored illus.

363. Nordenfalk, Carl. "Book illumination." (In Grabar, André. Early medieval painting from the fourth to the eleventh century. N.Y., Skira, 1957. p.89-218.)

364. Omont, Henri A. Reproductions de manuscrits et miniatures de la Bibliothèque Nationale. Paris, 1901-11. 32 vols.

365. Oxford University. Bodleian Library. Illuminated manuscripts in the Bodleian Library. Comp. by Otto Pächt and J. J. G. Alexander. Oxford, Clarendon Press, 1966-

366. Paret, Oscar. Die Bibel—ihre Überlieferung in Druck und Schrift. Stuttgart, 1949. 215p. plates. facs.

367. Pearsall, Derek. "Hunting scenes in medieval illuminated manuscripts." Connoisseur 196:170-81, Nov. 1977.

368. Pierpont Morgan Library, N.Y. Central European manuscripts in the Pierpont Morgan Library. Comp. by Meta Harrsen. N.Y., 1958. 86p. 90 plates.

369. _____. The Glazier collection of illuminated manuscripts. Comp. by John Plummer. N.Y., 1968. 50p. 57 plates.

370. _____. Major acquisitions of the Pierpont Morgan Library, 1924-1974. Vol. 2: Medieval and Renaissance manuscripts. N. Y., 1974. plates.

371. Pierpont Morgan Library, N.Y. The Pierpont Morgan Library exhibition of illuminated manuscripts held at the New York Public Library. Introduced by Charles R. Morey. Catalog of the manuscripts by Belle da Costa Greene and Meta P. Harrsen.... N.Y., Nov. 1933 to April 1934. N.Y., 1934. 85p. plates. facs.

372. Propert, John L. A history of miniature art. London, Macmillan, 1887. 285p.

373. Réau, Louis. Histoire de la peinture au moyen âge: la miniature. Melun, Librairie d'Argences, 1946. 256p. 96 plates.

374. Robb, David M. The art of the illuminated manuscript. N.Y., A. S. Barnes, 1973. 356p.

375. Robert Danon Collection. Manuscrits enluminés et livres rares. Paris, 1973. unpaged. 134 lots. illus. (auction catalog.)

376. Rothe, Edith. Medieval book illumination in Europe; the collections of the German Democratic Republic. N.Y., Norton, 1966. 307p. 96 colored plates. 64 monochrome.

377. Sallander, Hans. Medeltidens boktryckerihistoria. Uppsala, 1959. 211p. 117 plates.

378. Sawicka, Stanislawa, ed. "Illuminatorstwo." (In Birkenmajer, Aleksander, ed. Encycklopedia wiedzy o ksiazce. Wroclaw, 1971. columns 911-52.)

379. Saxl, Fritz. "Illustrated medieval encyclopedias." (In Lectures. London, Warburg Institute, Univ. of London, 1957. vol. 1, p.228-54; vol. 2, plates 155-74.)

380. Scheller, R. W. A survey of medieval model books. Haarlem, Bohn, 1963. 215p. illus.

381. Société Française de Reproductions de Manuscrits à Peintures. Bulletin, année 1-21. Paris, 1911-38. 21 vols. plates.

382. Sosa, Guillermo S. El arte del libro en la Edad Media. Buenos Aires, 1966. 370p. illus. (Introduction in Spanish, English, French, German, and Italian.)

383. Swarzenski, Hanns. Early medieval illumination. Tr. from the German by Barbara F. Sessions. N.Y., Oxford Univ. Press, 1952. 19p.

384. Thompson, Daniel V. The materials of medieval painting. London, Allen and Unwin, 1936. 239p.

385. Thompson, Edward M. "The grotesque and the humorous in illuminations of the middle ages." Bibliographica 2:309-32. 1896.

386. Walters Art Gallery, Baltimore. Illuminated books of the Middle Ages and Renaissance. Baltimore, 1949. 85p. 81 plates.

387. Weitzmann, Kurt. Ancient book illumination. Cambridge, Published for Oberlin College and the Dept. of Art and Archeology of Princeton University by Harvard Univ. Press, 1959. 166p.

388. _____. Illustrations in roll and codex; a study in the origin and method of text illustration. 2d printing with addenda. Princeton, Princeton Univ. Press, 1970. 261p.

389. _____. "Narration in early Christendom." American journal of archeology 61:83-91, Jan. 1957.

390. _____. Studies in classical and Byzantine manuscript illumination. Ed. by Herbert L. Kessler. Chicago, Univ. of Chicago Press, 1971. 346p.

391. Zbinden, Hans M. Early medieval illumination. Introduction by H. Swarzenski. N.Y., Oxford Univ. Press, 1951. 19p. 8 illus. 21 colored plates.

392. Zimmermann, Heinrich. Vorkarolingische Miniaturen. Berlin, Deutschen Vereins für Kunstwissenschaft, 1916-18. 5 vols. (one vol. text and 4 vols. plates).

Byzantine Illumination

393. Belting, Hans. Das illuminierte Buch in der Spätbyzantinischen Gesellschaft. Heidelberg, C. Winter, 1970. 110p. 36p. of illus.

394. Delvoye, Charles. "Byzantine manuscripts." (In Vervliet, Hendrik D. L., ed. The book through five thousand years. London, Phaidon, 1972. p.177-88.)

395. Demus, Otto. Byzantine art and the West. N.Y., New York Univ. Press, 1970. 274p. (Wrightsman Lectures, Institute of Fine Arts, New York University.)

396. Diringer, David. "Byzantine illumination." (In The illuminated book; its history and production. N.Y., Philosophy Library, 1958. p.75-118.)

397. Dufrenne, Suzy. L'illustration des psautiers grecs du moyen âge. Paris, Klincksieck, 1966- plates. (Bibliothèque des Cahiers Archéologiques.)

398. _____. "Psautiers byzantins." Oeil, no. 167:2-9, Nov. 1968.

399. Ebersolt, Jean. La miniature byzantine. Paris, G. Van Oest, 1926. 110p. and portfolio of 72 plates.

400. Frantz, M. Alison. "Byzantine illuminated ornament." Art bulletin 16:43-76 and plates, Mar. 1934.

401. Grabar, André. "Illuminated manuscripts." (In Byzantium from the death of Theodosius to the rise of Islam. London, Thames and Hudson, 1966. p.193-217.)

402. Kitzinger, Ernst. <u>Byzantine art in the making; main lines of</u> <u>stylistic development in Mediterranean art 3d-7th century.</u> Cambridge, Harvard Univ. Press, 1977. 175p. many plates.

403. Kondakov, Nikodim P. <u>Histoire de l'art byzantin considéré</u> <u>principalement dans les miniatures.</u> Edition française originale, <u>publiée par l'auteur sur la traduction de M. Trawinski.</u> Paris, Librairie de l'Art, 1886-91. 2 vols in 1.

404. Lazarev, Viktor N. <u>Storia della pittura bizantina.</u> Turin, 1967. plates.

 Published in 2 vols. in Russian in 1947 and 1948 in Moscow.

405. Milliken, William M. "Byzantine manuscript illumination." <u>Cleveland Museum bulletin</u> 34:50-56, Mar. 1947.

406. Morey, Charles R. "Byzantine renaissance." <u>Speculum</u> 14:139-59, Apr. 1939.

407. Muratoff, Paul. <u>La peinture byzantine avec 262 reproductions</u> <u>hors texte.</u> Paris, A. Weber, 1935. 174p.

408. Oxford University. Bodleian Library. <u>Byzantine illumination.</u> Oxford, 1952. 10p. 22 plates. (Bodleian picture books, no. 8.)

409. Spatharakis, Iohannis. <u>The portrait in Byzantine illuminated</u> <u>manuscripts.</u> Leiden, E. J. Brill, 1976. 287p. 68 leaves of plates.

410. Tikkanen, Johan J. <u>Die Psalterillustration im Mittelalter.</u> <u>Acta societas scientarum fennicae</u> 31, no. 5. 1903. 320p.

411. Weitzmann, Kurt. "Byzantine miniature and icon painting in the eleventh century." (In <u>Studies in classical and Byzantine manuscript</u> <u>illumination.</u> Ed. by Herbert L. Kessler. Chicago, Univ. of Chicago, 1971. p.271-313.)

 Originally in the <u>Proceedings of the xiii International</u> <u>Congress of Byzantine Studies</u>, Oxford, 5-10 Sept. 1966, p.207-24.

412. _____. <u>The place of book illumination in Byzantine art.</u> Princeton, Art Museum, Princeton Univ., 1975. 184p. many illus.

<u>Other Schools of Illumination</u>

413. Boinet, Amédée C. <u>La miniature carolingienne.</u> Paris, 1913. 6p. 160 plates.

414. <u>Carolingian painting.</u> Introduction by Florentine Mütherich. <u>Provenances and commentaries by Joachim E. Gaehde.</u> N.Y., G. Braziller, 1976. 126p. colored plates.

415. Coen Pirani, Emma. <u>Gothic illuminated manuscripts.</u> Tr. by Margaret Crosland from the Italian. London, Hamlyn, 1966. 158p.

416. Dodwell, Charles R. The Canterbury school of illumination 1066-1200. Cambridge, Univ. Press, 1954. 140p. plates. 291 photographs.

417. Koehler, Wilhelm R. Die Karolingischen Miniaturen. Berlin, B. Cassirer, 1930-60. 3 vols. in 7.

418. Mazal, Otto. Buchkunst der Gothik. vol. 1. Graz, Akademische Druck und Verlagsanstalt, 1975. 254p. 32 colored and 136 black and white illus.

419. Nordenfalk, Carl. Celtic and Anglo-Saxon painting; book illumination in the British Isles 600-800. N.Y., G. Braziller, 1977. 126p. illus. 48 plates.

420. _____. "Romanesque book illumination." (In Grabar, André. Romanesque painting from the eleventh to the thirteenth century. N.Y., Skira, 1958. p.133-206.)

421. Pichard, Joseph. "The world of manuscripts." (In Romanesque painting. London, Heron Books, 1968. p.36-42.)

422. Robinson, Stanford F. Celtic illuminative art in the Gospel books of Darrow, Lindisfarne and Kells. Dublin, Hodges, Figgis, 1908. 106p. 51 plates.

Manuscript Ornamentation

423. Bühler, Curt F. "The margins in medieval books." Papers of the Bibliographical Society of America 40:32-42, Jan.-Mar. 1946.

424. Denis, Ferdinand. Histoire de l'ornementation des manuscrits. Paris, L. Curmer, 1857. 143p. illus.

425. Guillot, Ernest. Eléments d'ornementation du xvie au xviiie siècle, tirés des manuscrits, des imprimés, des estampes de la Bibliothèque Nationale et des monuments historiques de l'époque. Paris, Turgis, 1899. 2 fascicules. plates.

426. _____. Ornementation des manuscrits au moyen-âge. Recueil de documents, lettres ornées, bordures, miniatures, etc., tirés des principaux manuscrits de la Bibliothèque Nationale, de diverses bibliothèques et des monuments de l'époque. Paris, Laurens, 1890?-1893? 4 vols. colored plates.

427. Labarte, Jules. "Ornementation des manuscrits." (In Histoire des arts industriels au moyen âge et à l'époque de la renaissance. Paris, A. Morel, 1865. vol. 3, p.9-326.)

428. Lamprecht, Carl G. Initial-Ornamentik des viii. bis xiii. Jahrhunderts. Leipzig, 1882. 32p.

429. Langlois, Eustache H. Essai sur la calligraphie des manuscrits du moyen-âge et sur les ornements des premiers livres d'heures imprimées. Rouen, 1841. 180p. 16 plates.

430. Moé, Emile A. van. La lettre ornée dans les manuscrits du viii au xii siècle. Paris, Editions du Chêne, 1943. 15p. 80 plates.

431. _____. Illuminated initials in medieval manuscripts. Tr. by Joan Evans. London, Thames and Hudson, 1950. 120p.

432. Randall, Lilian M. Images in the margins of Gothic manuscripts. Berkeley, Univ. of Calif. Press, 1966. 235p. 739 illus. (California studies in the history of art, no. 4.)

433. Rodger, William. "Manuscript initials, a fine art form." Hobbies 82:150-52, July 1977.

434. Shaw, Henry and Madden, Frederic. Illuminated ornaments selected from manuscripts and early printed works from the sixth to the seventeenth centuries, drawn and engraved by H. Shaw with descriptions by Sir Frederic Madden. London, Pickering, 1833. 80p. 59 colored plates.

435. Thiel, Erich J. "Neue Studies zur Ornamentalen Buchmalerei des frühen Mittelalters." Archiv für Geschichte des Buchwesens 11, no. 3-5: 1058-1126. 1970.

436. Victoria and Albert Museum, London. Historical introduction to the collection of illuminated letters and borders in the National Art Library, Victoria and Albert Museum. By J. W. Bradley. London, 1901. 182p.

Bibles, Books of Hours, and Other Religious Works

437. Délaissé, L. M. "The importance of books of hours for the history of the medieval book." (In Gatherings in honor of Dorothy Miner. Baltimore, 1974. p.203-25.)

438. Eule, Wilhelm. Zwei Jahrtausende Bibeldruck. Berlin, Evangelische Haupt-Bibelgesellschaft, 1958. 250p. illus.

439. Frick, Bertha M. "Books of hours." (In Encyclopedia of library and information science. Ed. by Allen Kent and Harold Lancour. N.Y., Marcel Dekker, 1970. vol. 3, p.57-73.)

440. "Great pages in great Bibles; illuminated manuscripts embellish the ancient stories." Life 34:76-88, Feb. 23, 1953.

441. Harthan, John P. The book of hours with a historical survey. N.Y., Crowell, 1977. 192p. illus. plates.

442. Haseloff, Gunter. Die Psalterillustration im 13. Jahrhundert. Kiel, 1938. 123p.

443. Labarre, A. "Livres d'heures." (In Dictionnaire de spiritualité ascétique et mystique. Paris, Beauchesne, 1968. vol. 7, p.410-31.)

444. Leclercq, H. "Livres d'heures." (In Cabrol, Fernand. Dictionnaire d'archéologie chrétienne et de liturgie. Paris, 1930. columns 1836-82.)

445. Leroquais, Victor. Les livres d'heures manuscrits de la Bibliothèque Nationale. Paris, 1927. 2 vols. and atlas. Supplement, 1943. 1 vol. 130 plates.

446. _____. Les bréviaires manuscrits des bibliothèques publiques en France. Paris, Mâcon, Protat, 1939. 5 vols.

447. _____. Les psautiers manuscrits des bibliothèques publiques de France. Paris, Mâcon, Protat, 1937. 4 vols.

448. _____. Les sacramentaires et les missels manuscrits des bibliothèques publiques en France. Paris, Mâcon, Protat, 1924. 4 vols.

449. Old Testament miniatures; a medieval picture book with 283 paintings from the Creation to the story of David. Introduction and legends by Sydney C. Cockerell. new ed. London, Phaidon, 1969. 209p. colored illus. facs.

450. Pierpont Morgan Library, N.Y. The Bible; manuscripts and printed Bibles from the fourth to the nineteenth century; illustrated catalogue of an exhibition Dec. 1, 1947 to Apr. 30, 1948. N.Y., 1947. 47p.

451. Ronci, Gilberto. "Libro d'ore." (In Enciclopedia cattolica. vol. 7, 1951, columns 1319-23.)

452. Rost, Hans. Die Bibel im Mittelalter; Beiträge zur Geschichte und Bibliographie der Bibel. Augsburg, Kommissions-Verlag M. Seitz, 1939. 428p. illus. facs.

453. Schmidt, Gerhard. Die Armenbibeln des 14. Jahrhunderts. Cologne, Bohlau, 1959. 163p. 44 plates.

454. Soleil, Félix. Les heures gothiques et la littérature pieuse aux 15e et 16e siècles. Rouen, E. Auge, 1882. 311p. 30 plates.

455. Westwood, John O. Illuminated illustrations of the Bible. Copied from select manuscripts of the middle ages. London, W. Smith, 1846. 8p. 39 leaves. 40 colored plates.

456. _____. Paleographica sacra pictoria; being a series of illustrations of the ancient versions of the Bible, copied from illuminated manuscripts, executed between the 4th and 16th centuries. London, Bohn, 1849. various paging. colored plates.

Fifteenth and Sixteenth Centuries

457. Adhémar, Jean. "Les livres d'emblèmes." Le portique 2:107-16. 1945.

458. Baer, Leo. Die illustrierten Historienbücher des 15. Jahrhunderts. Strassburg, Heitz, 1903. 216p.

459. Bayley, Harold. A new light on the Renaissance, displayed in contemporary emblems. London, J. M. Dent, 1909. 270p.

460. Bober, Harry. "The illustrations in the printed books of hours, iconographic and stylistic problems." Ph.D. dissertation, New York Univ., 1949. 481p.

461. Bouchot, Henri F. Les livres à vignettes du xve au xviie siècle. Paris, E. Rouveyre, 1891. 102p.

462. Brun, Robert. Le livre illustré de la Renaissance; étude suivie du catalogue des principaux livres à figures du xvie siècle. Paris, Picard, 1969. 329p. illus.

463. Bühler, Curt F. The fifteenth-century book; the scribes, the printers, the decorators. Phila., Univ. of Pa. Press, 1960. 195p.

464. Butsch, Albert F. Die Bücherornamentik der Renaissance. Leipzig, G. Hirth, 1878. 72p. 108 plates.

465. _____. Die Bücherornamentik der Hoch- und Spätrenaissance. Leipzig, G. Hirth, 1881. 56p. 118 plates.

466. _____, ed. Handbook of Renaissance ornament; 1290 designs from illustrated books. With a new introduction and captions by Alfred Werner. N.Y., Dover, 1969. 223 plates.

 The designs appeared originally in the editor's Die Bücher-ornamentik der Renaissance.

467. Chapman, Emily Del Mar. "Trends in Bible illustration in the 16th century." Master's thesis, Univ. of North Carolina, 1957. 129p.

468. Chicago Art Institute. The first century of printmaking 1400-1500; a catalogue compiled by Elizabeth Mongan and Carl O. Schniewind. An exhibition, Jan. 30-Mar. 2, 1941. Chicago, Lakeside Press, 1941. 152p. illus.

469. Cornell, Henrik. Biblia pauperum. Stockholm, The Author, 1925. 372p. 72 plates.

470. Donati, Lamberto. "Dal libro xilografico al manuscritto: L'Apocalissi." (In Studi offerti a Roberto Ridolfi. Florence, Olschki, 1973. p.249-84.)

471. Dutuit, Eugène. Manuel de l'amateur d'estampes. Paris, 1881-88. 4 vols. in 5 and an atlas of 37 plates.

472. Eichenberger, Walter. "Die Anfänge der gedrucken Bibelillustra-tion vor 500 Jahren." Librarium 18:68-74, Aug. 1975.

473. Geisberg, Max. Der Buchholzschnitt im 16 Jahrhundert in deutschen, schweizer, niederländischen, französischen, spanischen drucken des 16. Jahrhunderts. Berlin, O. Schloss, 1937. 55p.

474. _____. Woodcuts from books of the 16th century from German, Swiss, Dutch, French, Spanish, and Italian presses. Olten, Switzerland, Weisshesse Antiquariat, 1937. 50p. 100 plates.

475. Glaser, Curt. <u>Gotische Holzschnitte</u>. Berlin, Propyläen-Verlag, 1923. 56p. 55 plates.

476. Goldschmidt, Ernst P. <u>The printed book of the Renaissance; three lectures on type, illustration, ornament.</u> Cambridge (England), University Press, 1950. 92p. illus. facs.

477. Heitz, Paul, ed. <u>Einblattdrucke des fünfzehnten Jahrhunderts.</u> Strassburg, J. H. E. Heitz, 1899-1942. 100 fascicules.

478. Hofer, Philip. "The early illustrated book." <u>Quarterly journal of the Library of Congress</u> 35:77-91, Apr. 1978.

479. Homann, Holger. <u>Studien zur Emblematik des 16. Jahrhunderts.</u> Utrecht, Dekker and Gumbert, 1971. 173p. illus.

480. Ivins, William M. <u>The artist and the 15th-century printer.</u> N.Y., The Typofiles, 1940. 78p.

481. Jennings, Oscar. <u>Early woodcut initials, containing over thirteen hundred reproductions of ornamental letters of the fifteenth and sixteenth centuries.</u> London, Methuen, 1908. 287p.

482. Koopman, Harry L. "Pictorial initials." <u>Printing art</u> 32:101-07, Oct. 1918.

483. Lebeer, Louis. <u>L'esprit de la gravure au xv^e siècle.</u> Brussels, Editions du Cercle d'Art, 1943. 61p. illus.

484. Louvre, Paris. <u>Les primitifs de la gravure sur bois; étude historique et catalogue des incunables xylographiques du Musée du Louvre.</u> By André Blum. Paris, 1956. 80p. 48 plates.

485. McMurtrie, Douglas C. "Early book decoration." (In <u>The book; the story of printing and bookmaking.</u> 3rd ed. London, Oxford Univ. Press, 1943. p.269-77.)

486. Milan. Archivio Storico Civico. <u>I tesori della trivulziana; la storia del libro dal secolo viii al secolo xviii.</u> Commune di Milano, 1962. 250p. illus.

487. Morison, Stanley. <u>Four centuries of fine printing.</u> 4th ed. N.Y., Barnes and Noble, 1960. 254p. many plates.

488. _____. <u>The typographic book 1450-1905; a study of fine typography through five centuries exhibited in upwards of 350 title and text pages.</u> London, Ernest Benn, 1963.

489. Morris, William. <u>Some notes on early woodcut books, with a chapter on illuminated manuscripts.</u> New Rochelle, N.Y., Elston Press, 1902. [25p.] illus.

490. Olds, Clifton C. "Ars moriendi; a study of the form and content of fifteenth-century illustrations of the art of dying." Ph.D. dissertation, Univ. of Pennsylvania, 1966. 292p.

491. Olschki, Leo S. Le livre illustré au xve siècle. Florence, The Author, 1926. 80p. 220 plates.

492. Ottley, William Y. An inquiry into the origin and early history of engraving upon copper and in wood. London, Printed for J. and A. Arch by J. M'Creery, 1816. 2 vols.

493. Paret, Oscar. Die Bibel--ihre Uberlieferung in Druck und Schrift. Stuttgart, 1849. 215p. plates. facs.

494. Paris. Bibliothèque Nationale. Dépt. des Estampes. Les xylographies du xive et xve siècle au Cabinet des Estampes de la Bibliothèque Nationale. Par Paul A. Lemoisne. Paris, G. Van Oest, 1927-30. 2 vols.

495. Passavant, Johann D. Le peintre-graveur. Contenant l'histoire de la gravure ... jusque vers la fin du xvie siècle. Leipzig, R. Weigel, 1860-64. 6 vols. in 3.

496. Pierpont Morgan Library, N.Y. Major acquisitions of the Pierpont Morgan Library 1924-1974. Vol. 3: Early printed books. N.Y., 1974. plates.

497. Pollard, Alfred W. Early illustrated books; a history of the decoration and illustration of books in the 15th and 16th centuries. 2d ed. London, K. Paul, Trench, Trübner, 1917. 254p. illus. facs.

498. _____. "The transference of woodcuts in the fifteenth and sixteenth centuries." Bibliographica 2:343-68, 1896. (Also in his Old picture books. London, 1902. p.73-98.)

499. Rath, Erich von. "The history of copper engraving in the sixteenth century." Archiv für Buchgewerbe und Gebrauchsgraphik 64:1-27, 1927.

500. Ricketts, Charles. "Famous woodcuts of the xvth and xvith centuries." Ars typographica 1:28-35, Summer 1918.

501. Rouir, Eugène. La gravure, des origines au xvie siècle. Paris, Somogy, 1971. 256p.

502. Schramm, Albert. Der Bilderschmuck der Frühdruck. Leipzig, 1924-36. 19 vols.

Reproduces all the illustrations in the incunabula.

503. Schreiber, Wilhelm. Biblia pauperum. Strasbourg, J. H. E. Heitz, 1903. 45p.

504. _____. Manuel de l'amateur de la gravure sur bois et sur métal au xve siècle. Berlin, A. Cohn, 1891-1900. 8 vols.

A concordance to Schreiber's Manuel was compiled by Adalbert Lauter in 1925.

505. Schreiber, Wilhelm. Handbuch der Holz- und Metallschnitte des xv Jahrhunderts. Leipzig, Hiersemann, 1926-30. 8 vols.

This is an enlarged edition of the author's Manuel (8 vols., 1891-1900). H. P. Kraus published a 3d ed. in 1969, 10 vols. in 11.

506. Deleted.

507. Spamer, Adolf. Das kleine Andactsbild von xiv. bis xx. Jahrhundert. Munich, F. Bruckmann, 1930. 334p. illus.

508. Strachan, James. Early Bible illustrations; a short study based on some fifteenth and early sixteenth century printed texts. Cambridge, University Press, 1957. 169p.

509. Vatican. Biblioteca Vaticana. Miniatures of the Renaissance. Vatican City, 1950. 96p. 32 plates.

510. Volkmann, Ludwig. Bilderschriften der Renaissance. Leipzig, Hiersemann, 1923. 132p. illus.

511. Walters Art Gallery, Baltimore. Illuminated books of the Middle Ages and Renaissance. Baltimore, 1949. 85p. 81 plates.

512. Weitenkampf, Frank. "Fifteenth century, cradle of modern book illustration." New York Public Library bulletin 42:87-93, Feb. 1938.

513. Zimmermann, Hildegard. Beiträge zur Bibelillustration des 16. Jahrhunderts. Strassburg, J. H. E. Heitz, 1924. 180p. plates.

Seventeenth and Eighteenth Centuries

514. Adhémar, Jean. La gravure originale au xviiie siècle. Paris, Aimery Somogy, 1963. 255p.

515. Benesch, Otto. Artistic and intellectual trends from Rubens to Daumier as shown in book illustration. Cambridge, Dept. of Printing and Graphic Arts, Harvard College Library, 1943. 91p. plates.

516. Brussels. Exposition de la Miniature 1912. L'exposition de la miniature à Bruxelles en 1912; recueil des oeuvres les plus remarquables des miniaturistes de toutes les écoles, du xvie au xixe siècle. Bruxelles, G. Van Oest, 1913.

517. Cohen, Henry. Guide de l'amateur de livres à gravures du xviiie siècle. 6th ed. Rev., corrected and augmented by Seymour de Ricci. Paris, A. Rouquette, 1912. 2 vols. in 1.

518. Delteil, Loÿs. Manuel de l'amateur d'estampes du xviiie siècle, orné de 106 reproductions hors texte. Paris, Dorbonnaine, 1910. 447p. 106 plates.

42 BOOK ILLUSTRATION AND DECORATION

519. Eighteenth-century book illustrations. Selected with an introduction by Philip Hofer. Los Angeles, William Andrews Clark Memorial Library, Univ. of Calif., 1956. 50 illustrations.

520. Eppink, Norman R. 101 prints; the history and techniques of printmaking. Norman, Univ. of Okla. Press, 1971. 272p.

521. Goldschmidt, Lucien. "Baroque book illustration." (In Book illustration; papers presented at the third rare book conference of the American Library Association in 1962. Ed. by Frances J. Brewer. Berlin, Gebr. Mann Verlag, 1963. p.13-21.)

522. Hirth, George, ed. Kulturgeschichtes Bilderbuch aus drei Jahrhunderten. Leipzig, G. Hirth, 1881-1890. 6 vols.

523. _____. Les grands illustrateurs; trois siècles de la vie sociale 1500-1800. Leipzig, G. Hirth, 1882-1890. 6 vols. illus. ports. plates.

524. _____. Picture book of the graphic arts, 1500-1800. N.Y., Blom, 1972. 6 vols. illus. (Reprint of the 1882-90 ed. Text in English and German.)

525. Hofer, Philip. Baroque book illustration. Cambridge, Harvard Univ. Press, 1951. 43p. 149 illus.

526. _____. "Some precursors of the modern illustrated book." Harvard Library bulletin 4:191-202, Spring 1950.

526a. Lehmann-Haupt, Hellmut. An introduction to the woodcut of the seventeenth century with a discussion of the German woodcut broadsides of seventeenth century by Ingeborg Lehmann-Haupt. N.Y., Abaris, 1977. 282p. illus.

527. Morison, Stanley. Four centuries of fine printing. 4th ed. N.Y., Barnes and Noble, 1960. 254p. many plates.

528. _____. The typographic book 1450-1935; a study of fine typography through five centuries exhibited in upwards of 350 title and text pages. London, Ernest Benn, 1963.

529. Portalis, Roger and Béraldi, Henri. Les graveurs du xviii e siècle. Paris, Morgand et Fatout, 1880-82. 3 vols.

530. Praz, Mario. Studies in seventeenth century imagery. 2d ed. Roma, Edizioni di Storia et Letteratura, 1964. 607p.

531. Reynaud, Henry J. Notes supplémentaires sur les livres à gravures du xviii e siècle. Geneva, Bibliothèque des Erudits, 1955. 582 columns.

532. Rouir, Eugène. La gravure originale au xvii e siècle. Paris, Somogy, 1974. 251p.

533. Slythe, R. Margaret. The art of illustration 1750-1900. London, Library Association, 1970. 144p.

534. Sotheby & Co. A catalog of illustrated books and volumes of prints mostly of the 18th century. 1975. 111p. plates.

535. Spamer, Adolf. Das kleine Andachtsbild von xiv. bis xx. Jahrhundert. Munich, F. Bruckmann, 1930. 334p. illus.

Nineteenth Century

536. Bänfer, Carl. "Bild und Wort im illustrativen Schaffen der letzten 100 Jahre." Doctoral thesis, Univ. of Münster, 1952.

537. Bain, Iaian. "Gift book and annual illustrations." (In Faxon, Frederick W. Literary annuals and gift books; a bibliography 1823-1903. Pinner, Middlesex (England), Private Libraries Association, 1973. p.19-25 and plates.)

538. Béraldi, Henri. Les graveurs du xix e siècle. Paris, Conquet, 1885-1892. 12 vols.

539. Boston Museum of Fine Arts. The artist and the book 1860-1960, in western Europe and the United States. 2d ed. Boston, 1972. 232p.

540. Carteret, Leopold. Le trésor du bibliophile romantique et moderne 1801-1875. Paris, The Author, 1924-28. 4 vols. illus. facs.

541. Cincinnati Art Museum. One hundred and fifty years of lithography ... exhibition Mar. 19th to Apr. 28, 1948. Cincinnati, 1948. 36p. illus.

542. Delteil, Loÿs. Manuel de l'amateur d'estampes des xix e et xx e siècles (1801-1924). Paris, 1925. 2 vols. illus.

543. Edwards, George W. "The illustration of books." Outlook 57:817-23, Dec. 4, 1897.

544. Fleury, Jules. Les vignettes romantiques; histoire de la littérature et de l'art 1825-1840. Paris, E. Dentu, 1883. 438p.

545. French, George. Printing in relation to graphic art. Cleveland, Imperial Press, 1903. 118p.

546. Garvey, Eleanor M. et al. The turn of a century, 1885-1910. Art nouveau Jugendstil books. Cambridge, Dept. of Printing and Graphic Arts, Harvard Univ., 1970. 124p. illus. facs.

547. Ginnis, Carlajean K. "'Complete book' in art nouveau and modern expressionist book design." M. A. thesis, Univ. of Chicago, 1975. 184p.

548. Gravier, Charles. "Photographic processes used in book illustrations." Penrose annual 7:109-110. 1901-02.

549. Gray, Nicolete M. Xixth century ornamented types and title pages. London, Faber and Faber, 1938. 213p. new ed., 1976.

550. Hasler, Charles. "Mid-nineteenth century colour printing."
Penrose annual 45:66-68. 1951.

551. Kautzsch, Rudolf, ed. Die neue Buchkunst; studien im in- und
Ausland. Weimar, Gesellschaft der Bibliophilen, 1902. 200p.

552. Lambert, F. C. "Photography as an aid to the decoration of a
book." Penrose annual 4:57-61. 1898.

553. Lewis, John. "Art nouveau and the arts and crafts movement."
(In Anatomy of printing; the influence of art and history on its design.
N.Y., Watson-Guptill, 1970. p.201-08.)

554. Metzdorf, Robert F. "Victorian book decoration." Princeton
University Library chronicle 24:91-100, Winter 1963.

555. Morison, Stanley. Four centuries of fine printing. 4th ed.
N.Y., Barnes and Noble, 1960. 254p.

556. _____. The typographic book 1450-1935; a study of fine
typography through five centuries exhibited in upwards of three hundred
and fifty title and text pages drawn from presses working in the European
tradition. London, Ernest Benn, 1963.

557. National Book League, London. Victorian book illustration with
original photographs and by early photomechanical processes. Catalogue
of an exhibition held at the National Book League from 8 to 13 Oct. 1962.
Comp. by Rolf Schultze. London, 1962. 14p.

558. Pennell, Joseph. "Later nineteenth-century book illustrations."
Burlington magazine 2:293-307, Aug. 1903.

559. Pennell, Joseph and Pennell, Elizabeth. Lithography and lithog-
raphers; some chapters in the history of the art. London, F. F. Unwin,
1898. 279p. new ed., 1915.

560. Peppin, Brigid. Fantasy; the golden age of fantastic illustration.
N.Y., Watson-Guptill, 1975. 191p. 210 illus.

561. Roger-Marx, Claude. La gravure originale au xixe siècle. Paris,
Somogy, 1962. 255p.

562. _____. Graphic art of the 19th century. Tr. from the French
by E. M. Gwyer. London, Thames and Hudson, 1962. 254p.

563. Slythe, R. Margaret. "The art of illustration 1750-1900."
Fellowship thesis, Library Association, 1966. 152p.

564. Schmutzler, Robert. Art nouveau. N.Y., Abrams, 1962. 321p.
illus. plates.

565. Twyman, Michael. "The tinted lithograph." Journal of the Printing
Historical Society no. 1:39-56. 1965.

566. Wakeman, Geoffrey. Victorian book illustration; the technical
revolution. Newton Abbot, David and Charles, 1973. 182p.

567. Weitenkampf, Frank. "Influences and trends in nineteenth-century illustration." (In Fulton, Deoch et al., eds. Bookmen's holiday. N.Y., New York Public Library, 1943. p.345-50.)

Twentieth Century

568. Adhémar, Jean. Twentieth century graphics. Tr. from the French by Eveline Hart. N.Y., Praeger, 1971. 256p. illus. (Translation of La gravure originale au xx e siècle.)

569. Algeria. Direction de l'Intérieur et des Beaux Arts. L'art du livre au xx e siècle. A catalog of an exhibition organized by the Gouvernement Général de l'Algérie in collaboration with the Comité National du Livre Illustré Français with the Société de la Reliure Originale. By J. Veyrin-Forrer et al. Alger, 1955. 192p. illus.

570. Bland, David. "The influence of reproductive techniques on book illustration." Penrose annual 51:16-19. 1957.

571. Bostick, William A. "Contemporary book arts and their roots." (In Book illustration; papers presented at the third rare book conference of the American Library Association in 1962. Berlin, Gebr. Mann Verlag, 1963. p.56-73.)

572. Boston Museum of Fine Arts. The artist and the book 1860-1960 in western Europe and the United States. 2d ed. Boston, 1972. 232p. (exhibit catalog.)

573. Bradley, William A. "Illustrators and their recent work." Independent 73:1345-51, Dec. 12, 1912.

574. Buch und Bild. Buchgraphik der 20. Jahrhunderts. Ausstellung Kunstmuseum Dusseldorf, 28.2--19.4. 1970. Düsseldorf, 1970. 82p. illus.

575. Castleman, Riva. La gravure contemporaine depuis 1942. Fribourg, Office du Livre, 1973. 175p.

576. Child, Harold H. "Modern illustrated books; artist and typographer set a standard for the connoisseur." Creative art 7:33-41, July 1930.

577. Coleman, Morris. "Some technical notes on book illustration." American artist 17:48-56, Jan. 1953.

578. "Colour printing." (In Printing in the twentieth century; a survey reprinted from the special number of the Times, Oct. 29, 1929. London, 1930. p.132-53.)

579. Ede, Charles, ed. The art of the book; some record of work carried out in Europe and the U.S.A. 1939-1950. London, Studio, 1951. 214p.

580. Fawcett, Robert. "Contemporary illustration." Design 61:110-15, Jan. 1960.

581. Fishenden, R. B. "Technique of illustration printing." London Mercury 25:81-84, Nov. 1931.

582. François, Edouard. L'âge d'or de la bande dessinée. Ivry, S.E.R.G., 1974. 134p. (Collection Phénix, no. 3.)

583. Garvey, Eleanor M. et al. The turn of a century 1885-1910; art nouveau Jugendstil books. Cambridge, Dept. of Printing and Graphic Arts, Harvard Univ., 1970. 124p. (exhibition at Houghton Library.)

584. Gill, Bob and Lewis, John. Illustration: aspects and directions. N.Y., Reinhold, 1964. 96p.

585. Glaser, Curt. Die Graphik der Neuzeit vom Anfäng des XIX Jahrhunderts bis zur Gegenwart. Berlin, B. Cassirer, 1922. 585p.

586. Geobel, Theodor. Die graphischen Künste der Gegenwart. Hrsg. von Felix Krais. Stuttgart, F. Krais, 1895-1910. 3 vols. plates.

587. Gossop, Robert P. Book decoration; a review of the art as it is today. N.Y., Oxford Univ. Press, 1937. 45p.

588. Graphik zur Bibel. Zeitgenössische Darstellung zu biblischen Themen. Hrsg. von Hans-Martin Rotermund und Mitarbeit von Gerhard Gollwitzer. Freiburg/Breisgau, Christophorus Verlag, 1966. 303p.

589. Guégan, Bertrand. "Le livre d'art en Europe." Arts et métiers graphiques 26:2-40, Nov. 1931.

590. Hürlimann, Bettina. "Trends of European picture book production since 1945." International library review 3:51-60, Jan. 1971.

591. "Illustration within limits; making the best of techniques and tastes." Times literary supplement, Apr. 26, 1963, p.282-83.

592. Ivins, William M. Prints and visual communication. N.Y., Da Capo Press, 1969. 100p.

593. Jackson, F. Ernest. "Modern lithography." Print collector's quarterly 11:205-26, Apr. 1924.

594. Jacobi, Charles T. "Illustrated books." Penrose annual 20:51-53. 1915.

595. Johnston, Paul. "The use of illustration in fine book design." (In Biblio-typographica; a survey of contemporary fine printing style. N.Y., Covici Friede, 1930. p.152-64.)

596. Leighton, Clare V. "Book illustration." (In Wood engraving of the 1930's. London, Studio, 1936. p.99-126.)

597. Lewis, John. The twentieth century book; its illustration and design. N.Y., Reinhold, 1967. 272p.

598. Maclean, Ruari. "Putting pictures to the words." Times literary supplement, Dec. 7, 1973. p.1505.

599. McMurtrie, Douglas C. "Modern book illustration." (In The book; the story of printing and bookmaking. 3d ed. London, Oxford Univ. Press, 1943. p.509-23.)

600. Marty, André. L'imprimerie et les procédés de gravure au vingtième siècle. Paris, Chez l'Auteur, 1906. 81p.

601. Mathiesen, Egon et al. Moderne bogillustration. Copenhagen, R. Naver, 1934. 53p.

602. Melcher, Daniel. "Use of gravure in bookmaking." Publishers' weekly 159:1166-70, Mar. 3, 1951.

603. Mitchell, Breon. Beyond illustration; the livre d'artiste in the twentieth century. Bloomington, Lilly Library, Indiana University, 1976. 80p. illus. (Lilly Library publication, no. 24.)

604. Morison, Stanley. Four centuries of fine printing. 4th ed. N.Y., Barnes and Noble, 1960. 254p. many plates.

605. Nash, Paul. Room and book. N.Y., Scribner, 1932. 98p. 19 plates.

606. _____. "Surrealism and the illustrated book." Signature, no. 5, p.1-11. 1937.

607. N.Y. Museum of Modern Art. Modern painters and sculptors as illustrators. By Monroe Wheeler, 3d ed. N.Y., Museum of Modern Art, distributed by Simon and Schuster, 1947. 119p. illus. plates.

608. Newdigate, Bernard H. The art of the book. London, Studio, 1938. 104p.

609. Olcott, Charles S. "Photography in book illustrating." Art and progress 3:439-43, Jan. 1912.

610. Peppin, Brigid. Fantasy: the golden age of fantastic illustration. N.Y., Watson-Guptill, 1975. 191p. 210 illus.

611. Piper, John. "Book illustration and the printer-artist." Penrose annual 43:52-54. 1949.

612. Pitz, Henry C. "Book illustration since 1937." American artist 31:64-71, Apr. 1967.

613. Rauch, Nicolas (firm). Les peintres and les livres constituant un essai de bibliographie des livres illustré de gravures originales par les peintres et les sculpteurs de 1867 à 1957. Geneva, The Firm, 1957. 241p.

614. Rosenkrantz, Tessa. "Some modern illuminations." International studio 47:45-59, July 1912.

615. Sipley, Louis W. A half century of color. N.Y., Macmillan, 1951.
216p.

616. Salaman, Malcolm C. The woodcut of today at home and abroad.
Ed. by Geoffrey Holme. London, Studio, 1927. 182p. many illus.

617. Steiner-Prag, Hugo. "European books and designers." Dolphin
no. 1:209-49. 1933.

618. Stubbe, Wolf. Die Graphik des zwanzigsten Jahrhunderts. Berlin,
Rembrandt, 1962. 319p. plates.

 English translation in 1963 published by Thames and Hudson in
 London and by Frederick Praeger in New York City. The Ameri-
 can edition has 319 pages, including 40 color plates and 446
 illustrations in black and white.

619. Visel, Curt. "Buchillustration zwischen Tradition und Zukunft."
Gutenberg Jahrbuch, 1971, p. 338-49.

620. Zadig, Bertrand. "The revival of the woodcut in modern book-
illustration." Publishers' weekly 108:618-21, Aug. 22, 1925.

HISTORY OF BOOK ILLUSTRATION AND DECORATION IN THE COUNTRIES OF THE WORLD

Austria

621. Avermaete, Roger. "La gravure sur bois en Autriche." (In La gravure sur bois moderne de l'Occident. Vaduz, Quarto Press, 1977c1928. p. 221-35.)

622. Lanckorońska, Maria and Oehler, R. Die Buchillustration des xviii Jahrhunderts in Deutschland, Österreich und Schweiz. Leipzig, Insel-Verlag, 1932-34. 3 vols.

623. Levetus, A. S. "The art of the book in Austria." Studio, special no. 1914, p.203-30.

624. Sotriffer, Kristian. "Graphic art." (In Modern Austrian art. N.Y., Praeger, 1965. p.75-83.)

625. Tiessen, Wolfgang, ed. Die Buchillustration in Deutschland, Oesterreich und der Schweiz seit 1945. New-Isenberg, Verlag der Buchhandlung W. Tiessen, 1968. 2 vols.

626. Tietze, Hans. "Oesterreichische Buchmalerei der Gotik." Die graphischen Künste 51:1-14. 1928.

627. Tietze-Conrat, E. "Illustrierte Bücher von Heute." Die bildende Künste 2:no. 2:216-24. 1919.

628. Wickhoff, Franz, ed. Beschreibendes Verzeichnis der illuminierten Handschriften in Oesterreich. Leipzig, Hiersemann, 1905-17. 7 vols. illus. facs. plates.

629. Winkler, Erich. Die Buchmalerei in Niederösterreich von 1150-1250. Vienna, "Krystall"-Verlag, 1923. 26p. 60 illus. 20 plates.

Baltic States

630. Bulnaka, Mecys. Graviury na dereve. Vilnius, Vega, 1968. 18p. 31 plates.

630a. Gedminas, Antanas. Knyga ir dailininkas. Vilnius, Vega, 1966. 158p. illus.

(Summaries and list of books also in Russian, English, and German.)

631. Grafika. Sudare ir apipavidalino. Ed. by Jurenas. Vilnius,
VPMIL, 1960. 197p. (chiefly illustrations.)

632. Lietuvii grafika. vol. 1, 1960- Vilnius, 1960-

633. Latviesu gramatu grafika. Riga, Liesma, 1976. 182p. illus.
(summary in Russian, English, and German.)

634. Loodus, R. J. Kniznaja grafika sovetskoj Estonii. Tallin, Eesti
Raamat, 1976. 171p. plates. illus.

635. Raguotiene, Genovaite. Sintas Knygos misliu. Vilnius, Vega, 1974.
439p. illus.

Belgium

636. Alvin, Louis J. Les commencements de la gravure aux Pays-Bas.
Brussels, M. Hayes, 1857. 41p.

637. Avermaete, Roger. "La gravure sur bois en Belgique." (In La
gravure sur bois moderne de l'Occident. Vaduz, Quarto Press, 1977c1928.
p.81-118.)

638. Bacha, Eugene. Les très belles miniatures de la Bibliothèque
Royale de Belgique. Brussels, G. Van Oest, 1913. 1 vol. (chiefly
illus.). 56 plates,

639. Brussels. Bibliothèque Royale Albert I. Le cinquième centenaire
de l'imprimerie dans les anciens Pays-Bas. Brussels, 1973. 542p.
illus. plates. (exhibit catalog.)

640. Delen, Adrien J. Histoire de la gravure dans les anciens Pays-Bas
et dans les provinces belges. Paris, G. Van Oest, 1924-35. 2 parts
in 3.

641. _____. "L'illustration du livre en Belgique des origines à
1500." (In Histoire du livre et de l'imprimerie en Belgique. Pt. 2,
p.9-115.)

642. Funck, M. Le livre belge à gravures; guide de l'amateur de livres
illustrés imprimés en Belgique avant le xviiie siècle. Paris, G. Van
Oest, 1925. 428p.

643. Hippert, T. and Linnig, Joseph. Le peintre-graveur hollandais et
belge du xixe siècle. Brussels, 1879. 1123p.

644. Histoire du livre et de l'imprimerie en Belgique des origines à
nos jours. Brussels, Musée du Livre, 1923-34. 6 parts. many illus.

645. Landwehr, John. Emblem books in the low countries 1554-1949; a
bibliography. Utrecht, Haentjens, Dekker, and Gumbert, 1970. 151p.
plates.

646. Lebeer, Louis. Hedendaagse graverkunst in België. Hasselt,
Provinciale Bibliotheek van Limburg, 1957? 52p. 60 pages of illus.

647. Lebeer, Louis. "La gravure en Belgique du seizième siècle à nos jours; synthèse historique." (In Exposition du livre et de la gravure en Belgique du quinzième siècle à nos jours. Milan, 1948. p59-86.)

648. Liebrecht, Henri. "Le manuscrit à miniatures aux Pays-Bas des origines à la fin du xv-ᵉ siècle." (In Histoire du livre et de l'imprimerie en Belgique des origines à nos jours. Première partie. Brussels, Musée du Livre, 1923. 90p. illus. plates.

649. _____. "Les illustrateurs belges d'hier et d'aujourd'hui." (In Histoire du livre et de l'imprimerie en Belgique des origines à nos jours. Part 3, p.40-80.)

650. Linnig, Benjamin. La gravure en Belgique. Anvers, Janssens frères, 1911. 195p. plates.

651. Livre d'or du bibliophile. Paris, Editeurs de Livres d'Art, 1925-

 Contains pages of illustrations from books published in Brussels and Paris.

652. Marck, Jan H. M. van der. Romantische boekillustratie in België. Roermond, J. J. Romen, 1956. 294p.

653. Renouvier, Jules. Histoire de l'origine et des progrès de la gravure dans les Pays-Bas et en Allemagne jusqu'à la fin de quinzième siècle. Brussels, M. Hayes, 1860. 317p.

654. Simon, Howard. "Modern Belgium." (In 500 years of art in illustration. Cleveland, World Publishing Co., 1942. p.312-14.)

655. Someren, Jan F. Van. Essai d'une bibliographie de l'histoire spéciale de la peinture et de la gravure en Hollande et Belgique (1500-1875). Amsterdam, Muller, 1882. 207p.

656. Wijngaert, Frank Van Den. "Die Belgische Holzschnittkunst von heute." Buch und Schrift no.7-8:37-49 followed by plates. 1933-34.

Canada

657. Duval, Paul. Word and picture; the story of illustration in Canada. Toronto, Provincial Paper Ltd., 1961. [24]p. illus.

658. Harper, J. Russell. Early painters and engravers in Canada. Toronto, Univ. of Toronto Press, 1970. 376p.

659. Jeanneret, Marsh. "Textbook illustration in Canada." Canadian art 2:166-69, Apr.-May 1945.

660. Salaman, Malcolm C. "The woodcut in Canada." (In Holme, Geoffrey, ed. The woodcut of today at home and abroad. London, Studio, 1927. p.149-55.)

China

661. Centre Franco-Chinois d'Etudes Sinologique, Peking. Exposition d'ouvrages illustrés de la dynastie Ming. Peking, 1944. 167p. 26 plates.

662. Chêng, Chên-to. The history of Chinese graphic art. (English translation of title of work in Chinese.) Shanghai, 1940-42. 20 vols in 5 cases.

663. _____. A selection of Chinese wood engravings. (English translation of Chinese title.) Peking, Jung-pao Chai, 1958. 2 vols.

664. Chicago Art Institute. Ryerson Library. Catalogue of Japanese and Chinese illustrated books in the Ryerson Library of the Chicago Institute of Art. By Kenji Toda. Chicago, 1931. 466p. plates.

665. Douglas, Robert K. "Chinese illustrated books." Bibliographica 2:452-78. 1896.

666. Fribourg, Jean. "Wood engraving." (In Chinese art. N.Y., Universe Books, 1964. vol. 3, plates 128 to 174.)

667. Gimm, Martin. "The book in China." (In Vervliet, Hendrik D., ed. The book through 5000 years. London, Phaidon, 1972. p.109-28.)

668. Gulik, Robert H. van. Chinese pictorial art as viewed by the connoisseur. Rome, Instituto Italiana per il Media ed Estremo Oriente, 1958. 537p.

669. Hambis, Louis. "Engravings and other print media: China." (In Encyclopedia of world art. N.Y., McGraw-Hill, 1961. vol. 4, columns 778-82.)

670. Hejzlar, Josef. Early Chinese graphics. London, Octopus Books, 1973. 54p. 62 plates.

671. Kuo, Wei-ch'i. An outline of the history of Chinese wood engravings. (Translated title.) Peking, 1962. 219p.

672. Kurth, Julius. Der Chinesische Farbendruck. Plauen im Vogtland, C. F. Schulz, 1922. 87p. illus. 36 plates.

673. Tschichold, Jan. L'estampe chinoise ancienne en couleurs. Basle, Les Editions Holbeins, 1940. 2p. 3-13 leaves. 16 colored plates.

674. Tsien, Tsuen-Hsuin. Written on bamboo and silk; the beginnings of Chinese books and inscriptions. Chicago, Univ. of Chicago, 1962. 233p.

675. Wilhelm, Richard. "Schrift und Ornament in China." Buch und Schrift 2:59-62 and plates. 1928.

676. "Woodcuts." (In the Horizon book of the arts of China. N.Y., American Heritage Publishing Co., 1969. p.216-23.)

677. Wu, K. T. "Color printing in the Ming dynasty." T'ien hsia
monthly 11:30-44. 1940.

678. _____. "Illustrations in Sung printing." Quarterly journal of
the Library of Congress 28:173-95. 1971.

679. Zigrosser, Carl. "China and Japan." (In The book of fine prints.
N.Y., Crown, 1937. p.200-31.)

Czechoslovakia

680. Bohatec, Miloslav. Schöne Bücher des Mittelalters aus Böhmen.
Hanau/M., W. Dausien, 1970. 72p.

681. _____. Skryte poklady. Prague, Artia t. Svoboda 1, 1970. 62p.
62 pages of colored plates.

682. Dostál, Eugen. Prisperky k dejinám českého iluminatorského umeni
na sklondu xiv století. Contributions to the history of the Czech art
of illumination about the year 1400. Brno, Vydává Filosofická Faculta,
1928. 175p. plates. facs.

683. Drobná, Zoroslava. "The appearance of the Gothic style in book
illumination." (In Gothic drawing. Tr. by Jean Layton. Prague, Artia,
195-? p.26-52 plates.)

684. _____. "Art in the Hussite critique of society." (In Gothic
drawing. Tr. by Jean Layton. Prague, Artia, 195-? p.53-57.)

685. Güntherová-Mayerová, Alžbeta and Misianik, Ján. Stredoveká knizná
mal'bana Slovensku. V. Bratislave, Slovenské Vydavatel'sto Krásnej
Literatúry, 1961. 197p. 163 illus. (Summaries in Russian, French,
English, and German.)

686. Guégan, Bertrand. "Le livre d'art en Europe: Tchécoslovaquie."
Arts et métiers graphiques, special no. 26:30-39, Nov. 15, 1931.

687. Kneidl, Pravoslav. "Tschechische Buchkultur nach 1945."
Marginalien, no. 60, p.4-57. 1975.

688. Kvet, Jan. Illuminované rukopisy Královny Rejcky. (The illumi-
nated manuscripts of Queen Rejcka.) Prague, 1931. 288p. illus.

689. Masín, Jirí. "Buchmalerei." (In Backmann, Erich, ed. Romanik in
Böhmen. Munich, Prestel-Verlag, 1977. p.141-48.)

690. Novak, Arthur. Die Buchkünstlerischen Bestrebungen in der
Tschechoslovakai." Buch und Schrift, nos. 7-8, p.51-71. 1933-34.

691. Matejcek, Antonín and Pesina, Jaroslav. Czech Gothic painting
1350-1450. Prague, Melantrich, 1950. 94p. 279 plates.

692. Pesina, Jaroslav. Ceská moderni grafika. Prague, 1940. 198p.

693. Prague. National Museum. Illuminované nejkrásnejsi rukopisy.
Prague, 1965. 69p. illus. (exhibit catalog.) (Text in Czech, English,
German, and Russian.)

694. Roll, Dusan. "Contemporary book illustration in Czechoslovakia."
Graphis 31, no. 177:94-99. 1975-76.

695. Schmidt, Gerhard. "Bohemian painting up to 1450." (In Bachmann,
Erich. Gothic art in Bohemia. Oxford, Phaidon, 1977. p.41-68.)

This title was originally published as Gotik in Böhmen.

696. Unesco. Czechoslovakia: Romanesque and Gothic illuminated manu-
scripts. Preface by H. Swarzenski. Introduction by Jan Kvĕt.
Greenwich, Conn., N. Y. Graphic Society, 1959. 20p. 32 plates.

Denmark

697. Ellegaard Frederiksen, Erik. "Modern Danish book design."
American Scandinavian review 51:396-409, Dec. 1963.

698. Fischer, Erik. Moderne dansk grafik 1940-1956. Copenhagen,
Gyldendal, 1957. 22p. illus.

699. Gronborg, Kristian. "Tidlige litografiske tryk i Danmark."
Bogvennen 1974/76, p. 89-96. illus.

700. Lorentzen, Mogens et al. Moderne bogillustratorer. Copenhagen,
R. Naver, 1934.

701. Nielsen, Lauritz M. Den Danske bog. Copenhagen, Gyldendal, 1941.
370p. illus.

702. _____. Rokoken i Dansk bogkunst. Copenhagen, 1936. 65p.
illus. facs.

703. Rohde, Hermann P. Dansk bogillustration 1800-1890. Copenhagen,
1949. 89p.

704. Schwartz, Walter. Dansk illustrationskunst fra Valdemar Andersen
til Ib Andersen. Copenhagen, C. Andersen, 1949. 250p.

705. Sthyr, Jorgen. Dansk grafik 1500-1800. Copenhagen, Forening
for Boghaandvaerk, 1943. 299p.

706. _____. Dansk grafik 1800-1910. Copenhagen, Forening for
Boghaandvaerk, 1949.

Egypt

707. British Museum. Dept. of Egyptian and Assyrian Antiquities.
The Book of the Dead. By E. A. T. Wallis. London, 1920. 43p. 25
illus.

708. British Museum. Dept. of Oriental Printed Books and Manuscripts. Catalog of the Coptic manuscripts in the British Museum. By W. E. Crum. London, 1905. 625p. 17 plates.

709. Cramer, Maria. Koptische Buchmalerei; Illuminationem in Manu-skripten des Christlich-koptischen Ägypten vom 4.bis 19, Jahrhunderts. Recklinghausen, Aurel Bongers, 1964. 134p.

710. Deleted.

711. Lepsius, Richard, ed. Das Todtenbuch der Aegypter nach dem hieroglyphischen Papyrus in Turin. Leipzig, G. Wigand, 1842. 24p. plates.

712. Leroy, Jules. Les manuscrits coptes et coptes-arabes illustrés. Paris, P. Geuthner, 1974. 278p. 60 leaves of plates.

713. Mousa, Ahmed. Zur Geschichte der islamischen Buchmalerei in Aegypten. Cairo, Government Press, 1931. 122p. and 45 plates.

714. Pieper, M. "Die ägyptische Buchmalerei vergleichen mit der griechischen und frühmittelalterlichen." Deutsches Archäologisches Institut Jahrbuch 48, no. 1-2:40-54. 1933.

715. Wessel, Klaus. Kunst der Kopten. Recklinghausen, A. Bongers, 1963. 265p.

 Translated into English by Jean Carroll and Sheila Hatton and published by Thames and Hudson in 1966.

Ethiopia

716. Hammerschmidt, Ernst. Illuminierte Äthiopische Handschriften. Wiesbaden, F. Steiner, 1968. 200p. 60 plates.

717. Leroy, Jules. Ethiopian painting in the late middle ages and during the Gondar dynasty. Tr. by Claire Pace. N.Y., Praeger, 1967. 60p. 60 colored plates.

718. Unesco. Ethiopia; illuminated manuscripts. Inroduction by Jules Leroy. Texts by Stephen Wright and Otto A. Jäger. Greenwich, Conn., N.Y. Graphic Society, 1961. 32p. illus. 32 colored plates (Unesco world art series, no. 15.)

Finland

719. Gardberg, Carl R. Boktrycket i Finland. Helsingfors, Grafiska Klubb, 1948-

720. _____. Kirjapainotaito Suomessa. Helsinki, 1949-57. 2 vols. illus. facs.

France

General Works

721. Bourcard, Gustave. Graveurs et gravures, France et étranger: essai de bibliographie, 1540-1910. Paris, H. Floury, 1910. 320p.

722. Calot, Frantz et al. L'art du livre en France des origines à nos jours. Paris, Delagrave, 1931. 301p.

723. Courboin, François. La gravure en France des origines à 1900. Paris, Delagrave, 1923. 258p.

724. _____. Histoire illustrée de la gravure en France. Paris, M. Le Garrec, 1923-28. 4 vols.

725. Dacier, Emile. La gravure française. Paris, Larousse, 1945. 182p. 48 plates.

726. Duplessis, Georges. Histoire de la gravure en Italie, en Espagne, en Allemagne, dans les Pays-Bas, en Angleterre et en France. Paris, Hachette, 1880. 528p.

727. _____. De la gravure de portrait en France. Paris, Rapilly, 1875. 162p.

728. _____. Histoire de la gravure en France. Paris, Rapilly, 1861. 408p.

729. Espezel, Pierre d'. Les illustrateurs français de la Bible depuis les origines de l'imprimerie, 1499-1950. Paris, Club Bibliophile de France, 1950. 64p.

730. Girodie, André. Bibliographie de la gravure française. Paris, Frazier-Soye, 1913. 44p.

731. Lejard, André. The art of the French book, from early manuscripts to the present time. Paris, Les Editions du Chêne, 1947. 166p. illus. plates.

732. Lonchamp, Frédéric C. Manuel du bibliophile français (1470-1920). Paris, Librairie des Bibliophiles, 1927. 2 vols.

733. Mornand, Pierre and Thomé, Jules R. Vingt artistes du livre. Paris, Le Courrier Graphique, 1950. 307p.

734. Néret, Jean A. Histoire illustrée de la librairie et du livre français des origines à nos jours. Paris, Lamarre, 1953. 396p. 210 illus., facs.

735. Paris. Imprimerie Nationale. L'art du livre à l'Imprimerie Nationale; 5 siècles de typographie. Paris, 1873. 295p. illus. plates.

736. Robert-Dumesnil, A. P. <u>Le peintre-graveur français, ou catalogue raisonné des estampes gravées ... Ouvrage faisant suite au Peintre-graveur de M. Bartsch.</u> Paris, 1835-71. 11 vols.

737. Saunier, Charles. <u>Les décorateurs du livre.</u> Paris, F. Rieder, 1922. 125p. plates.

738. Tchemerzine, Avenir. <u>Bibliographie d'éditions originales et rares d'auteurs français des xv e, xvi e, xvii e, et xviii e siècles contenant environ 6,000 facsimilés de titres et de gravures.</u> Paris, M. Plée, 1927-34? (published in parts.)

Early History to 1500

739. Avril, François. <u>Buchmalerei am Hofe Frankreichs 1310-1380.</u> Munich, Prestel-Verlag, 1978. 38p. 40 plates.

740. Berger, Samuel. <u>La Bible française au moyen âge.</u> Paris, Imprimerie Nationale, 1884. 450p.

741. Boinet, Amédée C. <u>La miniature carolingienne.</u> Paris, A. Picard, 1913. 160 plates.

742. Branner, Robert. <u>Manuscript painting in Paris during the reign of Saint Louis; a study of styles.</u> Berkeley, Univ. of Calif. Press, 1977. 270p. illus. (Calif. studies in the history of art, vol. 18.)

743. Braunfels, Wolfgang. <u>Die Welt der Karolinger und ihre Kunst.</u> Munich, G. D. Callwey, 1968. 402p. illus., facs.

744. Dodwell, Charles R. "The Carolingian renaissance." (In <u>Painting in Europe 800 to 1200.</u> Baltimore, Penguin Books, 1971. p.15-42 and plates.)

745. Dupont, Jacques and Gnudi, Cesare. "Stained glass and miniatures in France." (In <u>Gothic painting.</u> N.Y., Skira, 1954. p.27-46.)

746. Hinks, Roger. "Image and ornament." (In <u>Carolingian art; a study of early medieval painting in western Europe.</u> London, Sidgwick and Jackson, 1935. p.198-213.)

747. Koehler, Wilhelm R. <u>Die karolingischen Miniaturen.</u> Berlin, B. Cassirer, 1930-60. 3 vols. in 7.

748. Lehrs, Max. <u>Geschichte und kritischer Katalog des deutschen, niederländschen und französischen Kupferstichs im XV Jahrunderts.</u> Vienna, Gesellschaft für Vervielfältigenden Kunst, 1908-34. 9 vols.

749. Martin, André. <u>Le livre illustré en France au XV e siècle.</u> Paris, F. Alcan, 1931. 172p.

750. _____. <u>La miniature française du xiii e au xv e siècle.</u> Paris, G. Van Oest, 1923. 118p.

751. Martin, André. Les miniaturistes français. Paris, Leclerc, 1906. 246p.

752. _____. Les peintres des manuscrits et la miniature en France. Paris, H. Laurens, 1909? 126p.

753. Meiss, Millard. French painting in the time of Jean de Berry; the late fourteenth century and the patronage of the Duke. 2d ed. N.Y., Phaidon, 1969. 2 vols. illus. (Kress Foundation studies in the history of European art, no. 2.)

754. _____. French painting in the time of Jean de Berry: the Limbourgs and their contemporaries. N.Y., G. Braziller, 1974. 2 vols. illus.

755. Mütherich, Florentine and Gaehde, Joachim. Carolingian painting. N.Y., G. Braziller, 1976. 126p. 48 plates.

756. Nordenfalk, Carl. "Miniature ottonienne et ateliers capétiens." Art de France, 1964. p.47-59.

757. Panofsky, Erwin. "French and Franco-Flemish book illumination in the fifteenth century." (In Early Netherlandish painting. Cambridge, Harvard Univ. Press, 1953. vol. 1, p.21-50.)

758. Paris. Bibliothèque Nationale. Les manuscrits à peintures en France du viie au xiie siècle. 2d ed. Paris, 1954. 138p.

759. _____. Les manuscrits à peintures en France du xiiie au xviie siècle. Preface by André Malraux. Paris, 1955. 190p.

760. _____. Les plus beaux manuscrits français du viiie au xvie siècle, conservés dans les bibliothèques nationales de Paris. Notices rédigées par Emile-Aurèle van Moé. Paris, 1937. 112p.

761. Pollard, Alfred W. "The illustrations in French books of hours 1486-1500." Bibliographica 3:430-73. 1897.

762. Porcher, Jean. "Book painting." (In Hubert, Jean et al. Carolingian art. London, Thames and Hudson, 1970. p.71-203.)

763. _____. L'enluminure française. Paris, Arts et Métiers Graphiques, 1959. 275p. illus.

764. _____. Medieval French miniatures. Tr. from the French by Julian Brown. N.Y., Abrams, 1960? 275p. (Translation of L'enluminure française.)

 Published by Collins in London under the title of French miniatures from illuminated manuscripts (1960).

765. Thierry-Poux, Olgar. Premiers monuments de l'imprimerie en France au xve siècle. Paris, Hachette, 1890. 24, 8p. 167 facs on 40 plates.

766. Wolf, Horst. Schätze französischer Buchmalerei 1400-1460. Berlin, Evangelische Verlagsanstalt, 1975. 63p. 16 leaves of plates. 32 illus.

16th and 17th Century

767. Blum, André S. and Lauer, Philippe. La miniature française aux
xv e et xvi e siècles. Paris, G. Van Oest, 1930. 128p.

768. Bouchot, Henri F. Les livres à vignettes du xv e au xvii e siècle.
Paris, 1891. illus. 8 plates.

769. Brun, Robert. Le livre français illustré de la Renaissance.
rev. ed. Paris, Picard, 1969. 329p.

770. _____. Le livre illustré en France au 16 e siècle. Paris,
1930. 336p. 32 plates.

771. Davies, Hugh W., ed. Catalogue of early French books in the
library of C. Fairfax Murray. London, Holland Press, 1961. 2 vols.
many illus.

772. Duportal, Jeanne. Etudes sur les livres à figures édités en
France de 1601 à 1660. Paris, E. Champion, 1914. 388p.

773. Harvard University Library. Dept. of Printing and Graphic Arts.
French sixteenth century books. Comp. by Ruth Mortimer. Cambridge,
Belknap Press of Harvard University Press, 1964. 2 vols. illus.

774. Lieure, Jules. L'école française de gravure, 17 e siècle. Paris,
Le Renaissance du Livre, 1931. 201p. plates.

775. _____. La gravure en France au 16 e siècle; la gravure dans
le livre et l'ornement. Paris, G. Van Oest, 1927. 62p. 72 plates.

776. Tchemerzine, Stéphane and Tchemerzine, Avenir. Répertoire de
livres à figures rares et précieux édités en France au xvii e siècle.
Paris, P. Catin, 1933. 499p. illus (facs).

 Contains about 1500 facsimiles of frontispieces, titles, and
 illustrations.

777. Valous, G. de. "Le livre en France au temps de Richelieu."
Portique 1:103-23. 1945.

778. Weigert, Roger-Armand. "L'illustration française de la première
moitié du xvii e siècle." Portique, no. 5:111-28. 1947.

18th Century

779. Adhémar, Jean. "The illustrated book: Oudry, Boucher, Cochin,
and the vignette engravers." (In Graphic art of the 18th century.
London, Thames and Hudson, 1964. p.29-59.)

780. Bernard, C. "Le livre illustré en France à l'époque de la
Révolution." La bibliofilia 30:256-76, July-Aug. 1928.

781. Boissais, Maurice and Deleplanque, Jacques. Le livre à gravures
au xviii e siècle, suivi d'un essai de bibliographie. Paris, Grund,
1948. 214p.

782. Bouchot, Henri F. Les livres à vignettes du xv^e au xviii^e siècle. Paris, 1891. 94p. illus. plates.

783. _____. La miniature française 1750-1825. Paris, 1907. 245p. illus. 72 plates.

784. Bouvy, Eugène. La gravure en France au xviii^e siècle; la gravure de portraits et d'allégories. Paris, 1929. 91p.

785. Cohen, Henry. Guide de l'amateur de livres à vignettes du xviii^e siècle. 5th ed. Revised, corrected, and considerably augmented by Baron Roger Portalis. Paris, P. Rouquette, 1886. 756 columns. (supplemented in 1890 by E. Crottet.)

786. Courboin, François. Histoire illustrée de la gravure en France. Paris, 1923-28. 4 vols. and atlas of plates.

787. _____ and Roux, Marcel. La gravure française; essai de bibliographie. Paris, M. Le Garrec, 1927-28. 3 vols.

788. Deusch, Werner R. Das Buch als Kunstwerk; französische illustrierte Bücher des 18. Jahrhunderts aus der Bibliothck Hans Fürstenburg; Ausstellung im Schloss Ludwigsburg, 15 Mai bis 20 Sept. 1965. Ludwigsburg, 1965. 161p.

789. Dilke, Emilia F. French engravers and draughtsmen of the xviiith century. London, G. Bell, 1902. 227p.

790. Fürstenberg, Hans. Das französische Buch im achtzehnten Jahrhundert und in Empirezeit. Weimar, Gesellschaft der Bibliophilen, 1929. 431p.

791. Fürstenberg, Jean. La gravure originale dans l'illustration du livre français au dixhuitième siècle. Hamburg, E. Hauswedell, 1975. 438p. many plates.

792. Gusman, Pierre. La gravure française au xviii^e siècle avec une suite de 44 estampes. Paris, C. Massin, 1921. 25p. (in portfolio.)

793. Hausenstein, Wilhelm. Rokoko; französische und deutsche Illustratoren des 18. Jahrhunderts. Munich, R. Piper, 1958. 165p.

794. Holloway, Owen E. French rococo book illustration. N.Y., Transatlantic Arts, 1969. 115, 131p.

795. Lanckorońska, Maria. "French wood-engraved book decorations of the 18th century." Tr. by H. P. Schmoller. Signature, no. 8:22-45. 1949.

796. Lucas de Peslouan, C. "L'art du livre illustré au xviii^e siècle." Arts et métiers graphiques 24:291-308, July 1931.

797. Maggs Bros., London. A collection of French xviiith century illustrated books ... in superb contemporary bindings. Issued in commemoration of the seventieth birthday of Maggs Bros. (1860-1930). 144p. plates.

798. Model, Julius and Springer, Jaro, eds. Der französische Farben-
stich des xviii Jahrhunderts. Stuttgart, Deutsche Verlags-anstalt,
1912. 70p. 50 colored plates.

799. Monglond, André. La France révolutionnaire et impériale; annales
de bibliographie méthodique et description des livres illustrés.
Grenoble, R. Artaud, 1930-63. 9 vols. plates, facs.

800. Pingrenon, Renée. Les livres ornés et illustrés en couleur depuis
le xv e siècle en France et en Angleterre avec une bibliographie.
Paris, Daragon, 1903. 162p.

801. Portalis, Roger. Les dessinateurs d'illustrations au dix-huitième
siècle. Paris, Morgand et Fatout, 1877. 2 vols.

802. Réau, Louis. La gravure d'illustration. Paris, G. Van Oest,
1928. 69p. 62 plates.

803. Singer, Hans W. Französische Buchillustration des achtzehnten
Jahrhunderts. Munich, 1923. 23p.

804. _____. "French book illustration of the eighteenth century."
Print collectors' quarterly 11:69-93, Feb. 1924.

805. Younger, Archibald. French engravers of the eighteenth century.
Edinburgh, Otto Schulze, 1913. 34p. and 96 plates.

19th Century

806. Bersier, Jean. La lithographie originale en France. Paris,
Librairie des Arts Décoratifs, 1944? 16p. 52 plates.

807. _____. Petite histoire de la lithographie originale en France.
Paris, Editions Estienne, 1970. 115p.

808. Bouchot, Henri F. Les livres à vignettes du xix e siècle. Paris,
E. Rouveyre, 1891. 2p. plus illus. and facsimiles.

809. Bruller, Jean. "Le livre d'art en France; essai d'un classement
rationnel." Arts et métiers graphiques, numéro spécial 26:41-66, Nov.
15, 1931.

810. Garvey, Eleanor M. "Art nouveau and the French book of the
eighteen-nineties." Harvard library bulletin 12:375-91. 1958.

811. Gräff, Walter. Die Anfänge der Lithographie in Frankreich 1800-
1816. Mitteilungen der Gesellschaft für vervielfältigende Kunst. Vienna,
1904.

812. _____. "Die Einführing der Lithographie in Frankreich."
Thesis, Univ. of Heidelberg, 1906.

813. Hesse, Raymond G. Le livre d'art illustré du xix e siècle à nos
jours. Paris, La Renaissance du Livre, 1927. 227p.

814. Hofer, Philip. "Some precursors of the modern illustrated book." Harvard library bulletin 4:191-202, Spring 1950.

815. Lemercier, Alfred. La lithographie française de 1796 à 1896 et les arts qui s'y rattachent. Paris, C. Lorilleux, 1899. 358p.

816. La lithographie en France au xixe siècle avec une étude par Jean Adhémar. Paris, Editions "Tel," 1944. 1p. and 50 illus. on 24 leaves.

817. Monglond, André. La France révolutionnaire et impériale; annales de bibliographie méthodique et description des livres illustrés. Grenoble, R. Artaud, 1930-63. 9 vols. plates, facs.

818. Newhall, Beaumont. "Vignettists." American magazine of art 28:31-35, Jan. 1935.

819. Passeron, Roger. La gravure impressioniste; origines et rayonnement. Fribourg, Office du Livre, 1974. 224p. illus.

820. Pennell, Joseph. "Pen drawing in France." (In Pen drawing and pen draughtsmen. London, Macmillan, 1889. p.87-134.)

821. Rümann, Arthur. Das illustrierte Buch des xix. Jahrhunderts in England, Frankreich und Deutschland 1790-1860. Leipzig, Insel-Verlag, 1930. 380p.

822. Sander, Max. Die illustrierten französischen Bücher des 19. Jahrhunderts. Stuttgart, J. Hoffmann, 1924. 255p.

823. Soderberg, Rolf. French book illustration 1880-1905. Tr. by Roger Tanner. Stockholm, Almqvist and Wiksell, 1977. 106p. (Stockholm studies in the history of art 28.)

824. Twyman, Michael. Lithography 1800-1850; the techniques of drawing on stone in England and France and their application in works of topography. London, Oxford Univ. Press, 1970. 304p.

825. Weber, Wilhelm. "Lithography in France." (In History of lithography. London, Thames and Hudson, 1966. p.45-60.)

826. Weitenkampf, Frank. "French illustrators of the Second Empire." Print collectors' quarterly 11:319-47, Oct. 1924.

20th Century

827. Arts Council of Great Britain. An exhibition of French book illustration 1895-1945. London, 1945. 24p. plates.

828. _____. Catalogue of an exhibition of the technique of modern French engraving. London, 1948. 19p.

829. Basler, Adolphe and Kunstler, Charles. Le dessin et la gravure modernes en France. Paris, Cres, 1930. 214p.

830. Clairouin, Denyse. "A survey of the making of books in recent
years: France." Dolphin no. 1:253-63. 1933.

831. Clément-Janin, Noël. Essai sur la bibliophilie contemporaine de
1900 à 1928. Paris, R. Keiffer, 1931-32. 2 vols. illus.

832. Devigné, Roger. "Construction and decoration of artistic books
(1897-1930)." L'art vivant 7:13-15, Jan. 1, 1931.

833. Fresnault-Deruelle, Pierre. La bande dessinée; l'univers et les
techniques de quelques "comics" d'expression française. Paris, Hachette,
1972. 189p.

834. Garvey, Eleanor M. and Wick, Peter A. The arts of the French books
1900-1965; illustrated books of the School of Paris. Dallas, Published
for the Friends of the Dallas Public Library by Southern Methodist Univ.
Press, 1967. 119p.

835. Guignard, Jacques. "Le livre au xxe siècle." (In Le livre; les
plus beaux exemplaires de la Bibliothèque Nationale. Paris, Edition du
Chêne, 1942. p.113-40.)

836. Léautaud, Jean. "French illustrators revive an old art."
International studio 83:64-67, Mar. 1926.

837. La lithographie en France. Mulhouse, Gangloff, 1946-

838. Livre d'or du bibliophile. Paris, Editeurs de Livres d'Art, 1925-

 Contains pages from illustrated books published in Paris and
 Brussels.

839. Manchester University. Whitworth Art Gallery. French book illus-
trators of the 20th century; an exhibition arranged under the auspices
of the French Embassy in London. 1958.

840. Passeron, Roger. La gravure française au xxe siècle. Paris,
Bibliothèque des Arts, 1970. 181p.

841. Pichon, Léon. The new book-illustration in France. Tr. from the
French by Herbert B. Grimsditch. London, Studio, 1924. 168p. many
illus.

842. Roberti, G. "Il libro d'arte illustrato in Gran Bretagna e in
Francia." Accademie e biblioteche d'Italia 12:132-42, Apr. 1938.

843. Salaman, Malcolm C. Modern woodcuts and lithographs by British
and French artists. London, Studio, 1919. 204p. illus.

844. _____ . "The woodcut in France." (In The woodcut of today at
home and abroad. Ed. by G. Holme. London, Studio, 1927. p.90-105.)

845. Scottish National Gallery of Art, Edinburgh. The artist and the
book in France; painters, sculptors, engravers 1931-1967. An anthology
from the collection of W. J. Strachan, with a contribution from the
Victoria and Albert Museum. 7 July to 6 August 1967. n.p. 1967?

846. Simon, Howard. "Modern France." (In 500 years of art in illustration. Cleveland, World Publishing Co., 1942. p217-55.)

847. Sotheby and Co. Catalogue of fine modern French and German illustrated books and bindings. 1970. 124p. illus. plates.

848. Strachan, Walter J. The artist and the book in France; the 20th century livre d'artiste. London, P. Owen, 1969. 368p.

849. _____. "Modern French bestiaries." Private library 3:171-91, Winter 1970.

849a. Sutton, Denys. "French painters and the book." Penrose annual 43:47-49. 1949.

850. Taylor, E. A. "The art of the book in France." (In Holme, Charles, ed. The art of the book. London, Studio, 1914. p.179-202.)

851. Valotaire, Marcel. "Photography in publicity and in books in France." Penrose annual 35:29-32. 1931.

Germany

Early History to 1700

852. Bock, Elfried. Die deutsche Graphik, mit 410 Abbildungen. Munich, Hanfstaengl, 1922. 363p.

853. Boeckler, Albert. Deutsche Buchmalerei der Gotik. Königstein im Taunus, Koster, 1959. 79p.

854. _____. Deutsche Buchmalerei vorgotischer. Königstein im Taunus, K. R. Langewiesche, 1959. 80p.

855. Cockerell, Sydney G. Some German woodcuts of the fifteenth century. Hammersmith, Kelmscott Press, 1897. 23p.

856. Davies, Hugh W., ed. Catalogue of early German books in the library of C. Fairfax Murray. London, Holland Press, 1961. 2 vols. many illus.

857. Doderer, Klaus and Müller, Helmut. Das Bilderbuch; Geschichte und Entwicklung des Bilderbuchs in Deutschland von den Anfängen bis zur Gegenwart. Weinheim, Basel, Beltz, 1973. 542p.

858. Dodwell, Charles R. "The Ottonian renaissance." (In Painting in Europe 800 to 1200. Baltimore, Penguin Books, 1971. p.45-74 and plates.)

859. Eichenberger, Walter and Wendland, Henning. Deutsche Bibeln vor Luther. Hamburg, F. Wittig, 1977. 159p. illus.

860. Geisberg, Max. Anfänge der Kupferstiches. 2d ed. Leipzig, Klinckhardt and Biermann, 1924. 81p. 74 plates.

861. _____. Der deutsche Einblatt-holzschnitt in der ersten Hälfte des xvi Jahrhunderts. Munich, H. Schmidt, 1923-29. 43 vols. 1600 mounted plates.

862. _____. The German single-leaf woodcut: 1500-1550. rev. and ed. by Walter L. Strauss. N.Y., Hacker Art Books, 1974. 4 vols.

863. Goldschmidt, Adolph. German illumination. N.Y., Hacker Art Books, 1970. 2 vols. in 1. (Translation of Die deutsche Buchmalerei published in Munich in 1928.)

864. Hollstein, F. W. German engravings, etchings and woodcuts ca. 1400-1700. Amsterdam, M. Hertzberger, 1954-57. 8 vols.

865. Homann, Holger. Studien zur Emblematik des 16. Jahrunderts. Utrecht, Dekker and Gumbert, 1971. 141p.

866. Johnson, Alfred F. German Renaissance title-borders. Oxford, Oxford Univ. Press, 1929. 20p. 86 facs on 80 plates.

867. Kiessling, Gerhard. Die Anfänge des Titelblattes in der Blütezeit des deutschen Holzschnitts 1470-1530. Leipzig, 1930. 140p. plates.

868. Kunze, Horst. Geschichte der Buchillustration in Deutschland. Das 15. Jahrhundert. Leipzig, Insel Verlag, 1975. 2 vols. 564 illus.

869. Küp, Karl. "Early German book illustration in the Spencer collection of the New York Public Library." American-German review 2:25-31. June 1936.

870. Kutschmann, Theodor. Geschichte der deutschen Illustration vom ersten Aufstreten des Formschnittes bis auf die Gegenwart. Goslar, F. Jäger, 1900. 2 vols.

871. Lehrs, Max. Geschichte und kritischer Katalog des deutschen niederländschen und französischen Kupferstichs im xv Jahrhunderts. Vienna, Gesellschaft für Vervielfältigenden Kunst, 1908-1934. 9 vols.

872. _____. Late Gothic engravings of Germany and the Netherlands; 682 copper plates from the "Kritischer Katalog." With a new essay "Early engraving in Germany and the Netherlands" by A. Hyatt Major. N.Y., Dover, 1969. 367p.

873. Lützow, Carl F. von. Geschichte des deutschen Kupferstiches und Holzschnittes. Berlin, B. Grote, 1891. 313p. illus. plates. (Geschichte der deutschen Kunst, vol. 4.)

874. Muther, Richard. Die deutsche Bücher-illustration der Gothik und Frührenaissance (1460-1530). Munich, G. Hirth, 1884. 2 vols in 1.

875. _____. German book illustration of the Gothic period and the early Renaissance (1460-1530). Tr. by Ralph Shaw. Metuchen, N.J., Scarecrow Press, 1972. 566p.

876. Redenbacher, Fritz. "Die Buchmalerei des frühen Mittelalters in Urteil der deutschen Romantik." (In Redenbacher, Fritz, ed. Festschriften Eugen Stollreither zum 75. Geburtstage. Erlangen, Universitätsbibliothek, 1950. p.203-17.)

877. Renouvier, Jules. Histoire de l'origine et des progrès de la gravure dans les Pays-Bas et en Allemagne jusqu'à la fin du quinzième siècle. Brussels, M. Hayes, 1860. 317p.

878. Schramm, Albert. Die illustrierten Bibeln der deutschen Inkunabel-Drucker. Leipzig, Deutsches Museum für Buch und Schrift, 1922. 23p.

879. Sotheby, Samuel L. Principia typographica; the block books ... issued in Holland, Flanders and Germany during the 15th century. London, McDowall, 1858. 3 vols.

880. Swarzenski, Hanns. Vorgotische Miniaturen. Die ersten Jahrhunderte deutscher Malerei. Leipzig, Langewiesche, 1927. 96p. 87 plates.

881. Worringer, Wilhelm. Die altdeutsche Buchillustration. Munich, Piper, 1912. 152p.

882. Zoege von Manteuffel, Curt. Der deutsche Holzschnitt. Sein Aufstieg im xv. Jahrhundert und seine grosse Blüte in der ersten Hälfte des xvi Jahrhunderts. Munich, 1921. 127p. 77 illus.

883. _____. Der deutsche Kupferstiche von seinen Anfängen bis zum Ende des sechzehnten Jahrhunderts. Munich, 1922. 111p. 80 illus.

18th Century

884. Hausenstein, Wilhelm. Rokoko; französische und deutsche illustratoren des 18. Jahrhunderts. Munich, R. Piper, 1958. 165p.

885. Lanckorońska, Maria and Oehler, R. Die Buchillustration des xviii Jahrhunderts in Deutschland, Oesterreich und der Schweiz. Leipzig, Insel-Verlag, 1932-34. 3 vols.

886. Rümann, Arthur. Das deutsche illustrierte Buch des 18. Jahrunderts. Stuttgart, 1931. 116p. plates.

19th Century

887. Brussels. Palais des Beaux Arts. Art graphique allemand des xixe et xxe siècle. Brussels, 1942. 62p. illus. (exhibit catalog.)

888. Fischer, Anita. Die Buchillustration der deutschen Romantik. Berlin, E. Ebering, 1933. 97p.

889. Grautoff, Otto. Die Entwicklung der modernen Buchkunst in Deutschland. Leipzig, H. Seemann nachfolger, 1901. 219p. illus. plates.

890. Lang, Oskar. Deutsche Romantik in der Buchillustration. Diessen,
Einhorn-Verlag, 1911. 93p. illus.

891. _____. Die romantische Illustration; die volkstümlichen Zeich-
ner der deutschen Romantik. Dachau bei Munich, Einhorn, 1920. 165p.
illus. plates.

892. Loeffler, Karl. Schwäbische Buchmalerei in romanischer Zeit.
Augsburg, 1928. 84p. 48 plates.

893. Pennell, Joseph. "Pen drawing of today--German work." (In Pen
drawing and pen draughtsman. London, Macmillan, 1889. p.61-86.)

894. Rümann, Arthur. Das illustrierte Buch des xix. Jahrhunderts in
England, Frankreich und Deutschland 1790-1860. Leipzig, Insel-Verlag,
1930. 380p.

895. _____. Die illustrierten deutschen Bücher des 19. Jahrhundert.
Stuttgart, Hoffmann, 1926. 429p.

896. Schwanecke, Erich. "Anmerkungen zur deutschen Buchillustration
1890-1913." Marginalien no. 26:38-50, June 1967.

897. Weber, Wilhelm. "Original lithography in Germany." (In History
of lithography. London, Thames and Hudson, 1966. p.105-20.)

20th Century

898. Bähring, Helmut. "Schönste Bücher der DDR." Marginalien no. 54:
13-20. 1974.

899. Baltzer, Hans. "Die schönsten Bücher des Jahres 1970."
Marginalien no. 42:1-8. 1971.

900. Bleistein, Rudolf. Neue deutsche Buchillustration. Berlin,
Verein der Plakatfreunde, 1915. 47p.? illus. plates.

901. Bock, Elfried. Die deutsche Graphik. Munich, F. Hanfstaengl,
1922. 363p. illus.

902. Brussels. Palais des Beaux Arts. Art graphique allemand des
xixe et xxe siècle. Brussels, 1942. 62p. illus. (exhibit catalog.)

903. Delafons, Allan. "Book design and illustration in the DDR."
Penrose annual 54:46-49. 1960.

904. Deubner, L. "The art of the book in Germany." (In Holme, Charles,
ed. The art of the book. London, Studio, 1914. p.127-76.)

905. Ehmcke, F. H. "Die neue deutsche Buchillustration." Maso fini-
guerra 1, fasc. 2-3, 202-38. 1936.

906. Fauth, Harry. "Schönste Bücher der DDR 1974." Marginalien no.
58:12-25. 1975.

907. Graham, Rigby. "German expressionist woodcuts." Private library 3:3-15, Spring 1970.

908. Hartlaub, Gustav F. Die neue deutsche Graphik. Berlin, E. Reiss, 1920. 96p.

909. Homeyer, Fritz. "A survey of the making of books in recent years: Germany." Dolphin no. 1:264-87. 1933. illus.

910. Horodisch, Abraham. "Zum Problem expressionistischer Buchillustration." Antiquariat 18, no. 5:115-18. 1968.

911. Klitzke, Gert. "Schönste Bücher der DDR." Marginalien no. 62:1-14. 1976.

912. Lang, Lothar. Expressionist book illustration in Germany 1907-1927. Tr. from the German by Janet Seligman. London, Thames and Hudson, 1976. 245p. 234 illus.

913. Richter, Hans. "Das deutsche Bilderbuch der Gegenwart." Archiv für Buchgewerbe und Gebrauchsgraphik 69:429-55. 1932.

914. Schauer, Georg K. Deutsche Buchkunst 1890 bis 1960. Hamburg, Maximillian-Gesellschaft, 1963. 2 vols. illus.

 Vol. 2 has illustrations and bibliography, "Literaturnachweis," p.1-32.

915. Scheffler, Karl. Die impressionistische Buchillustration in Deutschland. Berlin, Berliner Bibliophilenabend, 1931. 68p.

916. Schwanecke, Erich. "Anmerkungen zur deutschen Buchillustration 1890-1913." Marginalien no. 26:38-50, June 1967.

917. Simon, Howard. "Modern Germany." (In 500 years of art in illustration. Cleveland, World Publishing Co., 1942. p.256-69.)

918. Sotheby and Co. Catalog of fine modern French and German illustrated books and bindings. 1970. 124p. illus. plates.

919. Tiessen, Wolfgang, ed. Die Buchillustration in Deutschland, Oesterreich und der Schweiz seit 1945. Neu-Isenberg, Verlag der Buchlandlung W. Tiessen, 1968. 2 vols.

920. Visel, Curt. "Die Originalgraphik in der Buchillustration." Gutenberg Jahrbuch, 1973. p.409-22. illus.

921. Wills, Franz H. "East German graphic design." Graphis 32:70-79. 1976-77.

Great Britain and Ireland

Early History to 1500

922. Alexander, Jonathan J. and Kauffmann, Claus M. English illuminated manuscripts 700-1500; catalogue. Brussels, Bibliothèque Royale Albert I. Supplied by Worldwide Books, Boston, 1973. 120p. facs. (exhibit catalog.)

923. Boase, Thomas S. R. "The great Bibles." (In English art 1100-1216. Oxford, Clarendon Press, 1953. p.156-88.)

924. British Museum. English book illustration, 966-1846. London, 1965. 23p.

925. _____. Schools of illumination. Parts I-IV, English. London, 1914-22.

926. Brunn, Johan A. An inquiry into the art of the illuminated manuscripts of the Middle Ages: Celtic illuminated manuscripts. Stockholm, Centraltryckeriet, 1897. 87p.

927. Cartianu, Virginia. Miniatura irlandeza. Bucarest, "Meridiane," 1976. 51p. 32 leaves of plates.

928. Dodwell, Charles R. The Canterbury school of illumination 1066-1200. Cambridge, University Press, 1954. 140p.

929. Duft, Johannes and Meyer, Peter, eds. Die irischen Miniaturen der Stiftsbibliothek St. Gallen. Bern, Urs Graf-Verlag, 1953. 154p. illus. facs.

930. Dupont, Jacques and Gnudi, Cesare. "Evolution of the English miniature." (In Gothic painting. N.Y., Skira, 1954. p.19-26.)

931. Gray, Nicolete M. Jacob's ladder; a Bible picture book from Anglo-Saxon and 12th century English manuscripts. London, Faber and Faber, 1949. 118p. illus.

932. Harrison, Frederick. Treasures of illumination; English manuscripts of the fourteenth century (c.1250-1400). London, Studio, 1937. 48p.

933. Henderson, George. "Studies in English manuscript illumination." Journal of the Warburg and Courtauld Institutes 30:71-137. 1967.

934. Henry,Françoise. "Les débuts de la miniature irlandaise." Gazette des beaux arts 37:5-34. 1950.

935. _____. "The decoration of manuscripts 800-1020." (In Irish art during the Viking invasions (800-1020 A.D.) London, Methuen, 1967. p.58-110. plates.)

936. _____. "The decoration of manuscripts A.D. 1020-1170." (In Irish art in the Romanesque period (1020-1170 A.D.). London, Methuen, 1970. p.46-73. plates.)

937. Hovey, Walter R. "Sources of the Irish illuminative art."
Art studies 6:105-20. 1928.

938. Irish illuminated manuscripts of the early Christian period.
Introduction by James J. Sweeney. N.Y., New American Library by arrange-
ment with Unesco, 1965. 24p. 28 plates. (Mentor-Unesco art book.)

939. Kauffmann, Claus M. Romanesque manuscripts 1066-1190. London,
H. Miller, 1975. 235p. 350 illus. (Survey of manuscripts illuminated
in the British Isles, vol. 3.)

940. Koehler, Wilhelm R. Buchmalerei des frühen Mittelalters. Frag-
ments und Entwürfe aus dem Nachlass (Notes and outlines edited posthum-
ously by Ernst Kitzinger and Florentine Mütherich). Munich, Prestel,
1972. 210p.

941. Lister, Raymond. The British miniature. London, Pitman, 1951.
114p. 69 plates.

942. McGurk, J. J. "Celtic school of manuscript illumination."
History today 16:747-55, Nov. 1966.

943. Masai, François. Essai sur l'origine de la miniature irlandaise.
Brussels, Editions "Erasme," 1947. 146p. 64 plates.

944. Millar, Eric G. English illuminated manuscripts from the xth to
the xiiith century. Paris, G. Van Oest, 1926. 145p.

945. _____. English illuminated manuscripts of the xivth and xvth
centuries. Paris, G. Van Oest, 1928. 106p.

946. _____. "Fresh materials for the study of English illumination."
(In Miner, Dorothy, ed. Studies in art and literature for Belle da Costa
Greene. Princeton, Princeton Univ. Press, 1954. p.286-94.)

947. Oakeshott, Walter. The sequence of English medieval art, illus-
trated chiefly from illuminated manuscripts 650-1450. London, Faber
and Faber, 1950. 55p.

948. Oxford University. Bodleian Library. Anglo-Saxon illumination in
Oxford libraries. Oxford, 1970. 16, 36p. (Bodleian picture books,
Special series, no. 1.)

949. _____. English illumination of the thirteenth and fourteenth
centuries. Oxford, 1954. 10p. 22 plates. (Bodleian picture books,
no. 10.)

950. _____. English romanesque illumination. Oxford, 1951. 12p.
25 plates. (Bodleian picture books, no. 1.)

951. Pächt, Otto. Rise of pictorial narrative in twelfth century
England. Oxford, Clarendon Press, 1962. 63p.

952. Pfister, Kurt. Irische Buchmalerei; Nordeuropa und Christentum in
der Kunst des frühen Mittelalters. Potsdam, Kiepenheuer, 1927. 24p.
40 plates.

953. Rice, D. Talbot. "Manuscripts." (In English art 871-1100.
Oxford, Clarendon Press, 1952. p.173-225.)

954. Rickert, Margaret. La miniatura inglese dal xiii al xv secolo.
Milano, Electa Editrice, 1961. 37p. and 61 plates.

955. Robinson, Stanford F. Celtic illuminative art in the Gospel Books
of Durrow, Lindisfarne, and Kells. Dublin, Hodges, Figgis, 1908. 106p.
51 plates.

956. Saunders, O. Elfrida. English illumination. Florence, Pantheon,
1928. 2 vols.

957. Saxl, Fritz. "Illuminated science manuscripts in England."
(In Lectures. London, Warburg Institute, Univ. of London, 1957. vol. 1,
p.96-110; vol. 2, plates 52-61.)

958. Thompson, Edward M. English illuminated manuscripts. London,
Paul, Trench, Trübner, 1895. 67p. 21 plates.

959. Westwood, John O. Facsimiles of the miniatures and ornaments of
Anglo-Saxon and Irish manuscripts, drawn on stone by W. R. Tymme.
London, Quaritch, 1868. 155p. plates (some in color).

960. Wormald, Francis. "Decorated initials in English manuscripts from
A.D. 900 to 1100." Archeologia 91:107-35. 1945.

961. _____. English drawings of the 10th and 11th centuries.
London, Faber and Faber, 1952. 83p.

962. _____. The survival of Anglo-Saxon illumination after the
Norman conquest. London, G. Cumberlege, 1944. 19p. 9 plates.
(Reprinted from the Proceedings of the British Academy, vol. 30, 1944.)

16th Century to 1800

963. Blum, André. La gravure en Angleterre au xviii⁻ siècle. Paris,
G. Van Oest, 1930. 89p.

964. British Museum. Early engraving and engravers in England (1545-
1695); a critical and historical essay. By Sidney Colvin. London,
1905. 170p. 41 facs.

965. Christoffel, Ulrich. Meisterwerke englischer schabkunst von 1757
bis 1833. Munich, F. Hanfstaengl, 1922. 14p. 100 plates.

966. Duplessis, Georges. Histoire de la gravure en Italie, en Espagne,
en Allemagne, dans les Pays-Bas, en Angleterre, et en France. Paris,
Hachette, 1880. 528p.

967. Esdaile, Katherine. "English book illustration in the eighteenth
century." Bibliophile 2:114-23, 305-17. 1908.

968. Fagan, Louis A. A history of engraving in England. London, Low,
Marston, 1893. 8p. 155 leaves (in 3 portfolios of plates).

969. Foley, Matthew J. "English printing and book illustration 1780-
1820." Ph.D. dissertation, University of California, Santa Cruz, 1977.
646p.

970. Freeman, Rosemary. English emblem books. London, Chatto and
Windus, 1948. 256p. illus.

 Contains "Bibliography of English emblem books to 1700,"
 p.229-40.

971. Friedman, Joan. M. Color printing in England 1486-1870. An exhi-
bition at the Yale Center for British art, Apr. 20 to June 25.
New Haven, Yale Center for British Art, 1978. 72p. 72 plates.

972. Gray, Basil. The English print. London, Black, 1937. 224p.

973. Grolier Club, N.Y. Engraved titles and frontispieces published in
England during the 16th and 17th centuries. N.Y., 1898.

974. Hammelmann, Hanns. Book illustrators in eighteenth century
England. Ed. and completed by T. S. R. Boase. Published for the Paul
Mellon Center for Studies in British Art. New Haven, Yale University
Press, 1976. 120p. and 45 illus.

975. Hardie, Martin. English coloured books. London, Methuen, 1906.
339p.

 Reprinted in England in 1973 with an introduction by James Laver.

976. Hind, Arthur M. Engraving in England in the sixteenth and seven-
teenth centuries; a descriptive catalog with introductions. Cambridge,
University Press, 1952-64. 3 vols.

977. Hodnett, Edward. English woodcuts, 1480-1535. London, Printed
for the Bibliographical Society at the Oxford University Press, 1935.
438p.

 Reprinted with additions and corrections by the Bibliographical
 Society in 1973.

978. Hofer, Philip. Eighteenth century book illustrations. Los Angeles,
William Andrews Clark Memorial Library, Univ. of Calif., 1956. 48p.

979. Johnson, Alfred F. A catalog of engraved and etched English title-
pages down to the death of Willian Faithorne 1691. Prepared for the
Bibliographical Society at the Oxford University Press, 1934 (for 1933).
109p. facs.

980. Long, Basil S. British miniaturists. London, G. Bles, 1929.
475p. 32 plates.

981. McKerrow, Ronald B. "Border pieces used by English printers be-
fore 1641." Library, 4th series, 5:1-37, June 1, 1924.

982. McKerrow, Ronald B. and Ferguson, Frederic S. Title-page borders
used in England and Scotland, 1485-1640. London, Printed for the Biblio-
graphical Society at the Oxford University Press, 1932 (for 1931).
220p. 306 facs. indexes, p.221-34.

 Additions by Frederic S. Ferguson in Library, 4th series,
 17:264-311, Dec. 1936.

983. Pingrenon, Renée. Les livres ornés et illustrés en couleur depuis
le xv⁻ siècle en France et en Angleterre avec une bibliographie. Paris,
Daragon, 1903. 162p.

984. Pollard, Alfred W. "English woodcut illustrations." (In Fine
books. London, Methuen, 1912. p.250-66.)

985. _____. "Some notes on English illustrated books."
Bibliographical Society Transactions 6:29-61. 1903 (for 1900-02).

986. Salaman, Malcolm C. The old engravers of England in their rela-
tion to contemporary life and art (1540-1800). London, Cassell, 1906.
224p.

987. Smythe, Sara L. "Woodcuts in English books, 1536-1560." Ph.D.
dissertation, Univ. of North Carolina, 1974. 566p.

 Supplements Edward Hodnett's English woodcuts, 1480-1535.

988. Wheatley, H.B. [English illustrated books 1480-1900]
Bibliographical Society Transactions 6:155-58. 1901.

989. Williams, Iola. "English book illustration, 1700-1775."
Library, 4th series, 17:1-21, June 1936.

990. Wordsworth, Christopher and Littlehales, Henry. The old service-
books of the English church. London, Methuen, 1904. 319p. 38 plates.

19th Century

991. Arts Council of Great Britain. English book illustration since
1800. London, 1943. 28p. (Text by Philip James.)

992. Balston, Thomas. "English book illustration 1880-1900."
(In Carter, John, ed. New paths in book collecting. N.Y., Scribner,
1934. p.163-90.)

993. Bechtel, Edwin De T. "Illustrated books of the sixties; a
reminder of a great period in illustration." Print 23:20-23, May 1969.

994. Bliss, Douglas P. "A century of book illustration: 1830-1930."
Artwork 6:200-10, Autumn 1930.

995. Blunt, Wilfrid and Stearn, William T. "England in the early nine-
teenth century." (In The art of botanical illustration. 3d ed.
London, Collins, 1955. p.209-22.)

996. Blunt, Wilfrid and Stearn, William T. "England in the second half of the nineteenth century." (In The art of botanical illustration. 3d ed. London, Collins, 1955. p.236-49.)

997. Boase, Thomas S. R. [Book illustration] (In English art 1800-1870. Oxford, Clarendon Press, 1959. p.48-54, 58-63, 136-38, 287-91.)

998. De Mare, Eric. "The boxwood illustrators." Penrose annual 63: 49-68, 1970.

999. Foley, Matthew J. "English printing and book illustration 1780-1820." Ph.D. dissertation, Univ. of Calif., Santa Cruz, 1977. 646p.

1000. Freeman, Rosemary. English emblem books. London, Chatto and Windus, 1948. 256p. illus.

1001. Hardie, Martin. English coloured books. London, Methuen, 1906. 339p. (Reprinted in England in 1973 with an introduction by James Laver.)

1002. Harris, Elizabeth M. "Experimental graphic processes in England 1800-1859." Journal of the Printing Historical Society, no. 4:33-86. 1968. no. 5:41-80. 1969. no. 6:53-92. 1970.

1003. Hatfield, Susanne L. "Victorian color printing and the reproduction of art in books, 1822-1870." Master's thesis, Univ. of Chicago, 1973. 160p.

1004. Howe, Bea. "The Victorian illuminator." Country life 137:1292-93, May 27, 1965.

1005. James, Philip B. English book illustration, 1800-1900. London, Penguin Books, 1947. 72p. 16 plates.

1006. Laver, James. A history of British and American etching. London, Benn, 1929. 195p.

1007. Lewis, Charles T. The picture printer of the nineteenth century. London, Low, Marston, 1911. 363p.

1008. _____. The story of picture printing in England during the 18th century. London, Low, Marston, 1928. 405p. 59 plates.

1009. Long, Basil S. British miniaturists. London, G. Bles, 1929. 475p. 32 plates.

1010. McLean, Ruari. Victorian book design and colour printing. 2d ed. Berkeley, Univ. of Calif. Press, 1972. 241p. illus. facs.

1011. Man, Felix H. "Lithography in England (1801-1810)." (In Zigrosser, C., ed. Prints. N.Y., Holt, Rinehart and Winston, 1963. p.97-130.)

1012. Messina, R. "Immagini dell'incubo: le illustrazioni del romanzo gotico." Accademie e biblioteche d'Italia 44, no.4-5:344-58. 1976.

1013. Muir, Percival. Victorian illustrated books. London, Batsford, 1971. 287p.

1014. Paulson, Ronald. "The tradition of comic illustration from Hogarth to Cruikshank." Princeton University Library chronicle 35:35-60, Autumn-Winter 1973.

1015. Pennell, Joseph. [On English book-illustrators of 1860] Bibliographical Society Transactions 3:153-54. 1895.

1016. _____. "Pen drawing in England." (In Pen drawing and pen draughtsmen. London, Macmillan, 1889. p.135-92.)

1017. Pitz, Henry C. "Illustrators of the sixties." American artist 22:30-35, Sept. 1958.

1018. Prideaux, Sarah T. Aquatint engraving; a chapter in the history of book illustration. London, Duckworth, 1909. 434p.

1019. _____. "Color photography in England." Printing art 10:305-12, Jan. 1908.

1020. Ray, Gordon N. The illustrator and the book in England from 1790 to 1914. N.Y., Pierpont Morgan Library, 1976. 336p. illus. plates.

 A bibliography with descriptions by Thomas V. Lange. Appendix has "100 outstanding illustrated books published in England between 1790 and 1914."

1021. Reid, Forrest. Illustrators of the sixties. London, Faber and Gwyer, 1928. 295p.

1022. Rümann, Arthur. Das illustrierte Buch des xix. Jahrhunderts in England, Frankreich und Deutschland 1790-1860. Leipzig, Insel-Verlag, 1930. 380p.

1023. Salaman, Malcolm C. "British book illustration." (In Modern book illustrators and their work. Ed. by C. Geoffrey Holme and Ernest G. Halton. London, Studio, 1914. p.1-12.)

1024. _____. The graphic arts of Great Britain. Ed. by Charles Holme. London, Studio, 1917. 156p. (Special no. of the Studio.)

1025. _____. Modern woodcuts and lithographs by British and French artists with commentary by British and French artists. London, Studio, 1919. 204p. illus. (Special no. of the Studio.)

1026. _____. Old English mezzotints. Ed. by Charles Holme. London, Studio, 1910. 43p. 128 plates. (Special winter no. of the Studio.)

1027. _____. "The woodcut in Great Britain." (In The woodcut of today at home and abroad. Ed. by G. Holme. London, Studio, 1927. p.1-89. illus.)

1028. Sketchley, Rose E. English book-illustration of today--apprecia-
tions of the work of living English illustrators with lists of their
books. With an introduction by Alfred W. Pollard. London, Paul, Trench,
Trubner, 1903. 175p. illus.

> Originally appeared in The Library in 1902. Reprinted by
> Gale Research Co. in 1974.

1029. Sparrow, Walter S. A book of British etching from Francis Barlow
to Francis Seymour Haden. London, John Lane the Bodley Head Ltd., 1926.
227p.

1030. Tannahill, Reay. Regency England, the great age of the color
print. Folio Society, 1964. 1 vol. 50 colored illus.

1031. Thorpe, James. English illustration: the nineties. London,
Faber and Faber, 1935. 267p.

1032. Tooley, Ronald V. English books with coloured plates, 1790 to
1860; a bibliographical account of the most important books illustrated
by English artists in colour aquatint and color photography. London,
Batsford, 1954. 424p. rev. ed., 1978. 452p.

> First edition has title: Some English books with coloured
> plates.

1033. Thomas, Alan G. "English books with coloured plates 1790-1837."
(In Fine books. N.Y., Putnam, 1967. p.79-102.)

1034. Twyman, Michael. Lithography 1800-1850; the technique of drawing
on stone in England and France and their application in works of topog-
raphy. London, Oxford Univ. Press, 1970. 304p.

1035. Victoria and Albert Museum, London. Victorian engravings. By
Hilary Beck. London, 1973. 75, 109p.

1036. Wakeman, Geoffrey. XIX century illustration; some methods used
in English books; illustrated with original examples of the processes.
Loughborough, The Plough Press, 1970. (Consists of 15 portfolios and a
pamphlet.)

1037. Wedmore, Frederick. Etching in England. London, G. Bell, 1895.
184p.

1038. White, Gleason. English illustration, "the sixties": 1855-70.
Westminster, Constable, 1897. 203p.

20th Century

1039. Alderson, Brian. "Writer and illustrator; Brian Alderson looks
at the revival of Victorian and children's books." Times educational
supplement 3193:14, Aug. 13, 1976.

1040. Avermaete, Roger. "La gravure sur bois en Angleterre." (In La gravure sur bois moderne de l'occident. Vaduz, Quarto Press, 1977c1928. p.77-88.)

1041. Balston, Thomas. English wood-engraving, 1900-1950. London, Art and Technics, 1951. 84p. illus. plates.

 A reprint with alterations and additions of an essay which first appeared as a special issue (Nov. 1950) of Image.

1042. Bliss, Douglas P. "Modern English book illustration." Penrose annual 31:107-15, 1929.

1043. Cleverdon, Douglas. "A survey of the making of books in recent years: England." Dolphin, no. 1:342-56, 1933.

1044. Darton, Frederick J. H. Modern book illustration in Great Britain and America. London, Studio, 1931. 144p.

1045. Ede, Charles. "British book illustrators." American artist 20:28-32, Feb. 1956.

1046. Farleigh, John. "British book illustration is changing." Library journal 73:432-33, Mar. 15, 1948.

1047. Graham, Rigby. "Modern English woodcuts." Private library 4:70-84, 1971.

1048. _____. Romantic book illustration in England 1943-55. Pinner (Middlesex), Private Libraries Association, 1966. 35p.

1049. James, Philip B. British book illustration 1935-45; a catalogue of an exhibition ... held in Nov. 1946. With an introduction by Philip James. London, Cambridge Univ. Press, 1946. 37p. illus.

1050. Lambert, Frederick. Graphic design Britain. London, Owen, 1967. unpaged.

1051. Larkin, David, ed. Once upon a time; illustration of fantasy. N.Y., Peacock Press, 1976. 14p. 42 leaves of plates.

1052. Laver, James. "Neue Graphik in England." Graphischen Künste 49:13-22. 1926.

1053. National Book League, London. Wood engraving in modern English books. Catalogue of an exhibition arranged for the National Book League by Thomas Balston, Oct.-Nov. 1949. Cambridge, Cambridge Univ. Press, 1949. 48p. illus. plates.

1054. Roberti, G. "Il libro d'arte illustrado in Gran Bretagna e in Francia." Accademie e biblioteche d'Italia 12:132-42, Apr. 1938.

1055. Salaman, Malcolm C. British book illustration yesterday and today. London, Studio, 1923. 175p. illus. (Reprinted by Gale Research Co. in 1974.)

1056. Schwabe, Randolph. "British book illustration; change and development in present day technique." Studio 114:201-07, Oct. 1937.

1057. Simon, Howard. "Modern Great Britain." (In 500 years of art in illustration. Cleveland, World Publishing Co., 1942. p.326-91.)

1058. Sleigh, Bernard. Wood engraving since eighteen-ninety with 80 illustrations from the works of past and contemporary engravers--and many practical hints upon its technique and use. London, Pitman, 1932. 158p.

1059. Weber, Wilhelm. "Lithography in Britain and America after 1900." (In History of lithography. London, Thames and Hudson, 1966. p.133-36.)

Greece

> (See also Early History to 1500 in the chronological section.)

1060. Bertelli, C. "Illustrazione." (In Enciclopedia dell'arte antica classica e orientale. vol. 4, p.111-17. 1961.

1061. Bethe, Erich. Buch und Bild im Altertum. Aus dem Nachlass. Hrsg. von Ernst Kirsten. Amsterdam, A.M. Hakkert, 1964. 148p. illus.

1062. Birt, Theodor. Die Buchrolle in der Kunst. Leipzig, B. G. Teubener, 1907. 352p.

1063. _____. Das antike Buchwesen in Seinem Verhaltniss zur Litteratur. Berlin, Hertz, 1882. 518p.

1064. Bordier, Henri. Descriptions des peintures et autres ornements contenus dans les manuscrits grecs de la Bibliothèque Nationale. Paris, 1883. 336p. 193 illus.

1065. Codices graeci et latini photographice depicti. Lugduni Batavorum, A.W. Sijthoff, 1897-1919. Supplement 1902-

1066. Devreesse, Robert. Introduction à l'étude des manuscrits grecs. Paris, Impr. Nationale, Librairie C. Klincksieck, 1954. 347p.

1067. Diringer, David. "Graeco-Roman book illustration." (In The illuminated book; its history and production. N.Y., Philosophical Library, 1958. p.30-40. plates.)

1068. _____. "Greco-Roman world." (In Encyclopedia of world art. N.Y., McGraw-Hill, 1965. vol. 10, columns 128-34.)

1069. _____. "Greek and Latin book production." (In The hand-produced book. N.Y., Philosophical Library, 1953. p.228-74. plates.)

1070. Gasiorowski, Stanislaw J. Malarstwo miniaturowe grecko-rzymskie i jego tradycje w sredniowieczu. Kraków, 1928. 236p. 95 plates. (summary in English.)

1071. Gerstinger, Hans. Griechische Buchmalerei. Vienna, Druck und
Verlag der Osterreichischen Staatsdruckerei, 1926. 52p. plates and
altas.

1072. Hatch, William H. Greek and Syrian miniatures in Jerusalem.
With an introduction and description of each of the 71 miniatures repro-
duced by W. H. Hatch. Cambridge, Mass., 1931. 136p. 72 plates.
(Medieval Academy of America. Publication no. 6.)

1073. The illustrations in the manuscripts of the Septuagint. Ed. by
Ernest T. De Wald et al. Princeton, Princeton Univ. Press, 1941-
plates.

1074. Kraiker, Wilhelm. Malerei der Griechen. Stuttgart, 1958. 166p.
plates.

1075. Mackeprang, Carl M. et al., eds. Greek and Latin illuminated
manuscripts x-xiii centuries in Danish collections. Copenhagen, Aage
Marcus, 1921. 51p. 64 plates.

1076. Middleton, John H. Illuminated manuscripts in classical and
medieval times, their art and their technique. Cambridge, University
Press, 1892. 270p. illus.

1077. Omont, Henri A. Miniatures des plus anciens manuscrits grecs de
la Bibliothèque Nationale du vie au xive siècle. 2d ed. Paris,
H. Champion, 1929. 66p. 138 plates.

1078. Pfuhl, Ernst. Malerei und Zeichnung der Griechen. Munich, 1923.
3 vols. plates.

 Contains 800 reproductions. The English translation by
 John Beazley has the title Masterpieces of Greek drawing
 and painting (1955).

1078a. Princeton University. Art Museum. Illuminated Greek manuscripts
from American collections; an exhibition in honor of Kurt Weitzmann. Ed.
by Gary Vikan. Princeton, Princeton Univ. Press, 1973. 231p. illus.

1079. Schubart, Wilhelm. Das Buch bei den Griechen und Roemern. 3d ed.
Hrsg. von Eberhard Paul. Heidelberg, L. Schneider, 1962. 157p. illus.

1080. Weitzmann, Kurt. Ancient book illumination. Cambridge, Pub-
lished for Oberlin College and the Dept. of Art and Archeology of Prince-
ton Univ. by Harvard Univ. Press, 1959. 166p.

1081. _____. "Illustrated rolls and codices in Greco-Roman
antiquity." (In Vervliet, Hendrik D., ed. The book through five thou-
sand years. London, Phaidon, 1972. p.165-76.)

1082. _____. Illustrations in roll and codex; a study in the origins
and methods of text illustration. Princeton, Princeton Univ. Press, 1970.
261p.

1083. _____. Late antique and early Christian book illumination.
N.Y., G. Braziller, 1977. 126p. colored plates.

1084. Weitzmann, Kurt. Studies in classical and Byzantine manuscript illumination. Ed. by Herbert L. Kessler. Chicago, Univ. of Chicago Press, 1971. 346p.

Hebrew Illustration

1085. Freimann, Aron. "Zur Geschichte der judischen Buchillustration bis 1540." Zeitschrift für hebräische Bibliographie 21:25-32. 1918.

1086. Gaster, Moses. Hebrew illuminated Bibles of the ixth and xth centuries. London, Printed by Harrison and Sons, 1901. 52p.

1087. Habermann, Abraham M. "The Jewish art of the printed book." (In Roth, Cecil, ed. Jewish art; an illustrated history. Rev. by B. Narkiss. Greenwich, Conn., N.Y. Graphic Society, 1971. p.163-74. 8 plates.)

1088. Landsberger, Franz. "The illumination of Hebrew manuscripts in the Middle Ages and Renaissance." (In Roth, Cecil, ed. Jewish art; an illustrated history. Greenwich, Conn., N.Y. Graphic Society, 1971. p.137-48.)

1089. Mezer, Hermann M. "Incunabula." (In Encyclopedia Judaica. N.Y., Macmillan, 1971. vol. 8, columns 1319-44.)

1090. Milan. Biblioteca Ambrosiana. I. Catalog of undescribed Hebrew manuscripts in the Ambrosiana Library. II. Description of decorated and illuminated manuscripts in the Ambrosiana Library. Milan, Il Polifilo, 1972. 163p. illus. plates.

1091. Naményi, Ernest M. "The illumination of Hebrew manuscripts after the invention of printing." (In Roth, Cecil, ed. Jewish art; an illustrated history. Greenwich, Conn., N.Y. Graphic Society, 1971. p.149-62, 8 plates.)

1092. Metzger, Mendel. La Haggada enluminée. Pt. 1: Etude iconographique et stylistique des manuscrits enluminées et décorés de la Haggada du xiiie and xvie siècle. Preface by René Crozet. Leiden, E. J. Brill, 1973. 518p. and 481 illus.

1093. Narkiss, Bezalel. Hebrew illuminated manuscripts. Foreword by Cecil Roth. N.Y., Macmillan, 1969. 175p. illustrations in color.

1094. Nordstrom, C. O. "Some miniatures in Hebrew Bibles." (In Synthronon; art et archéologique de la fin de l'antiquité et du moyen âge. Paris, 1968. p.89-105.)

1095. Posner, Ralph and Ta-Shema, Israel, eds. The Hebrew book; an historical survey. Jerusalem, Keter Publishing House, 1975. 225p. 16 leaves of plates.

1096. Reider, Joseph. "The new ornament of Jewish books." (In Berger, Abraham et al., eds. The Joshua Bloch memorial volume. N.Y., New York Public Library, 1960. p.10-18.)

1097. Reider, Joseph. "Non-Jewish motives in the ornament of early Hebrew books." (In Ginsberg, Louis et al., eds. Studies in Jewish bibliography and related subjects in memory of Abraham Solomon Freidus (1867-1923). N.Y., Alexander Kohut Memorial Foundation, 1929. p.150-59.)

1098. Roth, Cecil. "Book illustrations." (In Encyclopedia Judaica. N.Y., Macmillan, 1971. columns 1233-37.)

1099. _____. "Illuminated manuscripts, Hebrew." (In Encyclopedia Judaica. N.Y., Macmillan, 1971. vol. 8, columns 1257-88.)

1100. Stasov, Vladimir and Gunsberg, David. L'ornement hébreu. Berlin, Calvary, 1906. 13p. 26 plates.

Hungary

1101. "The art of the book in Hungary." (In Holme, Charles, ed. The art of the book. London, Studio, 1914. p.231-42. illus.)

1102. Berkovits, Ilona. Illuminated manuscripts from the library of Matthias Corvinus. Tr. by Susan Horn. Budapest, Corvina, 1964. 147p. plates.

The original title is A magyarországi Corvinak.

1103. _____. Illuminated manuscripts in Hungary xi-xvi centuries. Tr. by Susan Horn. Rev. by Alick West. Shannon, Ireland, Irish Univ. Press, 1969. 110p. 44 plates.

1104. Fitz, József. Die Geschichte des ungarischen Buchdrucks, ungarischen Verlagswesens und des ungarischen Buchhandels. vol.1: Vor der Niederlage von mohács (1526). Budapest, Akadémiai Kiadó, 1959. 258p. illus. facs.

1105. _____. A magyar könyv története 1711-ig. Budapest, Magyar Helikon, 1959. 201p. illus. facs. (Part 1 of A magyar könyv története by J. Fitz and Béla Kéki.)

1106. Gyorgy, Rozsa. Magyar történetábrázolás a 17. szazadban. Budapest, Akadémiai Kiadó, 1973. 188p. plates with 226 illus.

1107. Nagy, Zoltán. "A modern magyar konyvillustráció." Kagyar konyvszemie 61:132-52, Apr.-June 1937.

1108. Naményi, Ernst. "Ungarische Buchkunst." Buch und Schrift no. 7-8:73-81 and plates. 1933-34.

1109. Rosner, Karl P. Ungarische Buchkunst. The art of the Hungarian book. Leipzig, 1938. 338p. illus. (In German and English.)

1110. Soltész, Elizabeth. A magyarországi könyvdiszites a xvi szazadban. Budapest, Akadémiai Kiadó, 1961. 195p. plates.

1111. Szántó, Tibor. Beautiful Hungarian book 1473/1973; five hundred years of Hungarian book art and illustration. (translated title.) Budapest, Akadémiai Kiadó, 1974. 628p. illus.

Iceland

1112. Björn, T. B. Islenska teiknibókin í Arnasafni. Reykjavik, Heimskringla, 1954. 186p. illus.

1113. Hermannsson, Halldór. "Book illustration in Iceland." Islandica 29:1-29. 1942. illus.

1114. _____. Icelandic illuminated manuscripts of the middle ages. Copenhagen, Levin and Munksgaard, 1935. 32p. 80 plates.

India and Tibet

1115. Archer, William G. Indian miniatures. Greenwich, Conn., N.Y. Graphic Society, 1960. 16p. 100 illustrations with 50 in color.

1116. Arts Council of Great Britain. Indian miniatures and folk paintings from the collection of Mildred and W. G. Archer. London, 1967. 49p. (Introduction and notes by W. G. Archer.)

1117. Barrett, Douglas E. and Gray, Basil. Painting of India. N.Y., Skira, 1963. 213p.

1118. Beatty, Alfred C. The library of Chester Beatty; a catalogue of the Indian miniatures, by Sir Thomas W. Arnold. London, Privately printed by J. Johnson at the Oxford Univ. Press, 1936. 3 vols. 100 plates.

1119. Boston Museum of Fine Arts. Catalog of the Indian collections in the Museum of Fine Arts, Boston. By Amanda K. Coomaraswamy. Boston, 1923- plates.

1120. Brown, W. Norman. A descriptive and illustrated catalog of miniature paintings of the Jaina Kalpasūtra as executed in the early western Indian style. Wash., D.C., 1934. 66p. 45p. of plates. (Freer Gallery of Art. Oriental studies, no. 2.)

1121. _____. "Six centuries of Indian manuscript illustration." Asia 38:434-39, July 1938.

1122. Bussagli, Mario. Indian miniatures. Tr. from the Italian by Raymond Rudorff. Feltham, N.Y., Hamlyn, 1969. 158p. 73 colored illus.

1123. Chandra, Moti. Jain miniature paintings from western India. Ahmedabad, India, 1949. 197p.

1124. Das Gupta, Rajatananda. Eastern Indian manuscript painting. Bombay, Taraporevala, 1972. 112p. many illus. plates.

1125. Ebeling, Klaus. Ragamala painting. Basel, Ravi Kumar, 1973.
305p. 446 illus. (60 col.).

1126. Gaur, Albertine. "Manuscripts of India, Ceylon, and Southeast
Asia." (In Vervliet, Hendrik D. L., ed. The book through five thousand
years. London, Phaidon, 1972. p.140-64.)

1127. Goetz, Hermann. "Indian miniatures in German museums and private
collections." Eastern art 2:143-66. 1930.

1128. Gray, Basil. "Miniatures and illumination: India." (In Encyclo-
pedia of world art. N.Y., McGraw-Hill, 1965. vol. 10, columns 176-82.)

1129. _____. Treasures of Indian miniatures in the Bikaner Palace
Collection. Oxford, B. Cassirer, 1951. 26p. illus.

1130. Khandalavala, Karl. Pahārī miniature painting. Bombay, New Book
Co., 1958. 409p. illus. 155 plates.

1131. _____ and Chandra Moti. New documents of Indian painting--a
reappraisal. Bombay, Board of Trustees of the Prince of Wales Museum,
1969. 162p. plates with 209 illus. 26 colored plates.

1132. Kheiri, Sattar. Indische Miniaturen der islamischen Zeit.
Berlin, E. Wasmuth, 1921. 17p. 48 plates.

1133. Lillys, William et al., eds. Oriental miniatures: Persian,
Indian, Turkish. Ed. with introduction and notes by William Lillys,
Robert Reiff, and Emel Esin. Rutland, Vt., Charles E. Tuttle, 1965.
102p. illus.

1134. Martin, Frederik R. "Indian miniature painting." (In The
miniature painting and painters of Persia, India, and Turkey from the
8th to the 18th century. London, Holland Press, 1971c1912. p.79-89.)

1135. Olschak, Blanche C. and Wangyal, Geshé T. Mystic art of ancient
Tibet. London, Allen and Unwin, 1973. 224p. illus. plates.

1136. Pal, Pratapaditya. The art of Tibet with an essay by Eleanor
Olson. N.Y., Asia Society, 1969. 162p. illus. plates. (exhibit
catalog.) (Distributed by the New York Graphic Society.)

1137. Portland, Oregon. Art Museum. Rajput miniatures from the collec-
tion of Edwin Binney, 3d. Portland, 1968. 131p. illus.

1138. Reiff, Robert, ed. Indian minatures. The Rajput painters.
Rutland, Vt., Charles E. Tuttle, 1959. 32p.

1139. Sastri, Hirananda. Indian pictorial art as developed in book
illustrations. Baroda, Baroda State Press, 1936. 24p. plates.

1140. Sotheby and Co. Catalogue of oriental manuscripts, Indian and
Persian miniatures from the celebrated collection formed by Sir Thomas
Phillipps (1792-1872). 1974. 128p. illus. plates (some in color).

1141. Strzygowski, Josef. Asiatische Miniaturenmalerei im Anschluss an
Wesen und Werden der Mogulmalerei. Klagenfurt, Verlag Kollitsch, 1933.
232p. 280 illus. 108 plates.

1142. Tucci, Giuseppe. Tibetan painted scrolls. Tr. from the Italian
by Virginia Vacca. Rome, Libreria della Stato, 1949. 2 vols. and port-
folio.

1143. Welch, Stuart C. Imperial Mughal painting. N.Y., G. Braziller,
1978. 38p. 40 plates.

Islam

(See also individual countries.)

1144. Arnold, Thomas W. and Grohmann, Adolph. The Islamic book; a
contribution to its art and history from the vii-xvii century. N.Y.,
Harcourt, Brace, 1929. 130p. 104 plates.

1145. Copenhagen. Forening for Boghaandverk. Den arabiske bog. By
Johannes Pedersen. Copenhagen, 1946. 159p. illus.

1146. Dimand, M. S. "Calligraphy and illumination." (In Handbook of
Muhammadan art. 2d ed. N.Y., Metropolitan Museum of Art, 1944. p.67-
78.)

1147. Ettinghausen, Richard. "The flowering of the art of the book."
(In Arab painting. N.Y., Skira, 1962. p.58-132.)

1148. Gray, Basil. "Arts of the book." (In The arts of Islam; an
exhibition [in the Hayward Gallery Apr. 18-July 4, 1976] organized by
the Arts Council of Great Britain in association with the World of Islam
Festival Trust. London, Arts Council of Great Britain, 1976. p.309-72.
illus.)

1149. _____. "Miniatures and illumination: Islam." (In Encyclo-
pedia of world art. N.Y., McGraw-Hill, 1965. vol. 10, columns 171-75.)

1150. Grube, Ernst J. The classical style in Islamic painting; the
early school of Herat and its impact on Islamic painting of the later
15th, the 16th, and 17th centuries; some examples in American collec-
tions. Edizione Oriens, 1978. 204p. many plates.

1151. _____. Islamic paintings from the 11th to the 18th century
in the collection of Hans P. Kraus. N.Y., H. P. Kraus, 1972? 291p.
55 colored plates.

1152. _____. Muslim miniature paintings from the xiii to xix century
from collections in the U. S. and Canada. Venezia, Neri Pozza Editore,
1962. 139p. 125 plates. (exhibit catalog.)

1153. Ipsiroglu, M. Das Bild in Islam, ein Verbot und seine Folgen.
Vienna, Schroll, 1971. 174p. 93 plates (39 in color).

1154. Kirketerp-Muller, Hertha. Det islamische bogmalerei.
Copenhagen, Nyt Nordisk Forlag, 1974. 178p.

1155. Kühnel, Ernst. "Arabic illuminated manuscripts." (In Islamic
arts. London, G. Bell, 1940. p.34-55.)

1156. _____. Miniaturmalerei im islamischen Orient. Berlin,
B. Cassirer, 1922. 68p. 154 plates.

1157. Pinder-Wilson, Ralph H., ed. Paintings from Islamic lands.
Oxford, B. Cassirer, 1969. 204p. many illus.

1158. Réau, Louis. "La miniature islamique." (In Histoire de la
peinture au moyen-âge: la miniature. Melun, Librairie D'Argences,
1946. p.229-40.)

1159. Robinson, Basil W., ed. Islamic painting and the arts of the
book. London, Faber and Faber, 1976. 322p. 157 plates.

1160. Staatsbibliothek der Stiftung Preussischer Kulturbesitz.
Illuminierte islamische Handschriften. Beschrieben von Ivan Stchoukine
et al. Wiesbaden, F. Steiner, 1971. 340p. plates.

1161. Titley, Norah M. "Islam." (In Vervliet, Hendrik D. L., ed.
The book through 5000 years. London, Phaidon, 1972. p.51-83.)

Italy

Reference Works

1162. Baudi Di Vesme, Alessandro. Le peintre-graveur italien.
Ouvrage faisant suite au Peintre-graveur de Bartsch. Milan, 1906. 542p.

1163. Bessone-Aurelj, Antoinette. Dizionario dei pittori italiani.
2d ed. Milan, Albright, 1928. 678p.

1164. Dizionario enciclopedico Bolaffi dei pittori e degli incisori
italiani. Dall'xi al xx secolo. Torino, G. Bolaffi, 1972-

Early History to 1700

1165. Alexander, Jonathan J. Italian renaissance illuminations. N.Y.,
G. Braziller, 1977. 118p. illus. colored plates.

1166. Ancona, Paola d'. La miniature italienne du xe au xvie siècle.
Tr. by P. Poirier. Paris, G. Van Oest, 1925. 128p.

1167. Barberi, Francesco. Il frontespizio nel libro italiano del
quattrocento e del cinquecento. Milan, Edizioni il Polifilo, 1969.
2 vols.

1168. Boffito, Giuseppe. Frontespizi incisi nel libro italiano del
seicento. Florence, Succ. Seeber, 1922. 131p. illus. 24 facs.

1169. Bunt, Cyril G. "Golden age of Italian book illustration."
Connoisseur 125:35-39, Mar. 1950.

1170. Daneu Lattanzi, Marguerite. La miniature italienne du x e au xvi e
siècle. Brussels, Bibliothèque Royale Albert I er, 1969. 92p. 32 plates.
(exhibit catalog.)

1171. Delaborde, Henri. La gravure en Italie avant Marc-Antoine (1452-
1505). Paris, Librairie de l'Art, 1883. 287p. illus. plates.

1172. Donati, Lamberto. Il libro illustrato italiano nel Rinascimento.
Maso finiguerra 5, no. 3:239-70. 1940.

1173. _____ . "Il libro illustrato italiano nel xv secolo."
Maso finiguerra 3:225-32. 1938.

1174. _____ . "Prolegomeni allo studio del libro illustrato italiano."
Maso finiguerra 4, no. 1-2:3-68. 1939. illus.

1175. Duplessis, Georges. Histoire de la gravure en Italie, en Espagne,
en Allemagne, dans les Pays-Bas, en Angleterre et en France. Paris,
Hachette, 1880. 528p.

1176. Fava, Domenico. I libri italiani a stampa del secolo xv con
figure della Biblioteca Nazionale Centrale di Firenze. Milano, U.
Hoepli, 1936. 278p.

1177. Harvard University Library. Dept. of Printing and Graphic Arts.
Catalog of books and manuscripts, part 2: Italian 16th century books.
Compiled by Ruth Mortimer. Cambridge, Belknap Press of Harvard Univ.
Press, 1974. 2 vols. illus.

1178. Hind, Arthur M. Early Italian engraving; a critical catalogue
with complete reproductions of all prints described. London, Published
for M. Knoedler, N.Y., by B. Quaritch, 1938-48. 2 vols. in 7. plates.

1179. Kristeller, Paul. Early Florentine woodcuts. London, 1897.
2 vols.

1180. _____ . "Florentine book illustrations of the fifteenth and
early sixteenth centuries." Bibliographica 2:81-111, 227-56. 1896.

1181. Levenson, Jay A. et al. Early Italian engravings from the
National Gallery of Art. Wash., D.C., National Gallery of Art, 1973.
587p. illus.

 Contains an introduction by Konrad Oberhuber, p.xiii-xxvi.

1182. Levi d'Ancona, Mirella. Miniatura e miniatori a Firenze del xiv
al xvi secolo. Florence, Olschki, 1962. 465p. illus.

1183. Lippmann, Friedrich. The art of wood-engraving in Italy in the
fifteenth century. London, B. Quaritch, 1888. 179p.

COUNTRIES OF THE WORLD 87

1184. McMurtrie, Douglas C. "Italian book illustration." (In The book;

the story of printing and bookmaking. London, Oxford Univ. Press, 1943.

p.348-59.)

1185. Mariani Canova, Giordana. La miniatura veneta del Rinascimento

1450-1500. Venice, Alfieri, 1969. 315p. 222 illus. 44 colored plates.

1186. La miniatura in Friuli. Udine, Palazzo Comunale 9 Settembre/15
Octobre, 1972. Catalogo a cura di Gian C. Menis and Giuseppe Bergaminia.
Scritti di Giuseppe Bergaminia et al. Milan, Electa Editrice, 1972.
199p. many plates.

1187. Morison, Stanley. Splendour of ornament; specimens selected from
the Essempio di recammi, the first Italian manual of decoration, Venice
1524 by Giovanni Antonio Tagliemente, his life and literary remains, the
Essempio di recammi and his typographical style by Esther Potter. London,
Lion and Unicorn Press, 1968. 72p.

1188. Mostra storica nazionale della miniatura. Palazzo di Venezia,
Roma. Catalog. 2d ed. Florence, Sansoni, 1954. 502p. 104 plates.

1189. Orcutt, William D. The book in Italy during the fifteenth and
sixteenth centuries shown in facsimile reproduction from the most famous
volumes. N.Y., Harper, 1928. 220p.

1190. Pächt, Otto and Alexander, Jonathan J. Illuminated manuscripts
in the Bodleian Library, Oxford. vol. 2: Italian school. Oxford,
Clarendon Press, 1970. 161p. 88 plates.

1191. Petrucci, Alfredo. Gli incisori del sec. xv al xix. Volume unico.
Rome, Istituto Poligraphico della Stato, Libreria della Stato, 1958.
228p. illus. 90 plates.

1192. Pierpont Morgan Library, N.Y. Italian manuscripts in the Pierpont
Morgan Library. N.Y., 1953. 78p. 78 plates.

1193. Pittaluga, Mary. L'incisione italiana nel cinquecento. Milan,
U. Hoepli, 1930. 398p. illus. plates.

1194. Pollard, Alfred W. Italian book illustrations and early printing;
a catalogue of early Italian books in the library of C. W. D. Perrins.
Oxford, University Press, 1914. 255p. illus.

1195. _____. Italian book illustrations, chiefly of the fifteenth
century. London, Seeley, 1894. 80p.

1196. Rava, Carlo E. Arte della illustrazione nel libro italiano del
Rinascimento. Milan, 1945. 96p. 53 plates.

1197. Ratta, Cesare, ed. Gli adornatori del libro in Italia; testo
critico di Stanislao Petri. Bologna, Impresso Coi Tipi Della Scuola
d'Arte Tipografica del Commune di Bologna, 1923-28. 9 vols.

1198. Rotili, Mario. La miniatura gotica in Italia. Naples, Libreria
Scientifica Editrice, 1968-69. 2 vols.

1199. Salmi, Mario. La miniatura italiana. Milan, Electa Editrice, 1956. 256p.

1200. _____. Italian miniatures. 2d ed. Tr. by Elisabeth Forgese-Mann. Milton S. Fox, ed. N.Y., Abrams, 1956. 214p.

1201. Sander, Max. Le livre à figures italien 1467 jusqu'à 1530. Milan, 1942. 6 vols.

A supplement by Carlo E. Rava was published by Hoepli in Milan in 1969.

1202. Scuricini Greco, Maria L. Miniature Riccardiane. Florence, Sansoni, 1958. 316p. illus.

1203. Servolini, Luigi. Incisione italiana di cinque secoli. Milan, 1951. 83p. 46 plates.

1204. _____. La xilografia originale in Italia. Turin, 1928. 32p. 88 plates.

1205. Toesca, Pietro. La pittura e la miniatura nella Lombardia, dai più antichi monumenti alla metà del quatrocento. Milan, U. Hoepli, 1912. 594p.

1206. Vagaggini, Sandra. La miniatura florentina nei secolo xiv e xv. Milan, 1952. 96p. illus. (Collana della storia miniatura, vol. 1.)

18th Century to Date

1207. Bertieri, Raffaello. "A survey of the making of books in recent years: Italy." Dolphin no. 1:357-63. 1933.

1208. Calabi, Augusto. La gravure italienne au xviiie siècle. Paris, G. Van Oest, 1931. 74p.

1209. Coen Pirani, Emma. Il libro illustrato italiano, secoli xvii-xviii. Rome, Edizioni d'Arte Bestetti, 1956. 25p. plates.

1210. Gli artisti italiani del libro. Milan, 1921-

1211. Morazzoni, Giuseppe. Il libro illustrato veneziano del settecento. Milan, U. Hoepli, 1943. 309p. 154 plates on 77 leaves.

1212. Ozzola, Leandro. La litografia italiana dal 1805 al 1870. Rome, 1923. 39p.

1212a. Pellegrini, Guido. "La photografia e il libro moderno." Risorgimento grafico 32:547-57, Nov. 1935.

1213. Pennell, Joseph. "Pen drawing of today--Spanish and Italian work." (In Pen drawing and pen draughtsmen. London, Macmillan, 1889, p.25-60.)

1214. Ratta, Cesare. L'arte della litografia in Italia. Bologna, 1929. 18p.

1215. Ratta Cesare. Artisti dell'ottocento e del novecento. Bologna,
C. Ratta, 1938. 2 vols.

1216. _____. La moderna xilografia italiana. Bologna, 1926-28.
6 vols.

1217. _____, ed. Gli adornatori del libro in Italia; testo critico
di Stanislao Petri. Bologna, Impresso Coi Tipi Della Scuola d'arte
Tipografica del Commune di Bologna, 1923-28. 9 vols.

1218. Salaman, Malcolm C. "The woodcut in Italy." (In The woodcut of
today at home and abroad. Ed. by G. Holme. London, Studio, 1927.
p.121-31.)

1219. Serventi, Nino. "Illustrazione del libro in Italia."
Risorgimento grafico 33:333-62, Sept. 1936.

1220. Servolini, Luigi. "La gravure italienne d'aujourd'hui."
Bibliophile 2:238-44. 1932.

1221. _____. La xilografia nell'ottocento. Lecco, 1932. 15p.
illus.

1222. Simon, Howard. "Modern Italy." (In 500 years of art in illus-
tration. Cleveland, World Publishing Co., 1942. p.298-311.)

1223. Teall, Gardner C. "Rebirth of Italian illustration." Bookman
38:515-21, Jan. 1914.

1224. Veronesi, Giulia. "Contemporary graphic art in Italy." Penrose
annual 47:39-45. 1953.

1225. Vitali, Lamberto. L'incisione italiana moderna. Milan,
U. Hoepli, 1934. 146p.

Japan

1226. Anderson, William. Japanese wood engravings; their history,
technique and characteristics. London, 1895. 80p. illus. plates.

1227. Bachhofer, Ludwig. Die Kunst der japanische Holzschnittmeister.
Munich, K. Wolf, 1922. 119p.

1228. Beres, Huguette (firm, Paris). Beaux livres japonais des xviie,
xviiie et xixe siècles. Paris, 1953. 69p. illus.

1229. Binyon, Laurence and Sexton, J. J. Japanese colour prints.
London, Benn, 1923. 236p. 46 plates.

1230. Boller, Willy. Masterpieces of the Japanese color woodcut;
collection W. Boller. Boston, Boston Book and Art Shop. 174p. 136
illus.

1231. Bowes, James L. Japanese marks and seals. London, Henry
Sotheran, 1882. 379p.

Part 2 is on illuminated manuscripts and printed books.

1232. Brown, Louise N. "Book illustration in old Japan." Scribner's
magazine 69:124-28; 252-56, Jan., Feb. 1921.

1233. _____. Block printing and book illustrations in Japan. N.Y.,
Dutton, 1924. 261p.

1234. Bruijn, R. de. "Japanse prenten en geillustrierde boeken."
Antiek 10:69-92, June-July 1975. (Summary in English.)

1235. Burlington Fine Arts Club, London. Prints and books illustrating
history of engraving in Japan. Introduction by William Anderson, London,
1888. xxxv, 79p. (exhibit catalog.)

1236. Chibbett, David. The history of Japanese printing and book illus-
tration. Tokyo, Kodansha, distributed by Harper, 1977. 264p.

The bibliography, p. 237-38, contains many Japanese language
titles.

1237. Chicago Art Institute. Ryerson Library. Catalogue of Japanese
and Chinese illustrated books in the Ryerson Library of the Chicago
Institute of Art by Kenji Toda. Chicago, 1931. 466p. plates.

1238. The Clarence Buckingham collection of Japanese prints. Chicago,
Art Institute of Chicago, 1955, 1965. 2 vols.

1239. Dawes, Leonard G. Japanese illustrated books. London, H. M.
Stationery Office, 1972. 15p. 60 plates. (Victoria and Albert Museum.
Large picture book, no. 24.)

1240. Douglas, Robert K. "Japanese illustrated books." Bibliographica
3:1-28. 1897.

1241. Fujikake, Shizuya. Japanese wood-block prints. Tokyo, 1938.
221p.

1242. Gardner, Kenneth. "The book in Japan." (In Vervliet, Hendrik D.,
ed. The book through 5000 years. London, Phaidon, 1972. p. 129-39.)

1243. Geneva. Musée d'Art et d'Histoire. Cabinet des Estampes.
Dessins et livres japonais des xviiie et xixe siècles (exhibition)
9 juin-24 septembre 1972. Geneva, 1972. 66p. 122 illus.

1244. Gray, Basil. Japanese woodcuts. Oxford, B. Cassirer, 1957. 11p.
20 plates.

1245. Hillier, Jack R. Japanese masters of the colour print. 2d ed.
London, Phaidon, 1954. 139p.

1246. _____. The uninhibited brush; Japanese art in the Shijo style.
London, H. Moss, 1974. 378p. illus.

1247. Holloway, Owen E. Graphic art of Japan: the classical school.
London, A. Tiranti, 1957. 135p. 121 illus. and 5 plates.

1248. Isaac, Auguste P. "La gravure sur bois à la manière japonaise."
Art et décoration 33:155-62. 1913. illus.

1249. Ishida, Mosaku et al. Japanese Buddhist prints. English adapta-
tion by Charles S. Terry. N.Y., Abrams, 1964. 195p.

1250. Kurth, Julius. Die Geschichte des japanischen Holzschnitts.
Leipzig, Hiersemann, 1925. 3 vols.

1251. Nakada, Katsunosuke. Ehon no kenkyu [Study of illustrated books].
Tokyo, 1950. 298p. 12 text illus. and 32 plates.

1252. Narazaki, Muneshiga. The Japanese print; its evolution and
essence. English adaptation by C. H. Mitchell. Tokyo, Kodansha, 1966.
274p. 107 plates.

1253. Okudaira, Hideo. Emaki; Japanese picture scrolls. Tr. by John
Bester and Charles Pomeroy. Tokyo, Charles E. Tuttle, 1962. 241p.
illus.

1254. Paris. Bibliothèque Nationale. Dépt. des Estampes. Livres et
albums illustrés du Japon; réunis et catalogués par Theodore Duret.
Paris, E. Leroux, 1900. 322p. 9 illus. and 5 color plates.

1255. Salaman, Malcolm C. "The woodcut in Japan." (In The woodcut at
home and abroad. London, Studio, 1927. p.136-48.)

1256. Seidlitz, Woldemar von. A history of Japanese color prints.
Phila., Lippincott, 1910. 207p. 75 plates.

1257. Stewart, Basil. Subjects portrayed in Japanese colour-prints.
N.Y., Dutton, 1922. 382p. 270 illus.

1258. Strange, Edward F. Japanese colour-prints. 4th ed. London,
H. M. Stationery Office, 1913. 169p. (Victoria and Albert Museum hand-
book.)

1259. _____. Japanese illustration; a history of the arts of wood-
cutting and colour-printing in Japan. 2d ed. London, G. Bell, 1904.
155p. 88 illus.

1260. Takahaski, Seiichiro. Traditional woodblock prints of Japan.
N.Y., Weatherhill/Heibonsha, 1972. 176p. illus.

 Original publication in Japanese under the title Edo no
 ukiyo-e-shi.

1261. Tanako, Ikko. "Illustration in Japan." Graphis 32, no. 183:56-
69. 1976-77.

1262. Toda, Kenji. Japanese scroll painting. Chicago, Univ. of
Chicago Press, 1935. 167p. illus.

1263. Tokuno, T. Japanese wood-cutting and wood-cut printing. Ed. by Sylvester R. Koehler. Wash., Government Printing Office, 1894. (Also in U.S. National Museum. Annual report. 1892. p.221-44.)

1264. Vaucaire, Michel. "Les anciens livres japonais illustrés." Bulletin de la librairie ancienne et moderne, 1975. p.41-46.

1265. Yoshida, Hiroshi. Japanese wood-block printing. Tokyo, Sanseido, 1939. 136p.

1266. Yoshikawa, Itsuji. "Narrative picture scrolls." (In Major themes in Japanese art. N.Y., Weatherhill/Heibonsha, 1976. p.116-22.)

1267. Zigrosser, Carl. "China and Japan." (In The book of fine prints. N.Y., Crown, 1937. p.200-31.)

Mexico

1268. Ahlborn, Richard E. "American beginnings: prints in sixteenth-century Mexico." (In Prints in and of America to 1850. Winterthur conference report 1970. Ed. by John D. Morse. Charlottesville, Univ. press of Va., 1970. p.1-22.)

1269. Catlin, Stanton L. Art moderne mexicain. Paris, Braun, 1951. 15p. 48 plates.

1270. Cortés Juáres, Erasto. El grabado contemporaneo 1922-1950. Mexico, Ediciones Mexicanas, 1951. 79p. 56 plates. (Enciclopedia mexicana de arte, 12.)

1271. Durán, Diego. Historia de las Indias de Nueva-Espagne y Islas de Tierra Firma. Mexico, 1867-80. 2 vols and atlas of facs on 66 plates.

1272. Fernández, Justino. "Las ilustraciones en el libro mexicano durante quatro siglos 1539-1939." Maso finiguerra 4:124-56. 1939.

1273. "Grabado." (In Enciclopedia de Mexico. 1971. vol. 5, p.483-92. illus.

1274. Haab, Armin. Mexican graphic art. N.Y., G. Wittenborn, 1957. 126p.

1275. Mexico City. Biblioteca National. La litografia en Mexico en el siglo xix. 2d ed. Mexico City, 1934. 27p. 60 plates.

1276. Robertson, Donald. "Mexican manuscript painting of the early colonial period." Ph.D. dissertation, Yale Univ., 1956.

1277. _____. Mexican manuscript painting of the early colonial period: the metropolitan schools. New Haven, Yale Univ, Press, 1959. 234p. 88 plates.

1278. Romero de Terreros y Vinent, Manuel. "Illumination and miniatures in colonial Mexico." Bulletin of the Pan American Union 63:669-75, July 1929.

1279. Romero de Terreros y Vinent, Manuel. Grabados y grabadores en la
Nueva España. Mexico, Ediciones Arte Mexicano, 1948. 575p.

1280. Simon, Howard. "Modern Mexico." (In 500 years of art in illus-
tration. Cleveland, World Publishing Co., 1942. p.320-25.)

1281. Toussaint, Manuel. La litografia en Mexico en el siglo xix.
2d ed. Mexico, Estudios Neolitho, 1934. 3p., ix-xxviii, 3p. 60 plates.
facs.

Netherlands

1282. Alvin, Louis J. Les commencements de la gravure aux Pays-Bas.
Brussels, M. Hayes, 1857. 41p.

1283. Binyon, Laurence. Dutch etchers of the seventeenth century.
London, Seeley, 1895. 80p. illus.

1284. Braches, Ernst. Het boek als Nieuwe Kunst 1892-1903; een studie
in art nouveau. Utrecht, Oosthoed's Uitgevermaatschappij, 1973. 555p.
(Contains a summary in English.)

1285. Brounts, Albert. Noordnederlandse miniaturen. Brussels, Royal
Library of King Albert I, 1971. 97p. illus. facs.

1286. Byvanck, Alexander W. De middeleeuwsche boekillustratie in de
noordelijke Nederlanden. Antwerp, De Sikkel, 1943. 85p. illus.

1287. _____. La miniature dans les Pays-Bas septentrionaux.
Traduit du néerlandais par Adrienne Haye. Paris, 1937. 185p.

1288. _____ and Hoogewerff, G. J. La miniature hollandais et les
manuscrits illustrés du xive au xvie siècle aux Pays-Bas septentrionaux.
La Haye, Nijhoff, 1922-26. 91p. and 2 portfolios of 240 plates.

1289. _____ and _____. Noord-nederlandsche miniaturen in Hand-
schriften der 14de, 15de, en 16de eeuwen verzameld en beschreven.
The Hague, 1922-26. 3 vols.

1290. Conway, William M. The woodcutters of the Netherlands in the
fifteenth century. Cambridge (England), University Press, 1884. 359p.

1291. Delaissé, L. M. J. A century of Dutch manuscript illumination.
Berkeley, Univ. of Calif. Press, 1968. 102p. 161 illus.

1292. Delen, Adrien J. Histoire de la gravure dans les anciens Pay-Bas
et dans les provinces belges, des origines jusqu'à la fin du dix-
huitième siècle. Paris, G. Van Oest, 1924-35. 2 pts in 3 vols.

1293. _____. Oude vlaamsche graphiek. Antwerp, Het Kompas, 1943.
168p. plates.

1293a. De Roos, S. H. "A survey of the making of books in recent years:
Holland." Dolphin no. 1:326-41. 1933.

1294. De Roos, S. H. "Ueber die neuzeitliche Buchkunst und Schrift-
gestaltung in den Niederlanden." Buch und Schrift no. 7-8:3-17 followed
by plates. 1933-34.

1295. De Vries, R. W. P., Jr. "La xilographie hollandaise moderne."
Maso finiguerra 2:129-46. 1937.

1296. Duplessis, Georges. Histoire de la gravure en Italie, en Espagne,
en Allemagne, dans les Pays-Bas, en Angleterre et en France. Paris,
Hachette, 1880. 528p.

1297. Durrieu, Paul. La miniature flamande au temps de la cour de
Bourgogne (1415-1530). 2d ed. Brussels, G. Van Oest, 1927. 104p.
153 miniatures.

1298. Gelder, Jan G. van. Prenten en tekeningen. Amsterdam, Contact,
1958. 107p. illus. plates.

1299. Hall, H. van. Repertorium voor de geschiedenis der nederlandsche
schilder- en graveerkunst sedert het begin der 12de eeuw. 's-Gravenhage,
Nijhoff, 1936-49. 2 vols.

1300. Heijbroeck, Jan F. De fabel; ontwikkeling van een literatuursoort
in Nederland en in Vlanderen. Amsterdam, H. J. Paris, 1941. 254p.

1301. Hellinga, Wytze Gs. Copy and print in the Netherlands; an atlas
of historical bibliography. With introductory essays by H. de la
Fontaine Verwey and G. W. Ovink. Amsterdam, North-Holland Publishing
Co., 1962. 253p. 219 plates.

1302. Hindman, Sandra. "The transition from manuscripts to printed
books in the Netherlands: illustrated Dutch Bibles." Nederlands archief
voor kergeschiedenis 56:189-209. 1975/76.

1303. Hippert, T. and Linnig, Joseph. Le peintre-graveur hollandais et
belge du xixe siècle. Brussels, 1879. 1123p.

1304. Hollstein, F. W. Dutch and Flemish etchings, engravings and wood-
cuts ca. 1450-1700. Amsterdam, M. Hertzberger, 1949-56. 14 vols. illus.

1305. Hoogewerff, Godefridus J. De noor-nederlandsche schilderkunst.
's-Gravenhage, Nijhoff, 1936-47. 5 vols. illus.

1306. Landwehr, John. Dutch emblem books; a bibliography. Utrecht,
Dekker and Gumbert, 1962. 98p. illus.

1307. _____. Emblem books in the Low Countries 1554-1949; a bibliog-
raphy. Utrecht, Dekker and Gumbert, 1970. 151p. plates.

1308. _____. Fable books printed in the Low Countries; a concise
bibliography until 1800. Nieuwkoop, B. de Graaf, 1963. 43p. 12 plates.

 Contains an introduction by Prof. H. De la Fontaine Verwey,
 p.ix-xi.

1309. Landwehr, John. Studies on Dutch books with coloured plates published 1662-1875; natural history, topography and travel costumes and uniforms. The Hague, Junk, 1976. 136, 605p. illus.

1310. Lebeer, Louis. De vlaamsche houtsnede. Brugge, Uitgave "Excelsior," 1928. 116p. 49 plates.

1311. Lehrs, Max. Geschichte und kritischer Katalog des deutschen, niederländschen und französischen Kupferstiches im xv. Jahrhundert. Vienna, Gesellschaft für Vervielfältigenden Kunst, 1908-1934. 9 vols.

1312. _____. Late Gothic engravings of Germany and the Netherlands; 682 copper plates from the "Kritischer Katalog." With a new essay "Early engraving in Germany and the Netherlands" by A. Hyatt Major. N.Y., Dover, 1969. 367p.

1313. Meyer, Maurits de. De volks- en kinderprent in de Nederlanden van de 15 tot de 20e eeuw. Antwerp, Uitgeversmij n.v. Standaard-Boekhandel, 1962. 621p. plates.

1314. _____. Imagerie populaire des Pays-Bas: Belgique, Hollande. Milan, Electa, Exclusivité Weber, 1970. 216p. facs.

1315. Monroy, Ernst F. von. Embleme und emblembücher in den Niederlanden, 1560-1630; eine Geschichte der Wandlungen ihres Illustrationsstils. Hrsg. von Hans M. von Erffa. Utrecht, Dekker and Gumbert, 1964. 128p.

1316. Musper, Theodor. "Der originare hollandische blockbuchdruck." Maso finiguerra 3:103-07. 1938.

1317. Panofsky, Erwin. "French and Franco-Flemish book illumination in the fourteenth century." (In Early Netherlandish painting. Cambridge, Harvard Univ. Press, 1953. vol. 1, p.21-50.)

1318. Salaman, Malcolm C. "The woodcut in Holland." (In The woodcut of today and at home and abroad. Ed. by G. Holme. London, Studio, 1927. p.106-13.)

1319. Schretlen, Martinus J. Dutch and Flemish woodcuts in the 15th century. London, E. Benn, 1925. 71p.

1320. Simon, Howard. "Modern Holland." (In 500 years of art in illustration. Cleveland, World Publishing Co., 1942. p.315-19.)

1321. Someren, Jan. F. van. Essai d'une bibliographie de l'histoire spéciale de la peinture et de la gravure en Hollande et en Belgique (1500-1875). Amsterdam, Muller, 1882. 207p.

1322. Sotheby, Samuel L. Principia typographica; the block-books issued in Holland, Flanders and Germany during the 15th century. London, McDowall, 1858. 3 vols.

1323. Van der Kellen, Johan P. Le peintre-graveur hollandais et flamand ... ouvrage faisant suite au Peintre-graveur de Bartsch. Utrecht, Kemink et fils, 1867-1873. 244p. plates. (Published in parts from 1867 to 1873.)

1324. Verwey, Herman de la Fontaine. "The Netherlands book." (In Hellinga, Wytze Gs. Copy and print in the Netherlands; an historical atlas. Amsterdam, North-Holland Publishing Co., 1962. p.3-70 and many plates.)

1325. Vogelsand, Willem. Hollandische Miniaturen des spätern Mittelalters. Strasbourg, J. Heitz, 1899. 115p.

1326. Vries, Anne G. L. de. De nederlandsche emblemata. Geschiedenis en bibliographie tot de 18ᵉ eeuw. Amsterdam, Ten Brink and de Vries, 1899. 91p. plates.

1327. Waller, François G. Biographisch woordenboek van noord nederlandsche graveurs. 's-Gravenhage, Nijhoff, 1938. 551p.

1328. Winkler, Friedrich. "Studien zur Geschichte der niederländischen Miniaturmalerei des xv and xvi Jahrhunderts." Jahrbuch der Kunsthistorischen Sammlungen der Kaiserhauses 32:279-342. 1915.

1329. _____. Die flamische Buchmalerei des xv und xvi Jahrunderts. Leipzig, E. A. Seemann, 1925. 210p. plates.

1330. Zilcken, Philip. Moderne Hollandsche etsers. Amsterdam, 1897. 94p. 40 photogravures.

Norway

1331. Fett, Harry P. Norges malerkunst i middlealderen. Kristiania, A. Cammermeyer, 1917. 256p. illus. col. plates.

1332. Johnsen, Nils J. Døler og troll; fra norsk illustrationskunst historie. Oslo, Forening for Norsk Bokkunst, 1935. 175p.

1333. Salaman, Malcolm C. "The woodcut in Sweden and Norway." (In The woodcut of today at home and abroad. Ed. by G. Holme. London, Studio, 1927. p.114-20.)

1334. Sundseth, Arnt B. and Melhus, Alf C. Norsk illustrasjonskunst 1850-1950; bibliografi. Forening for Norsk Bokkunst, 1952. 349p. illus. 72 plates.

> Contains a list of books illustrated by Norwegian artists, p.1-198, with some vignettes. Plates are arranged chronologically.

Persia

1335. Arnold, Thomas W. et al. "Book painting." (In Pope, Arthur U., ed. Survey of Persian art. London, Oxford Univ. Press, 1939. vol. 3, p.1809-1927.)

1336. Barrett, Douglas E. Persian painting of the fourteenth century. London, Faber and Faber, 1955. 24p.

1337. Binyon, Laurence et al. Persian miniature painting, including a critical and descriptive catalogue of the miniatures exhibited at the Burlington House, Jan.-Mar. 1931. London, Oxford Univ. Press, 1933. 212p. plates. (Reprinted in 1971 by Dover Publications.)

1338. Blaikie, W. G. "Splendors of the Persian book." Bookman's journal and print collector 5:148-54, Feb. 1922.

1339. Blochet, E. "Musulman manuscripts and miniatures as illustrated in the recent exhibition at Paris." Burlington magazine 2:132-45; 3:276-85, July, Dec. 1903.)

1340. Blunt, Wilfrid. "The Timurids and the art of the book." (In Splendors of Islam. N.Y., Viking Press, 1976. p.88-96. plates.)

1341. Burlington Fine Arts Club, London. Catalog of specimens illustrative of Persian and Arab art exhibited in 1885. London, 1885. 70p.

1342. _____. Persian art; an illustrated souvenir of the exhibition of Persian art at Burlington House. 2d ed. London, Printed for the executive committee of the exhibition by Hudson and Kearne, 1931. xixp. 101 plates on 51 leaves.

1343. De Lyée de Belleau. "La miniature persane." Bibliophile, no. 2: 86-93, 125-34. 1932.

1344. Ettinghausen, Richard. "Manuscript illumination." (In Pope, Arthur U., ed. Survey of Persian art. London, Oxford Univ. Press, 1939. vol. 3, p.1937-74 and 25 plates.

1345. _____. Persian miniatures in the Bernard Berenson collection. Milan, Arti Grafiche Ricordi, 1962. 37p.

1346. Gray, Basil. Persian painting. N.Y., Skira (distributed by World Publishing Co., Cleveland), 1961. 191p.

1347. _____. Persian painting from miniatures of the xiii-xvi centuries. N.Y., Oxford Univ. Press, 1940. 13p. 12 colored plates. (Published also in German and French.)

1348. Holter, Kurt. Persische Miniaturen. Vienna, Kunstverlag Wolfrum, 1951. 46p. 24 colored plates.

1349. Lillys, William et al., eds. Oriental miniatures: Persian, Indian, Turkish. Ed. with introduction and notes by William Lillys, Robert Reiff, and Emel Esin. Rutland, Vt., Charles E. Tuttle, 1965. 102p. illus.

1350. Martin, Frederik R. The miniature painting and painters of Persia, India, and Turkey from the 8th to the 18th century. London, Holland Press, 1971c1912. 156p. 271 plates.

1351. Meredith-Owens, G. M. Persian illustrated manuscripts. London, British Museum, 1965. 32p. 24 plates.

1352. Metropolitan Museum of Art, N.Y. Persian miniatures; a picture
book. N.Y., 1944. 2p. 20 plates.

1353. Morand, Paul. Chefs-d'oeuvre de la miniature persane (xiii-xvie
siècles). Paris, Librairie Plon, 1947. 11p. 12 colored plates.

1354. "Persian painting--fifteenth century." Marginalien 30:1-76,
Mar. 1977.

1355. "Persian painting--fourteenth century." Marginalien 30:1-9,
38-60, Dec. 1976.

1356. Pinder-Wilson, Ralph H. Persian painting of the fifteenth century.
London, Faber and Faber, 1958. 24p.

1357. Pope, Arthur U. "The arts of the book." (In Masterpieces of
Persian art. N.Y., Dryden Press, 1945. p.146-51 and 30 plates.)

1358. Preetorius, Emil, ed. Persische Miniaturen. Munich, R. Piper,
1958. 46p. illus.

1359. Sakisian, Arménag. La miniature persane du xiie au xviie siècle.
Paris, G. Van Oest, 1929. 174p. 105 plates.

1360. Schulz, Philipp W. Die persisch-islamische Miniaturmalerei.
Leipzig, K. W. Hiersemann, 1914. 2 vols.

1361. Sotheby and Co. Catalog of oriental manuscripts, Indian and
Persian miniatures from the celebrated collection formed by Sir Thomas
Phillipps (1792-1872). 1974. 128p. illus. plates (some in color).

1362. Stchoukine, Ivan V. Les peintures des manuscrits tîmûrides.
Paris, G. Geuthner, 1954. 176p.

1363. Unesco. Iran: Persian miniatures--Imperial Library. Preface by
Basil Gray. Introduction by André Godard. Greenwich, Conn., N.Y.
Graphic Society, 1956. 25p. 32 colored plates.

1364. Victoria and Albert Museum, London. Persian miniature painting
from collections in the British Isles. By B. W. Robinson. London,
H. M. Stationery Office, 1967. 120p. and 52 plates.

1365. Welch, Anthony. Artists for the Shah; late 16th century painting
at the Imperial Court of Iran. New Haven, Yale Univ. Press, 1976. 233p.
illus.

 Large parts of this work appeared in the author's 1972
 doctoral dissertation at Harvard University.

1366. Welch, Stuart C. Royal Persian manuscripts. London, Thames and
Hudson, 1976. 127p. illus. (some in color).

Poland

1367. Avermaete, Roger. "La gravure sur bois en Pologne." (In La gravure sur bois moderne de l'Occident. Vaduz, Quarto Press, 1977c1928. p.247-58.)

1368. Banach, Andrzej. Polska ksiazka ilustrowana 1800-1900. Krakow, Wydawn Literackie, 1959. 508p. illus.

1369. Betterówa, Antonina. "Polskie ilustracye ksiazkowe xv i xvi wieku (1490-1525)." (In Towarzystwo naukowe we Lwowie. Prace sekeyi historyi sztuki kultury. Lwow, 1929. vol. 1, p.289-398.)

1370. Bialostocki, Jan. The graphic arts in Poland 1954-1955. Warsaw, Polonia Publishing House, 1956. 37p. plates.

1371. _____. W pracowniach dawnych grafików. Warsaw, 1957. 125p. illus.

1372. Blum, Elena. "La xilografia moderna polacca." Maso finiguerra 2:57-68. 1937.

1373. Bojko, Szymon. "Graphic design in Poland." Penrose annual 66:147-58. 1973.

1374. Czarnocka, Krystyna. Póltora wieku grafiki polskiej. Warsaw, 1962. 378p. illus.

1375. I., A. "Les enluminures et les enlumineurs en Pologne." Bibliophile 3:255-59. 1933.

1376. Kloss, Ernst. Die schlesische Buchmalerei des Mittelalters. Berlin, Deutscher Verein für Kunstwissenschaft, 1942. 243p. 281 plates.

1377. Kopera, Feliks. Dzieje malarstwa w Polsce. Krakow, 1925-29. 3 vols.

1378. Kraków. Uniwersytet Jagielonski. Biblioteca. Rekopisy i pierwodrucki illuminowane Biblioteki Jagielinskich. Wroclaw, 1958. 233p. 154 pages of facs.

1379. Lam, Stanislaw. Ksiazka wytworna. Warsaw, W. Lazarski, 1922. 123p. facs.

1380. _____. Le livre polanais au xve et xvie siècle. Varsovie, W. Lazarski, 1923. 79p. illus.

1381. Rastawiecki, Edward. Slownik rytownikow polskich. Poznan, 1886. 316p.

1382. Simon, Howard. "Modern Poland." (In 500 years of art in illustration. Cleveland, World Publishing Co., 1942. p.270-78.)

1383. Skierkowska, Elzbieta. Wspólczesna ilustracja ksiazki. Wroclaw, Ossolineum, 1969. 230p. 98 illus.

1384. Smolik, Przeclaw. Zdobnictwo ksiązki w twórczości wyspiańskiego. W. Lodzi, 1928. 89p. illus. facs.

1385. Tessaro-Kosimowa, Irena. Historia litografii warszawskiej. Warsaw, 1973. 301p.

1386. Warsaw. Museum Narodowe. Polska grafika wspolozesna, 1900-1960. Warsaw, 1960. 69p. 32 plates. (exhibit catalog.)

Portugal

1387. Barreira, João. Arte portuguesa; volume consagrado a pintura. Lisbon, Ediçoes Excelsior, 194-? 456p.

1388. Kraus, H. P. (firm). Portugal and Spain. 68p. plates. (catalog 112.)

1389. Kurz, Martin. Handbuch der iberischen Bildrucke des xv Jahrhunderts. Leipzig, Hiersemann, 1931. 250p.

1390. Manuel II, King of Portugal. Livros antigos portuguezes 1489-1600 da biblioteca de sua Majestade Fidelissima. Cambridge, 1929-35. 3 vols. illus. plates. facs.

1391. Pereira Forjaz de Sampaio, Albino, ed. Historia da literatura portuguesa, ilustrada. Paris, 1929-32. 3 vols. plates.

1392. Rowan, Rosalind. "Illustration in Portugal 1600-1880." M. A. thesis, Univ. of Chicago, 1942. 173p.

1393. Soares, Ernesto. Historia da gravura artistica em Portugal os artistas e as suas obras. Lisbon, Santelmo, 1940-41. 2 vols.

1394. Thomas, Henry. "Copperplate engravings in Portuguese books of the late sixteenth century." Library, 4th series, 22:145-62, Sept.-Dec. 1941.

Russia

1395. Abdullah, Seraphin and Macler, Frédéric. Etudes sur la miniature arménienne. Paris, G. Geuthner, 1909. 46p. illus. plates.

 Extract from la Revue des études ethnographiques et sociologique, 1909.

1396. Aranowitz, D. "Modern Russian illustrators." Gebrauchsgraphik 5:46-61, Mar. 1928.

1397. Avermaete, Roger. "La gravure sur bois en Russie." (In La gravure sur bois moderne de l'Occident. Vaduz, Quarto Press, 1977c1928. p.259-68.)

1398. B'ikova, V. Art books 1967. Half a century of Soviet book illustration. Moscow, Kniga, 1971. 199p. illus. facs. (Test in Russian.)

1399. Blankoff, Jean. L'art de la Russie ancienne. Brussels, 1963.
95p. 150 plates.

1400. Boyko, Szymon. New graphic design in revolutionary Russia. N.Y.,
Praeger, 1972. 156p. illus.

1401. Born, Wolfgang. "Moderne russische Graphik." Die graphischen
Kunste 55:1-21. 1932.

1402. Chanashian, Mesrop. Armenian miniature paintings of the monas-
tic library at San Lazzaro. English version of the text by Bernard
Grebanier. Venice, 1966- colored plates.

1403. Der Nersessian, Sirarpie. "Armenian manuscripts." Apollo, n.s.
100:360-67, Nov. 1974.

1404. _____. Armenian manuscripts in the Walters Art Gallery.
Baltimore, Trustees of the Walters Art Gallery, 1973. 111p. 243p. of
illus. 8 colored plates.

1405. Dresden. Staatliches Kunferstich-Kabinett. 150 Jahre russische
Graphik, 1813-1963. Katalog einer Berlin Privatsammlung. Dresden, 1964.
324p. illus. 96 plates.

1406. Duchartre, Pierre L. L'imagerie populaire russe et les livrets
graves, 1629-1885. Paris, Grund, 1961. 187p.

1407. Durnovo, Lidiia A. Armenian miniatures. Text and notes by Lydia
A. Durnovo. Preface by Sirarpie Der Nersessian. London, Thames and
Hudson, 1961. 181p. illus. colored plates.

1408. Georgievsky, Grigory. Old Russian miniatures . Moscow, Academia,
1934. 42p. 100 colored plates.

1409. Gourfinkel, Nina. "L'ornementation teratologique des manuscrits
russes." Bibliophile 3:140-47. 1933.

1410. Javurek, Josef. "Sowjetische Buchgraphik 1917-1937."
Marginalien no. 29:53-72, Apr. 1968.

1411. Klepikov, S. A. "Russian blockbooks of the seventeenth and
eighteenth centuries." Papers of the Bibliographical Society of America
65:213-24, third quarter, 1971.

1412. Korostin, A. F. Lithography in Russia (1816-1818). Moscow, 1943.
148p. (In Russian.)

1413. _____. Russian lithography in the nineteenth century. Moscow,
1953. 183p. (In Russian.)

1414. Lebedev, Georgy E. Russkaya kniznaja illustracija 19. Moscow,
1952. 209p. illus.

1415. Macler, Frederic. L'enlumineure armenienne profane. Paris,
P. Geuthner, 1928. 42p. illus. 93 plates.

1416. Miniatures arméniennes. Bibliothèque des Pères Mekhitharistes de
Saint-Lazare. Venice, 1966- colored plates.

1417. Osiakovski, S. "Graphic arts in Soviet Russia." Studio 109:
118-37, Mar. 1935.

1418. Pakhomov, Viktor V. Knizhnoye iskusstvo. Moscow, 1961-62.
2 vols. illus. facs.

1419. Podobedova, Ol'ga I. O privode knizhnoi illjustratsii. Moscow,
Sov. Hudoznik, 1973. 336p. illus.

1420. Radlov, Nikolai E. Der moderne Buchschmuck in Russland.
St. Petersburg, 1914. 111p. illus. plates.

1421. Romanczuk, A. "Ukrainische graphische Kunst." Maso finiguerra
3, no. 2:183-202. 1938.

1422. Rothemund, Herbert J. Russische Holzschnitte. Munich, 1956.
20p. illus.

1423. Rovinskii, Dmitrii A. Russian engravers and their productions
1564 to the establishment of the Academy of Fine Arts; a survey.
Ed. by Count Uvarov. Moscow, 1870. 403p. atlas (73 illus.).

1424. Sakisian, Arménag. "Thèmes et motifs d'enluminure et de décora-
tion arméniennes et musulmanes." Ars islamica 6:66-87. 1939.

1425. Schmidt, Werner. Russische Graphik des xix und xx Jahrhunderts.
Eine Berliner Privatsammlung. Leipzig, 1967. 476p. illus.

1426. Sidorov, Aleksei A. Drevnerusskaya knizhnaya gravyura. Moscow,
1951. 392p. illus.

1427. _____. Istoriya aformleniya russkoi knigi. 2d ed. Moscow,
1964. illus.

1428. _____. Russkaya grafika nachala xx veka. Moscow, 1969. 250p.
illus.

1429. Simon, Howard. "Modern Russia." (In 500 years of art in illus-
tration. Cleveland, World Publishing Co., 1942. p.279-97.)

1430. Solovev, N. "L'illustration du livre russe au xviiie siècle."
(Text in Russian.) Starye gody 3:415-38. 1907.

1431. _____. "Russkaia knishnaia illustratsiia xvii vieka."
Starye gody 3:415-38, July-Dec. 1907.

1432. Sovetskaya grafika (1917-1957). With an introduction by G.
Demosfenova. Moscow, 1957. 14p. 181 plates.

1433. Stasov, Vladimir V. L'ornement slave et oriental d'après les
manuscrits anciens et modernes. St. Petersburg, 1887. 78p. 156 colored
plates.

1434. Svirin, Aleksei. La miniature dans l'ancienne Arménie. Moscow, 1939. 144p. illus. facs. plates.

1435. Tugenhold, I. "Die Kunst des Buchgewerbes in der Sowjetunion." Buch und schrift no. 7-8:83-89 and plates. 1933-34.

1436. _____. "L'illustration russe." L'art décoratif 28:125-44, Sept. 1912.

1437. Vysheslavtsev, N. "Knishnaia illustratsia." (In Iskuestvo 4, pt. 2:86-119. 1936.)

1438. Weitzmann, Kurt. Die armenische Buchmalerei des 10 und beginnenden 11 Jahrhunderts. Bamberg [J. M. Reindl] 1933. 25p. 17 plates.

Spain

1439. Ainaud, Juan. "Grabado." (In Ars Hispaniae. Madrid, Editorial Plus-Ultra, 1962. vol. 18, p.245-320.)

1440. Bohigas Balaguer, Pedro. La ilustración y la decoración del libro manuscrito en Cataluña. Barcelona, Asociacion de Bibliogilos de Barcelona, 1960-67. 2 vols in 3. facs.

1441. Brussels. Bibliothèque Royale de Belgique. Miniatures espagnoles et flamandes dans les collections d'Espagne. [Exposition Avril-Mai 1964.] Brussels, 1964. 99p. plates.

1442. Chambers, Marlene. "Early printing and book illustration in Spain." Library chronicle of the University of Pennsylvania 30:3-17. 1973.

1443. Dodwell, Charles R. "Spain: manuscript painting." (In Painting in Europe 800 to 1200. Baltimore, Penguin Books, 1971. p.96-117.)

1444. Domínguez Bordona, Jesús. El arte de la miniatura española. Editorial Plutarco, 1932. 24p. 24 plates.

1445. _____. "Diccionario de iluminadores españoles." Boletin de la Real Academia de la Historia (Madrid) 140:49-170. 1957.

1446. _____. "La miniatura." (In Ars Hispaniae. Madrid, Editorial Plus-Ultra, 1962. vol. 18, p.17-242.)

1447. _____. La miniatura española. Florence, Pantheon, 1930. 2 vols. 160 plates.

1448. _____. Manuscritos con pinturas. Notas para un inventorio de los conservados en colecciones públicas y particulares en España. Madrid, 1933. 2 vols. facs.

1449. _____. Spanish illumination. N.Y., Harcourt, 1930. 2 vols.

1450. Durrieu, Paul. Manuscrits d'Espagne remarquables par leur
peintures ou par la beauté de leur exécution. Nogent-le-Rotrou, Impr.
de Daupeley-Gouverneur, 1893. 78p. (Extrait de la Bibliothèque de
l'Ecole des Chartes, vol. 54. 1893.)

1451. García de la Fuente, Arturo. La miniatura española primitiva
siglo viii-xi. Madrid, 1936. 152p. illus.

1452. Garcia Villada, Z. "La ornamentation de los códices españoles."
Razón y Fe 63:328-35. 1923.

1453. Guilmain, Jacques. "Interlace decoration and the influence of
the North on mozaribic illumination." Art bulletin 42:211-18, Sept.
1960.

1454. Huntington, Archer M. Initials and miniatures of the ixth, xth,
and xith centuries from the mozarabic manuscripts of Santo Domingo de
Silos in the British Museum. N.Y., De Vinne Press, 1904. 56 leaves.
illus. 46 colored plates.

1455. Kraus, H. P. (firm). Portugal and Spain. 68p. (catalog 112.)

1456. Kurz, Martin. Handbuch der iberischen Bildrucke des xv Jahr-
hunderts. Leipzig, Hiersemann, 1931. 250p.

1457. Lyell, James P. Early book illustration in Spain. London,
Grafton, 1926. 331p.

1458. Manent, Maria. "A survey of the making of books in recent years:
Spain." Dolphin, no. 1:314-25. 1933.

1459. Montanes Fontenla, L. "Illustradores españoles contemporáneos."
Bibliographia Hispanica 7:123-44, 226-47, 325-37. 1947.

1460. Neuss, Wilhelm. Die Apokalypse des hl. Johannes in der
altspanischen und altchristlichen Bibel-Illustration. Munster, 1931.
2 vols.

1461. _____. Die katalanische Bibel-Illustration um die Wende des
ersten Jahrtausends und die altspanische Buchmalerei. Bonn, 1922.
156p. 64 plates.

1462. Pennell, Joseph. "Pen drawing of today--Spanish and Italian
work." (In Pen drawing and draughtsmen. London, Macmillan, 1889.
p.25-60.)

1463. Perrera, A. "Miniaturas y miniaturistas españoles." Arte español,
4th quarter, 1942, p.6-12.

1464. Rico y Sinobas, Manuel. El arte del libro en España. Madrid,
Editorial Escelicer, 1941. 500p.

1465. Sierra Corella, Antonio. "El libro ilustrado en España."
Sociedad de amigos del arte. Revista española de arte 3:83-89, June
1934.

1466. Spaulding, Frances. Mudejar ornament in manuscripts. N.Y.
[Hispanic Society of America] 1953. 58p. illus. facs.

1467. Thomas, Henry. "Copperplate engravings in early Spanish books."
Library, 4th series 21:109-42, Sept. 1940.

1468. _____. Spanish sixteenth-century printing. London, E. Benn,
1926. 38p. 50 facs.

1469. Williams, John. Early Spanish manuscript illumination. N.Y.,
Braziller, 1977. 117p. illus. colored plates.

Sweden

1470. Bjurström, Per. Svenska illustratörer. Solna, Seelig, 1972.
95p. illus.

1471. Brunius, August. "The art of the book in Sweden." (In Holme,
Charles, ed. The art of the book. London, Studio, 1914. p.243-58.)

1472. Dal, Erik. Scandinavian bookmaking in the twentieth century.
Urbana, Univ. of Illinois Press, 1968. 134p.

1473. Fischerström, Karl P. Bokens konstnärer. Tolv svenska bokillus-
tratörer presenteras av I. W. Fischerström. Stockholm, 1950. 121p.
illus.

1474. Hoppe, Ragmar and Jungmarker, Gunnar. Svart och vitt; svenska
grafiker och technare under 1900 talet. Stockholm, L. Hökerberg, 1947.
107, 20p. 200 plates.

1475. Hultmark, Emil. Svenska kopparstickere och etsare 1500-1944.
Ed. by Carna Hultmark and Carl D. Moselius. Uppsala, Almqvist and
Wiksell, 1944. 391p.

1476. Kumlien, Akke. "A survey of the making of books in recent years:
Scandinavia." Dolphin no. 1:301-13. 1933.

1477. Lagerström, Hugo. Svensk bokkonst. Stockholm, Bröderna Lager-
ström, 1920. 177p. illus.

1478. Möller, Bert N. Svensk bokhistoria. Stockholm, Norstedt, 1931.
227p.

1479. Olingdahl, Gote. Svenka Bibelillustrationer. Lund, Gleerup
(distributor), 1966. 42p.

1480. Salaman, Malcolm C. "The woodcut in Sweden and Norway." (In
The woodcut of today at home and abroad. Ed. by G. Holme. London,
Studio, 1927. p.114-20.)

1481. Svenska Institutet für Kulturellt Utbyte met Utlandet, Stockholm.
Graphic art in Sweden. Stockholm, 1946. 50p. illus. (exhibit
catalog.)

1482. Svensson, Georg V. Modern svensk bokkonst. Stockholm, Sällkapet
Bokvanerna, 1953. 253p. illus.

1483. Wellergren, Erik. "Modern Swedish book production." Penrose
annual 26:49-52. 1924.

Switzerland

1483a. Avermaete, Roger. "La gravure sur bois en Suisse." (In La
gravure sur bois moderne de l'Occident. Vaduz, Quarto Press, 1977c1928.
p.209-20.)

1484. Baud-Bovy, Daniel. Les maîtres de la gravure suisse. Geneva,
A. Julien, 1935. 204p. 51 plates.

1485. Ganz, Paul. Geschichte der Kunst in der Schweiz von den Anfängen
bis zur Mitte des 17. Jahrhunderts. Basel, B. Schwabe, 1960. 646p.
plates.

1486. _____. La peinture suisse avant la Renaissance. Tr. from the
German by Paul Budry. Paris, J. Budry, 1925. 156p. illus. 120 plates.

1487. Lanckorońska, Maria and Oehler, R. Die Buchillustration des xviii
Jahrhunderts in Deutschland, Österreich und der Schweiz. Leipzig,
Insel-Verlag, 1932-34. 3 vols.

1488. Lonchamp, Frédéric C. L'estampe et le livre à gravures (un siècle
d'art suisse 1730-1830). Lausanne, 1920. 100p.

1489. _____. Manuel du bibliophile suisse. Paris, Librairie des
Bibliophiles, 1922. 440p.

1490. Tiessen, Wolfgang, ed. Die Buchillustration in Deutschland,
Oesterreich und der Schweiz seit 1945. Neu-Isenburg, Verlag der
Buchhandlung W. Tiessen, 1968. 2 vols.

Thailand

1491. Boisselier, Jean. Thai painting. Tokyo, Kodansha, 1976. 270p.

1492. Wenk, Klaus. Thai-Handschriften. Verzeichnis der orientalischen
Handschriften in Deutschland, vol. 9, no. 1. Wiesbaden, 1963. 88p.
plates.

1493. _____. Thailändische Miniaturmalereien. Verzeichnis der
orientalischen Handschriften in Deutschland, supplement vol. 3.
Wiesbaden, F. Steiner, 1965. 116p. 24 reproductions in color.

Turkey

1494. And, Metin. Turkish miniature painting; the Ottoman period;
thirty nine miniatures in full colour. Ankara, Dost Yaymlari, 1974.
118p.

1495. Aslanapa, Oktay. "Turkish miniature painting." (In Turkish art and architecture. N.Y., Praeger, 1971. p.308-22.)

1496. Boston Museum of Fine Arts. Les miniatures orientales de la collection Goloubow au Museum of Fine Arts. By A. K. Coomaraswamy. Paris, G. Van Oest, 1929. 111p. 88 plates.

1497. Dublin. Chester Beatty Library. The Chester Beatty Library; a catalog of the Turkish manuscripts and miniatures. By V. Minorsky. Dublin, 1958. 145p. 42 plates.

1498. Esin, Emel T. Turkish miniature painting. Tokyo, Charles E. Tuttle, 1960. 32p.

1499. Ettinghausen, Richard, ed. Turkey: ancient miniatures. N.Y., N.Y. Graphic Society by arrangement with Unesco, 1961. 26p. 32 plates. (Unesco world art series.)

1500. _____ . Turkish miniatures from the thirteenth to the eighteenth century. N.Y., New American Library by arrangement with Unesco, 1965. 24p. 28 colored plates.

1500a. Lillys, William et al. Oriental miniatures: Persian, Indian, Turkish. Ed. with introduction and notes by William Lillys, Robert Reiff, and Emel Esin. Rutland, Vt., Charles E. Tuttle, 1965. 102p. illus.

1501. Martin, Frederik R. The miniature painting and painters of Persia, India, and Turkey from the 8th to the 18th century. London, Holland Press, 1971c1972. 156p. 271 plates.

1502. Meredith-Owens, G. M. Turkish miniatures. London, British Museum, 1963. 32p. and 25 plates.

1503. Sotheby and Co. Catalogue of Persian, Turkish and Arabic manuscripts, Indian and Persian miniatures from the celebrated collection formed by Sir Thomas Phillipps (1792-1872). 1968. 148p. 55 plates.

1504. Stchoukine, Ivan V. La peinture turque d'après les manuscrits illustrés. Paris, P. Geuthner, 1966-

1505. Yetkin, Suut K. L'ancienne peinture turque du xiie au xviiie siècle. Paris, Editions Klincksieck, 1970. 61p. plates.

The United States

REFERENCE WORKS

1506. Bolton, Theodore. American book illustrators; bibliographic checklists of 123 artists. N.Y., Bowker, 1938. 290p.

1507. Dykes, Jefferson C. Fifty great western illustrators; a bibliographic checklist. Flagstaff, Ariz., Northland Press, 1975. 457p.

1508. Fielding, Mantle. American engravers upon copper and steel; biographical sketches and checklists of engravings. Phila., 1917. 365p. illus.

1509. _____. Dictionary of American painters, sculptors, and engravers. Phila., 1926. 433p.

1510. Levis, Howard C. A bibliography of American books relating to prints and the art and history of engraving. London, Chiswick Press, 1910. 79p.

1511. McKay, George L. A register of artists, engravers, booksellers, bookbinders, printers and publishers in New York City 1633-1820. N.Y., New York Public Library, 1942. 78p.

 A reprint with additions from the New York Public Library bulletin of 1939-41.

1512. New York Historical Society. Dictionary of artists in America 1564-1860. By George C. Groce and David H. Wallace. New Haven, Yale Univ. Press, 1957. 759p.

1513. Princeton University Library. Early American book illustrators and wood engravers 1670-1870. Princeton, N.J., Princeton Univ. Press, 1968. 265p. Supplement, 1968. 178p.

1514. Reilly, Elizabeth C. A dictionary of colonial American printers' ornaments and illustrations. Worcester, American Antiquarian Society, 1976. 514p.

1515. Smith, Ralph C. A biographical index of American artists. Baltimore, Williams and Wilkins, 1930. 102p.

1516. Stauffer, David M. American engravers upon copper and steel. N.Y., Grolier Club, 1907. 2 vols. illus.

1517. Stokes, I. N. Phelps. One hundred notable American engravers, 1683-1850; annotated list of prints. N.Y., N.Y. Public Library, 1928. (Reprint from the Bulletin of the N.Y. Public Library 32:139-74, Mar. 1928.)

1518. Walpole Society (U.S.). Prints pertaining to America; a list of publications in English ... with emphasis on the period 1650-1850 and a checklist of prints in an exhibition to commenorate the 1962 fall meeting of the Walpole Society from the collection of the Henry Francis Du Pont Winterthur Museum. Portland, Maine, Walpole Society, 1963. 99p.

1519. Who's who in American art, vol. 1, 1936/37- Bowker, 1935-

HISTORY OF METHODS OF ILLUSTRATION IN THE UNITED STATES

Wood and Metal Engraving

1520. Baker, William S. American engravers and their work. Phila., Gebbie and Barrie, 1875. 184p.

1521. Contemporary American etching. With an introduction by Ralph
Flint. N.Y., American Art Dealers Association, 1930. 100 plates.

1522. Dreppard, Carl W. "Golden age of American engraving." (In Early
American prints. N.Y., Century, 1930. p.83-123.)

1523. Dunlap, William. "Engraving." (In A history of the rise and
progress of the arts of design in the United States. new ed. Boston,
C. E. Goodspeed, 1918. vol. 1, p.170-89.)

1524. Griffin, Gillett G. "The development of woodcut printing in
America." Princeton University Library chronicle 20:7-17, Aug. 1958.

1525. Heintzelman, Arthur W. "Modern wood-engraving in America."
Boston Public Library quarterly 12:57-63, Jan. 1960.

1526. Hitchings, Sinclair. "Some American wood engravers 1820-1840."
Printing and graphic arts 9:121-38, Dec. 1961.

1527. Hitchcock, Ripley. Etching in America. N.Y., White, Stokes and
Allen, 1886. 95p.

1528. Laver, James. A history of British and American etching. London,
Benn, 1929. 195p.

1529. Linton, William J. The history of wood engraving in America.
Boston, Estes and Lauriat, 1882. 71p.

1530. _____. American wood engraving; a Victorian history with new
index, bibliography and introduction by N. C. Schrock. Watkins Glen,
N.Y., American Life Foundation and Study Institute, 1976. 71p. plates.

1531. Wood engravings; three essays by A. V. S. Anthony, Timothy Cole
and Elbridge Kingsley, with a list of American books illustrated with
woodcuts. N.Y., Grolier Club, 1916. 84p.

1532. Wray, Henry R. A review of etching in the United States. Phila.,
R. C. Pengield, 1893. 91p.

 Contains a section on the formation of etching societies
 and clubs, p.67-91.

1533. Wroth, Lawrence C. and Adams, Marion W. American woodcuts and
engravings, 1670-1800. Providence, R.I., Associates of John Carter
Brown Library, 1946. 44p. facs.

Lithography

1534. Carey, John T. "The American lithograph from its inception to
1865 with biographical considerations of twenty lithographers and a
checklist of their works." Ph.D. dissertation, Ohio State Univ., 1954.
466p.

1535. Comstock, Helen. American lithographs of the nineteenth century.
N.Y., Barrows, 1950. 170p. 75 illus.

1536. Dreppard, Carl W. "Beginnings of American lithography." (In Early American prints. N.Y., Century, 1930. p.124-44.)

1537. Marzio, Peter C. "American lithographic technology before the Civil War." (In Prints in and of America to 1850. Report of the Winterthur Conference 1970. Ed. by John D. Morse. Charlottesville, Univ. Press of Va., 1970. p.215-56.)

1538. Peters, Harry T. America on stone; the other printmakers to the American people. Garden City, N.Y., Doubleday, Doran, 1931. 415p. illus. 136 black and white plates. 18 colored plates.

1539. Taylor, Charles H. "Some notes on early American lithography." Proceedings of the American Antiquarian Society, n.s. 32:68-80. 1922.

1540. Weber, Wilhelm. "Lithography in Britain and America after 1900." (In History of lithography. London, Thames and Hudson, 1966. p.133-36.)

Other Methods

1541. Albert, Karl. "The history of rotogravure in America." Penrose annual 33:162-63. 1931.

1542. Cartwright, Herbert M. and MacKay, Robert. Rotogravure; a survey of European and American methods. Lyndon, Ky., MacKay Publishing Co., 1956. 303p.

1543. Jussim, Estelle. "Photographic technology and visual communication in the 19th century American book." D.L.S. dissertation, Columbia Univ., 1970.

1544. Mixon, Muriel W. "Development of photographic reproduction techniques and their application to American magazine and book illustration during the years 1850-1890." M.A. thesis, Univ. of Minnesota, 1961. 103p.

GENERAL WORKS

1545. Meyer, Susan E. America's great illustrators. N.Y., Abrams, 1978. 311p. illus. plates.

1546. Murrell, William. A history of American graphic humor. N.Y., Whitney Museum of American Art, 1933-38. 2 vols.

1547. Museum of Graphic Art. American printmaking the first 150 years. Catalogue and commentary by Wendy J. Shadwell. Published for the Museum of Graphic Art by the Smithsonian Institution Press, Washington, D.C., 1969. 54p. plus 115 plates.

1548. Neuhaus, Eugen. "The illustrators." (In The history and ideals of American art. Stanford, Stanford Univ. Press, 1931. p.413-19.)

1549. Pitz, Henry C. A treasury of American book illustration. N.Y., American Studio Books and Watson-Guptill Publishers, 1947. 128p.

1550. Pitz, Henry C. <u>200 years of American illustration</u>. N.Y., Random House, 1977. 436p. plates.

1551. Richardson, Edgar P. [Book illustration] (In <u>A short history of painting in America</u>. N.Y., Crowell, 1963. p.137-39, 176-78, 244-45, 257-58.)

1552. Simon, Howard. "The United States." (In <u>500 years of art in illustration</u>. Cleveland, World Publishing Co., 1942. p.392-463.)

1553. Skidmore, Maria E. "The American emblem book and its symbolism." Ph.D. dissertation, Ohio State Univ., 1947. 339p.

1554. Smith, Francis H. <u>American illustrators</u>. N.Y., Scribner, 1892. 68p.

1555. Weitenkampf, Frank. <u>American graphic art</u>. new ed. rev. and enlarged. N.Y., Macmillan, 1924. 328p.

EARLY HISTORY TO 1800

1556. Boston, Museum of Fine Arts. <u>Descriptive catalog of an exhibition of early engraving in America, Dec. 12, 1904-Feb. 5, 1905</u>. Cambridge, University Press, 1904. 151p.

1557. _____. <u>New England miniature 1750 to 1850</u>. [Exhibition] April 24 to May 28, 1957, sponsored by the National Society of Colonial Dames. Boston, 1957.

 Contains "The art of miniature painting in New England" by Barbara N. Parker.

1558. Dolmetsch, Joan. "Prints in colonial America: supply and demand in the mid-eighteenth century." (In <u>Prints in and of America to 1850. Winterthur Conference report 1970</u>. Ed. by John D. Morse. Charlottesville, Univ. Press of Va., 1970. p.53-74.)

1559. Dow, George F. "Painting and engraving." (In <u>The arts and crafts in New England 1704-1775; gleanings from Boston newspapers</u>. Topsfield, Mass., Wayside Press, 1927. p.1-40.)

1560. Dreppard, Carl W. "Book and magazine illustrations." (In <u>Early American prints</u>. N.Y., Century, 1930. p.174-99.)

1561. Glaser, Lynn. <u>Engraved America; iconography of America through 1800</u>. Phila., Ancient Orb Press, 1970. 76p. 221 plates.

1562. Goff, Frederick R. "Rubrication in American books of the eighteenth century." <u>Proceedings of the American Antiquarian Society</u> 79:29-43. 1969.

1563. Green, Samuel M. "An introduction to the history of American illustration from its beginning in the late 17th century until 1850." Ph.D. dissertation, Harvard Univ., 1944.

1564. Grolier Club, N.Y. Catalogue of an exhibition of early American engraving upon copper 1727-1850 with 296 examples by 147 different engravers. N.Y., De Vinne Press, 1908. 100p.

1565. Hamilton, Sinclair. "Early American book illustration." (In Princeton University Library. Early American book illustrators and wood engravers 1670-1870. Princeton, Princeton Univ. Press, 1958. p.xxiii-xlviii.)

> Reprinted with substantial revisions from the Princeton University Library chronicle 6:101-26, Apr. 1945.

1566. Haugh, G. C. "The beginning of American book illustration." (In Book illustration; papers presented at the third rare book conference of the American Library Association in 1962. Ed. by Frances J. Brewer. Berlin, Gebr Mann Verlag, 1963. p.34-44.)

1567. Henke, Frances S. "Evolution of book illustration in America 1639-1800." Master's thesis, Univ. of Chicago, 1937. 202p.

1568. Hitchings, Sinclair H. "The graphic arts in colonial New England." (In Prints in and of America to 1850. Winterthur Conference report 1970. Ed. by John D. Morse. Charlottesville, Univ. Press of Va., 1970. p.75-110.)

1569. Holman, Richard B. "Seventeenth century American prints." (In Prints in and of America to 1850. Winterthur Conference report 1970. Ed. by John D. Morse. Charlottesville, Univ. Press of Va., 1970. p.23-52.)

1570. Karshan, Donald H. "American printmaking, 1670-1968." Art in America 56:22-55, July-Aug. 1968.

1571. Parker, Barbara N. "The art of miniature painting in New England." (In Boston Museum of Fine Arts. New England miniature, 1750 to 1850. Boston, 1957. p.8-18.)

1572. Princeton University Library. Early American book illustrators and wood engravers 1670-1870. Princeton, Princeton Univ. Press, 1958. 265p. Supplement, 1968. 178p.

1573. Stoddard, Roger E. "List of American dramatic illustrations 1776-1800." Proceedings of the American Antiquarian Society 81:184-87. 1971.

1574. Tebbel, John W. "Book illustration." (In A history of book publishing in the United States. N.Y., Bowker, 1972. vol. 1, p.170-75.)

1575. Wood, Charles B. "Prints and scientific illustration in America." (In Prints in and of America to 1850. Winterthur Conference report 1970. Ed. by John D. Morse. Charlottesville, Univ. Press of Va., 1970. p.161-92.)

1576. Wroth, Lawrence C. and Silver, Rollo G. "Book illustration." (In Lehmann-Haupt, Hellmut et al. The book in America. 2d ed. N.Y., Bowker, 1951. p.90-93.)

1577. Zigrosser, Carl. "Graphic arts of the eighteenth and nineteenth centuries." (In Pierson, William and Davidson, Martha. Arts of the United States. N.Y., McGraw-Hill, 1960. p.50-56.)

19th CENTURY

1578. American printmaking before 1876; fact, fiction, and fantasy; papers presented at a symposium held at the Library of Congress., June 12 and 13, 1972. Washington, D.C., 1972. 79p. illus.

1579. Bender, H. S. "Illuminated manuscripts among the Pennsylvania Mennonites." (In Mennonite encyclopedia. vol. 3, p.11-12. 1957.)

1580. Bennett, Whitman. A practical guide to American nineteenth century color plate books. N.Y., Bennett Book Studios, 1949. 132p.

1581. Borneman, Henry S. Pennsylvania German illuminated manuscripts; a classification of fraktur-schriften and an enquiry into their history and art. N.Y., Dover, 1975. 50p. 32p. of illus.

 A corrected republication of the work originally published in 1967 by the Pennsylvania German Society as vol. 46 of its proceedings and papers.

1582. Boston Museum of Fine Arts. The artist and the book 1860-1960 in western Europe and the United States. 2d ed. Boston, 1972. 232p.

 The catalog was prepared by Eleanor M. Garvey. An excerpt from Philip Hofer's introduction to the 1961 edition is in Publishers' weekly 180:88-92, July 10, 1961.

1583. Coffin, William A. "American illustration of today." Scribner's magazine 11:106-17, 134, 196-205, 266, 333-49, Jan.-Mar. 1892.

1584. Collier, Margaret S. "Art nourveau book design in America." Master's thesis, Univ. of North Carolina, 1968. 59p.

1585. Davison, Nancy R. American sheet music illustration; reflections of the nineteenth century; a guide to an exhibition in the Museum of Art, University of Michigan, Oct. 12-Nov. 18. Ann Arbor, Mich., William L. Clements Library, 1973. 24p.

1586. Delaware Art Museum, Wilmington. The golden age of American illustration: 1880-1914. Catalog of the exhibition Sept. 13-Oct. 15, 1972. Wilmington, 1972. 67p. illus.

1587. Eberlein, Harold and Hubbard, Cortlandt Van D. "Fractur painting in Pennsylvania." American German review 3:11-15, Sept. 1936.

1588. Edye, M. Louise. Pennsylvania German illuminated manuscripts. Plymouth Meeting, Pa., Mrs. C. N. Keyser, 1944? 24p. illus. (Home craft course, vol. 7.)

1589. Ferber, Linda S. "American illustration 1850-1920." (In Brooklyn Institute of Arts and Science Museum. A century of American illustration. Brooklyn, 1972. p.13-78. plates.)

1590. Gambee, Budd L. "American book and magazine illustration of the late nineteenth century." (In Book illustration; papers presented at the third rare book conference of the American Library Association in 1962. Ed. by Frances J. Brewer. Berlin, Gebr. Mann Verlag, 1963. p.45-55.)

1591. Green, Samuel M. "The graphic arts." (In American art; a historical survey. N.Y., Ronald Press, 1966. p.102-02, 172, 283-85, 419-23, 613-20.)

1592. _____. "An introduction to the history of American illustration from its beginning in the late 17th century until 1850." Ph.D. dissertation, Harvard Univ., 1944.

1593. Hoeber, Arthur. "A century of American illustration." Bookman 8:213-19, 316-24, 429-39, 506, 540-48, Nov. 1898-Feb. 1899.

1594. Hornung, Clarence P. and Johnson, Fridolf. 200 years of American graphic art; a retrospective survey of the printing arts and advertising since the colonial period. N.Y., G. Braziller, 1976. 211p. illus.

1595. Karshan, Donald H. "American printmaking 1670-1968." Art in America 56:22-55, July-Aug. 1968.

1596. Lawall, David B. "American painters as book illustrators 1810-1870." Princeton University Library chronicle 20:18-28, Autumn 1958.

1597. Lovejoy, David S. "American painting in early nineteenth century gift books." American quarterly 7:345-61, Winter 1955.

1598. McGrath, Daniel F. "American color-plate books 1800-1900." Ph.D. dissertation, University of Michigan, 1966. 237p.

1599. Mercer, Henry C. The survival of the medieval art of illuminative writing among Pennsylvania Germans. Phila., 1897. p.423-32. illus. 3 plates.

 Reprint from the Proceedings of the American Philosophical Society, vol. 36, no. 156.

1600. Nash, Ray. "Ornamented types in America." (In Gray, Nicolete. Nineteenth century ornamented typefaces. London, Faber and Faber, 1976. p.115-32. illus.)

1601. Nichols, Frederick D. "The illustration of school books." Printing art 6:141-52, Nov. 1905.

1602. Pennell, Joseph. "Pen drawing in America." (In Pen drawing and pen draughtsmen. London, Macmillan, 1889. p.193-232.)

1603. Princeton University Library. Early American book illustrators and wood engravers 1670-1870. Princeton, Princeton Univ. Press, 1958. 265p. Supplement 1968. 178p.

1604. Rowland, Benjamin. "Popular romanticism: art and the gift books." Art quarterly 20:364-81, Winter 1957. illus.

1605. Shelley, Donald A. The fraktur-writings or illuminated manu-
scripts of the Pennsylvania Germans. Allentown, Pennsylvania Folklore
Society, 1961. 375p.

1606. _____. "The Pennsylvania German style of Illumination." Ph.D.
dissertation, New York Univ., 1953. 336p.

1607. Stoudt, John J. "The illuminating art." (In Early Pennsylvania
arts and crafts. N.Y., A. S. Barnes, 1964. p.273-317.)

1608. Taft, Robert. Artists and illustrators of the old west 1850-1900.
N.Y., Scribner, 1953. 400p. plates.

1609. "Textbook illustration." Printing art 4:279-86, Jan. 1905.

1610. Thompson, Susan O. "The arts and crafts book." (In Clark,
Robert J. The arts and crafts movement in America 1876-1916.
Princeton, Distributed by the Princeton Univ. Press, 1972. p. 94-116.)

1611. Thompson, Susan O. American book design and William Morris.
N.Y., Bowker, 1977. 258p. illus.

1612. Weiser, Frederick S. Fraktur; Pennsylvania folk art. [Ephrata,
Pa.] Science Press, 1973. 103p. col. illus.

1613. Weitenkampf, Frank. "American Bible illustration." Boston
Public Library quarterly 10:154-57, July 1958.

1614. Wood, Charles B. "Prints and scientific illustration in America."
(In Prints in and of America to 1850. Winterthur Conference report 1970.
Ed. by John D. Morse. Charlottesville, Univ. Press of Va., 1970.
p.161-92.)

1615. Wood, T. Kenneth. "Medieval art among Pennsylvania Germans."
Antiques 7:263-66, May 1925.

1616. Woodward, David. "The decline of commercial wood-engraving in
nineteenth century America." Journal of the Printing Historical Society,
no. 10:56-82. 1974-75.

20th CENTURY

1617. Avermaete, Roger. "La gravure sur bois dans l'Amérique du Nord."
(In La gravure sur bois moderne de l'Occident. Vaduz, Quarto Press,
1977c1928. p.305-10.)

1618. Aymar, Gordon. "A gauntlet to American illustration."
Advertising arts, July 1932, p. 33-36.

1619. Ballou, Robert O. "The renaissance of the illustrated book."
Publishers' weekly 110:2059-65, Nov. 27, 1926.

1620. Ballou, Robert O. "American book illustration." Publishers'
weekly 111:94-100, Jan. 1, 1927.

1621. Bland, David. "The twentieth century: the United States of
America." (In A history of book illustration. Cleveland, World Pub-
lishing Co., 1958. p.387-401.)

1622. Brooklyn Institute of Arts and Science Museum. Ten years of
American prints 1947-56. By Una E. Johnson. Brooklyn, 1956. 48p.

1623. Boston Museum of Fine Arts. The artist and the book, 1860-1960,
in western Europe and the United States. 2d ed. Boston, 1972. 232p.
illus.

1624. Brown, Robin. "American illustration 1920-1972." (In Brooklyn
Institute of Arts and Science Museum. A century of American illustra-
tion. Brooklyn, 1972. p.79-140. plates.)

1625. Cannon, R. V. "Photo-engraving trends in the United States."
Print in Britain 13:22-24, 27-29, Feb. 1966.

1626. Broad, Harry A. "Contemporary American lithography." Ph.D.
dissertation, Univ. of Michigan, 1946. 852p.

1627. Collier, Margaret S. "Art nouveau book design in America."
M.S.L.S. thesis, Univ. of North Carolina, 1968. 59p.

1628. Daniels, Les. Comix; a history of comic books in America.
London, Wildwood House, 1973. 198p. illus.

1629. Darton, Frederick. Modern book illustration in Great Britain
and America. London, Studio, 1931. 77p.

1630. Delaware Art Museum, Wilmington. The golden age of American
illustration: 1880-1914; catalog of the exhibition Sept. 14-Oct. 15,
1972. Wilmington, 1972. 67p. illus.

1631. Ede, Charles, ed. The art of the book; some record of work
carried out in Europe and the U.S.A. 1939-1950. London, Studio, 1951.
214p.

1632. Guégan, Bertrand. "Le livre d'art aux Etats-Unis." Arts et
métiers graphiques, special no. 26:82-88, Nov. 15, 1931.

1633. Larned, William T. "Some American illustrators of today."
Bookman 44:352-69, Dec. 1916.

1634. Lehmann-Haupt, Hellmut. "A note on American book illustration
since 1860." (In Lehmann-Haupt, Hellmut et al. The book in America.
2d ed. N.Y., Bowker, 1951. p.305-16.)

1635. McLean, Ruari. "The nineteen-twenties in Europe and the U.S.A."
(In Modern book design from William Morris to the present day. London,
Faber and Faber, 1958. p.59-83.)

1636. Nash, Ray. "American book illustration 1945-1955." Gutenberg
Jahrbuch, 1957, p. 286-93.

1637. Orcutt, William D. "The art of the book in America." (In Holme,
Charles, ed. The art of the book. London, Studio, 1914. p.259-76.)

1638. Pennell, Joseph. Adventures of an illustrator. Boston, Little,
Brown, 1925. 372p.

1639. Pitz, Henry C. "American book illustration today." Studio 141:
72-79, Mar. 1951.

1640. _____. "American illustration then and now." American artist
26:51-63, June 1962.

1641. Reed, Walt, ed. The illustrator in America, 1900-1960's. N.Y.,
Reinhold, 1967. 271p.

1642. Reese, Albert. American prize prints of the 20th century. N.Y.,
American Artists Group, 1949. 257p.

1643. Rollins, Carl P. "A survey of the making of books in recent years:
the United States of America." Dolphin no. 1:288-300. 1933.

1643a. Thompson, Susan O. American book design and William Morris.
N.Y., Bowker, 1977. 258p. illus.

1644. Watson, Ernest W. Forty illustrators and how they work. N.Y.,
Watson-Guptill, 1946. 318p.

1645. Weitenkampf, Frank. "American Bible illustration." Boston
Public Library quarterly 10:154-57, July 1958.

1646. _____. "Trend in American book illustration." International
studio 82:199-202, Nov. 1925.

1647. Zigrosser, Carl. "Graphic arts of the twentieth century."
(In Pierson, William and Davidson, Martha. Arts in the United States.
N.Y., McGraw-Hill, 1960. p.57-60.)

Yugoslavia

1648. Folnesics, Hans. Die illuminierten Handschriften in Dalmatien.
Leipzig, 1917. 175p. 150 illus.

1649. Kolarić, Miodrag. The Serbian graphic arts in the 18th century.
(translated title.) 1953. 32p. plates.

1650. Millet, Gabriel. La peinture du moyen âge en Yougoslavie.
Paris, Imprimerie Nationale, 1954-

1651. Radojčić, Svetozar. Stare srpske minijature. Belgrade, Naučna,
1950. 69p. 57 plates.

1652. Rosner, Karl P. Ungarische Buchkunst. The art of the Hungarian
book. Leipzig, Verlagsabteilung des Deutschen Buchgewerbevereins,
1938. 338p. (In German and English.)

1653. Šakota, Mirjana. "Illuminated manuscripts." (In Bihalji-Merin,
Oto, ed. Art treasures of Yugoslavia. N.Y., Abrams, 1969. p.221-36.)

1654. Vasić, Vera. "Portraits and the illustration of the Serbian book 1830-1850." (translated title.) Bibliotekar 17:175-89, May 1965.

Other Countries

1655. Buchthal, Hugo. Miniature painting in the kingdom of Jerusalem with liturgical and paleographical chapters by Frances Wormald. Oxford, Clarendon Press, 1957. 163p.

1656. Eckardt, Andreas. "Illumination and wood engraving." (In A history of Korean art. Tr. by J. M. Kindersley. London, E. Goldston, 1929. p.150-52. plates.)

1657. Esin, Emel. "Central Asia [Iranian Tokharian, Tibetan, Nepalese, Turkish, Si-Hia, Mongolian, Manchu written records]." (In Vervliet, Hendrik, D. L., ed. The book through five thousand years. London, Phaidon, 1972. p.84-96.)

1658. Gaur, Albertine. "Manuscripts of India, Ceylon, and Southeast Asia." (In Vervliet, Hendrik D. L., ed. The book through five thousand years. London, Phaidon, 1972. p.140-64.)

1659. Hambis, Louis. "Manichaean art: paintings on paper and miniatures." (In Encyclopedia of world art. N.Y., McGraw-Hill, 1964. vol. 9, columns 439-43. plates 281-87.)

1660. Ipsiroglu, Mazhar S. Malerei der Mongolen. Munich, Hirmer, 1965. 106p. 54 illus. and maps.

1661. Jaramillo, Gabriel G. El grabado en Colombia. Bogota, Editorial ABC, 1959. 224p. illus.

1662. Le Coq, Albert von. Buddhistische spätantike in Mittelasien, II: die Manichäische Miniaturen. Berlin, D. Reimer, 1923.

1663. "Libros ilustrados." (In Gran enciclopedia Argentina. 2d ed. 1966. vol. 4. unpaged. (The article is two pages in length.)

1664. Lindsay, Lionel. "Etching in Australia." Print collector's quarterly 11:293-318, Oct. 1924.

1665. Oxford University. Bodleian Library. Mughal miniatures of the earlier periods. Oxford, 1953. 8p. 24 plates. (Bodleian picture book, no. 9.)

1666. Pigeaud, Theodore G. "Illustrations." (In Literature of Java. vol. 3: Illustrations and facsimiles of manuscripts, maps, addenda and a general index of names and subjects. The Hague, M. Nijhoff, 1967. p.39-52.)

1667. Plá, Josefina. El grabado en Paraguay. [Asuncion.] Alcor. [1962.] 39p. illus.

1668. Racoveanu, George. The new Rumanian woodcuts for book illustration [English title] Freising, Freisinger Tagblatt, 1949. 20p. 17 leaves of plates.

1669. Rojax Mix, M. A. La imagen artística de Chile. Santiago de Chile, Editorial Universitaria, 1970. 152p.

1670. Sinclair, Nora. "South African book illustrators of the last two decades." South African libraries 35:77-80, Jan. 1968.

1671. Tomov, Evtim. Bulgarian graphic art: engraving. Tr. by Alexander Rizov. Sofia, Bulgarski Houdozhnik Publishing House, 1956. 75p.

ILLUSTRATION AND DECORATION IN CHILDREN'S BOOKS

Art, Technique, and Principles

1672. Ardizzone, Edward. "Creation of a picture book." Junior bookshelf 25:325-35, Dec. 1961.

1673. Burningham, John. "Drawing for children." Junior bookshelf 28:139-41, July 1964.

1674. Chappell, Warren. "Benchmarks for illustrators of children's books." Horn book 33:413-20, Oct. 1957. Also in Horn book reflections on children's books and reading. Ed. by Elinor W. Field. Boston, Horn Book, 1969. p. 73-77.

1675. Cianciolo, Patricia. "Appraising illustrations in children's books." (In Illustrations in children's books. Dubuque, Ia., W. C. Brown, 1970. p.1-21.)

1676. _____. "Styles of art in children's books." (In Illustrations in children's books. Dubuque, Ia., W. C. Brown, 1970. p.22-41.)

1677. Colby, Jean P. "Illustration and book design." (In The children's book field. N.Y., Pellegrini and Cudahy, 1952. p.71-138.)

1678. _____. Writing, illustrating and editing children's books. N.Y., Hastings House, 1967. 318p.

1679. Cooney, Barbara. "An illustrator's viewpoint." (In Horn book reflections on children's books and reading. Ed. by Elinor W. Field. Boston, Horn Book, 1969. p.82-85.)

1680. Curtis, William J. "An analysis of the relationship of illustration and text in picture-story books as indicated by the oral responses of young children." Ed. D. dissertation, Wayne State Univ., 1968. 163p.

1681. Fletcher, David. "Pictures on paper." Horn book 37:21-25, Feb. 1961.

1682. Halbey, Hans A. "Artistic quality in the children's book." Graphis 20:30-51, 83-84, Jan. 1964.

1683. Holešovský, Frantisek. Tvar a reč ilustrácie pre deti [Form and language in illustration for children]. Bratislava, Mladé Letá, 1971. 195p. illus. plates.

1684. _____. "The function of illustration in children's books." Bookbird no. 1:3-6. 1966.

1685. Holešovský, Frantisek. "On the specific features of illustrations for children." Bookbird 8:56-61, Mar. 1970.

1686. Jacques, Robin. Illustrators at work. London, Studio Books, 1963. 112p.

1687. Johnson, Margaret. "Vitality of picture books." Canadian library 18:14-18, July 1961.

1688. Kingman, Lee. "High art of illustration." Horn book 50:95-103, Oct. 1974.

1689. Klemin, Diana. The art of art for children's books; a contemporary survey. N.Y., C. N. Potter, 1966. 128p.

1690. Lewis, John N. "The illustration and design of children's books." (In The twentieth century book, its illustration and design. N.Y., Reinhold, 1967. p.176-241.)

1691. Lorraine, Walter, ed. "Art of the picture book; symposium." Wilson library bulletin 52:144-73, Oct. 1977.

1692. MacCann, Donnarae. The child, the artist, and the book. Issued on the occasion of an exhibit of contemporary art in children's books at the Library, University of California, Los Angeles: 14 Dec. 1962-14 Jan. 1963. Los Angeles, Plantin Press, 1962. 18p. illus.

1693. _____ and Richard, Olga. Child's first books; a critical study of pictures and texts. N.Y., H. W. Wilson, 1973. 135p. illus.

1694. Mathiesen, Egon. "The artist and the picture book." Horn book 42:93-97, Feb. 1966.

1695. Moore, Annie C. "Illustrating books for children." Bookman 57:73-77, Mar. 1923.

1696. Mosier, Rosalind A. "Modern art in children's book illustration." Library journal 84:3293-95, Oct. 15, 1959.

1697. Olga, Richard. "The visual language of the picture book." Wilson library bulletin 44:435-47, Dec. 1969.

1698. Pitz, Henry C. Illustrating children's books: history, technique, production. N.Y., Watson-Guptill, 1963. 207p.

1699. Rudisill, Mabel. "Children's preferences for color versus other qualities in illustrations." (In Robinson, Evelyn R. Readings about children's literature. N.Y., McKay, 1966. p.205-16.)

1700. Slonska, Irena. Psychologiczne problemy ilustracji dla dzieci [Psychological problems of illustrations for children]. Warsaw, Pantswowe Wydawnictwo Naukowe, 1969. 224p. illus.

1701. Tucker Nicholas. "Looking at pictures." Children's literature in education no. 14:37-51. 1974.

1702. Witty, F. R. "Children's tastes in book illustration." School librarian 7:248-55, Mar. 1955.

1703. Zerfoss, Charlotte. "Picture books; art for young children." Drexel library quarterly 12:12-19, Oct. 1976.

Early History to 1900

1704. Bland, David. "Children's books." (In The illustration of books. 3d ed. London, Faber and Faber, 1962. p.127-36.)

1705. Bonafin, Ottavia. La letteratura per l'infanzia. 11th ed. Brescia, La Scuola, 1962. 214p.

1706. Bravo Villasante, C. "La ilustración de los libros infantiles." Bellas artes 1, no. 2:13-19. 1970.

1707. "Children's book illustration through the ages." Print 18:24-29, Mar. 1964.

1708. Commire, Anne, ed. Yesterday's authors of books for children; facts and pictures about authors and illustrators of books for young people, from early times to 1960. vol. 1, Detroit, Gale Research, 1977. 250p.

1709. Durand, Marion and Bertrand, Gérard. L'image dans le livre pour enfants. Paris, L'Ecole des Loisirs, 1975. 224p. illus.

1710. Ellis, Richard W. "Illustrators in the nursery." (In Targ, William, ed. Bibliophile in the nursery. Cleveland, World Publishing Co., 1957. p.468-87.)

1711. Feaver, William. When we were young: two centuries of children's book illustration. N.Y., Holt, Rinehart and Winston, 1977. 96p. illus.

1712. Gillespie, Margaret C. "Memorable moments in illustrating." (In History and trends. Dubuque, Ia., W. C. Brown, 1970. p.107-14.)

1713. Gottlieb, Gerald. Early children's books and their illustration. N.Y., Pierpont Morgan Library, 1975. 263p. 225 illus. (exhibit catalog.)

 Contains an essay by J. H. Plumb.

1714. Gumachian, MM. et Cie. Les livres d'enfance du xve au xixe siècle. Paris, Gumachian et Cie, 1931. 2 vols. (vol. 2 has plates.)

1715. James, Philip. Children's books of yesterday; choice examples through three centuries. Ed. by C. G. Holme. London, Studio, 1933. 128p.

1716. Levine, Muriel Z. "Historical development of the ABC book." Research paper, Long Island Univ., 1970. 162p.

1717. Luigi, Antonio. Storia della letteratura per l'infanzia. Florence, Sansoni, 1960. 395p.

1718. Meigs, Cornelia et al. A critical history of children's litera-
ture. N.Y., Macmillan, 1953. 624p.

1719. Quayle, Eric. The collector's book of children's books. N.Y.,
C. N. Potter, 1971. 144p.

1720. Santucci, Luigi. La letteratura infantile. 3d ed. Milan,
Fratelli Fabbri, 1961. 478p.

1721. Schatzki, Walter. Old and rare children's books. N.Y., 1941.
46p. 16 plates. (sales catalog no. 1.)

1722. Targ, William, ed. Bibliophile in the nursery; a bookman's
treasury of collectors' lore on old and rare children's books. Cleveland,
World Publishing Co., 1957. 503p. illus.

1723. Toronto Public Libraries. Osborne collection of early children's
books 1566-1910; a catalogue prepared by Boys and Girls House by Judith
St. John. With an introduction by Edgar Johnson. Toronto, 1958. 561p.
illus. plates. facs.

1724. _____. The Osborne collection of early children's books 1476-
1910; a catalogue, vol. 2. Prepared by Judith St. John et al. Toronto,
1975. 1138p.

1725. Tuer, Andrew W. Pages and pictures from forgotten children's
books. London, Leadenhall Press, 1898-99. 510p. 400 illus. plates.
facs.

1726. Turnbull, Margaret. "Illustration in early children's books."
British Columbia library quarterly 25:15-22, July 1961.

1727. Valeri, Mario and Monaci-Guidotti, Enrichetta. Storia della
letteratura per i fanciulli. Bologna, G. Malipiero, 1961. 575p.

1728. Welsh, Charles. On coloured books for children. London, Wyman,
1887. 5-47[11]p.

 Contains a catalog of colored books for children, p.27-47.

1729. Whalley, Joyce I. Cobwebs to catch flies; illustrated book for
nursery and schoolroom, 1700-1900. Berkeley, Univ. of Calif. Press, 1975.
163p. illus. plates.

1730. White, Gleason. Children's books and their illustrators. N.Y.,
J. Lane, 1897. 68p. (Special winter no. of International studio, 1897-
98.)

Twentieth Century

1731. Alderson, Brian W. Looking at children's books, 1973; an exhibi-
tion prepared by Brian Alderson and arranged by the National Book League.
London, National Book League, 1973. 64p. illus.

1732. Bias, Elizabeth B. "The effect of the new techniques in printing and designing on illustration and format of children's books." Master's thesis, Univ. of North Carolina, 1960.

1733. Bienále Ilustrácií Bratislava. La biennale d'illustrations Bratislava, 1967- Bratislava, Polygrafické Zárody, 1967- (A biennial written in Solvak and French.)

1734. Brown, Marcia. "Shifting tides of children's illustration." Publishers' weekly 206:78-79, July 15, 1974.

1735. Children's book illustration. Graphis 27, no. 155. 1971-72. (whole issue.)

1736. Durand, Marion and Bertrand, Gérard. L'image dans le livre pour enfants. Paris, L'Ecole des Loisirs, 1975. 224p. illus.

1737. Evans, Margaret B. "Some problems in modern book illustration." Horn book 22:176-82, May-June 1946.

1738. Freeman, Ruth S. Children's picture books, yesterday and today; an analysis. Watkins Glen, N.Y., Century House, 1967. 200p. illus.

1739. Geist, Hans-Friedrich. "Illustrations for children's books." Graphis 11:408-27. 1965.

1740. Hürlimann, Bettina. "Children's picture books of our day." Graphis 16:282-99, July 1960.

1741. _____ . Die Welt im Bilderbuch; moderne Kinderbilderbücher aus 24 ländern. Angaben von Elizabeth Waldmann. Zurich, Atlantis, 1965. 213p. illus.

 A translation by Brian W. Alderson was published by Oxford University Press in 1968.

1742. Keeping, Charles. "Illustrations in children's books." Children's literature in education no. 1:41-54, Mar. 1970.

1743. MacCann, Donnarae and Richard, Olga. "Outstanding contemporary illustrators." (In The child's first books. N.Y., H. W. Wilson, 1973. p.47-72.)

1744. MacKinstry, Elizabeth. "The illustrations of children's books as a fine art; some of its past and present tendencies." Publishers' weekly 110:1577-84, Oct. 16, 1926.

1745. Newton, Lesley. "Modern trends in book illustration for children." Elementary English review 9:89-94, Apr. 1932.

1746. Petersen, Vera D. "Some graphic processes used in the illustration of contemporary children's books." Ph.D. dissertation, Columbia Univ., 1951. 134p.

1747. Pierpont Morgan Library, N.Y. Children's literature: books and manuscripts; an exhibition, Nov. 19, 1954 through Feb. 28, 1955. N.Y., 1954. 1 vol. unpaged. illus.

1748. Urblikovā, Anna. "Fourth international symposium on illustration." Bookbird 12, no. 1:72-76. 1974.

1749. Ward, Lynd. "The book artist and the twenty-five years." Horn book 25:375-81, Sept. 1949.

1750. Weisgard, Leonard. "Contemporary art and children's book illustration." Horn book 36:155-58, Apr. 1960.

1751. Wills, Franz. "Illustrationen zur biblischen Geschichte." Gebrauchsgraphik 40:28-39, Apr. 1969.

Austria

1752. Bamberger, Richard. Jugendlektüre. 2d ed. Vienna, Verlag für Jugend und Volk, 1965. 848p.

1753. Casper, Franz. "The children's picture book today: Austria." Graphis 27:304-05. 1971-72.

1754. Schwab, Edith. "Beiträge zur Geschichte der Kinder- und Jugendschriftums in Österreich." Dissertation, Univ. of Vienna, 1949. 449p.

1755. Waissenberger, Robert. Buchkunst aus Wien. Vienna, Verlag für Jugend und Volk, 1966. 53p. illus.

Brazil

1756. Amaral, Maria L. Criança e criança; literatura infantil e seus problemas. Petropolis, Vozes, 1971. 118p. illus.

1757. Lourenço Filho, Manuel B. "La literatura infantil en el Brasil." Educacion, April-June 1959, p.25-29.

1758. Werneck, Regina. "Illustration of children's books in Brazil." Bookbird 11, no. 2:64-69. 1973.

Bulgaria

1759. Dimitrov-Rudar et al. Detska literatura. Sofia, Narodna Prosveta, 1964. 368p.

1760. Mikhailova, Ganka. Bulgarska detska literatura. Sofia, Nauka i Izkustvo, 1964. 312p.

China

1761. Ch'ên Po-ch'ui. Êrh t'ung wên hsueh chien lun. Wu-han, Ch'ang-chiang Wên Yi, 1959. 302p.

1762. Mei-lan, Sun. "Illustrations for children's books." Chinese literature no. 6:149-52. 1959.

1763. "Picture books for Chinese children." Intellect 106:357-58, Mar. 1978.

Czechoslovakia

1764. Pospišil, Otakar and Suk, V. F. Dětská literatura česká. Prague, 1924. 308p.

1764a. Roll, Dušan. "Development of children's book illustration in Czechoslovakia." Graphis 27:284-91. 1971-72.

1765. Tenčik, František. Cetba mládeže v počátcích obrozeni. Prague, Státni Nakladatelstvi Dětské Knihy, 1962. 107p.

Denmark

1766. Mollerup, Helga. "Danish children's books before 1900." Junior bookshelf 15:50-56, Mar. 1951.

1767. Simonsen, Inger. Den danske børnebog i det 19 aarhundrede. Copenhagen, Nyt Nordisk (Arnold Busck), 1942. 294p.

France

1768. Chagnoux, Christine. "Children's book production in France today." Graphis 27:258-67. 1971-72.

1769. _____. "New children's books—or parents' books in France." Graphis 31:38-47. 1975-76.

1770. Durand, Marion. "One hundred years of illustrations in French children's books. Tr. by D. Wormuth." Yale French studies no. 43:85-96. 1969.

1771. Klein, Robert F. "Children's books in France." Graphis 23:216-23. 1967.

1772. Latzarus, Marie T. La littérature enfantine en France dans la seconde moitié du xixe siècle. Paris, Presses Universitaires de France, 1924. 309p.

1773. Trigon, Jean de. Histoire de la littérature enfantine de ma mère l'oye au roi Babar. Paris, Librairie Hachette, 1950. 241p.

1774. Valotaire, Marcel. "Children's books in France." Creative art
5:843-54, Dec. 1929.

Germany

1775. Doderer, Klaus, ed. Bilderbuch un Fibel; eine kritischer Analyse
der Literatur für Lescanfänger. Weinheim, Beltz, 1972. 232p. illus.

1776. _____ and Müller, Helmut. Das Bilderbuch: Geschichte und
Entwicklung des Bilderbuchs in Deutschland von den Anfängen bis zur
Gegenwart. Weinheim, Beltz, 1973. 542p.

1777. Dyhrenfurth-Graebsch, Irene. Geschichte des deutschen Jugenbuches.
2d ed. Hamburg, E. Stichnote, 1951. 324p. 3d ed., 1967.

1778. Für Kinder gemalt: Buchillustratoren der DDR. Berlin, Kinderbuch
Verlag, 1975. about 150p. illus.

1779. Halbey, Hans A. "The German picture book gains ground." Graphis
23:224-31. 1967.

1780. Hobrecher, Karl. Alte vergessene Kinderbücher. Berlin, Mauritius
Verlag, 1924. 159p.

1781. Kaiser, Bruno. "Schöne Kinderbücher aus der DDR." Marginalien
no. 22:1-15, June 1966.

1782. Köster, Herman L. Geschichte der deutschen Jugendliteratur.
4th ed. Braunschweig, G. Westermann, 1927. 478p. facs.

1783. Künnemann, Horst. "Present and future evolution of the German
picture-book." Graphis 27:228-41. 1971-72.

1784. Prestel, Josef. Geschichte des deutschen Jugendschriftums.
Freiburg, Herder, 1933. 163p. (Handbuch der Jugendliteratur. Part 3.)

1785. Ramseger, Ingeborg. "New trends in children's books in Germany."
Graphis 31:48-59. 1975-76.

1786. Rümann, Arthur. Alte deutsche Kinderbücher. Vienna, R. Reichner,
1937. 101p. 367 plates.

1787. Wills, Franz H. "Children's books from East and West Germany."
Gebrauchsgraphik novum 46:10-23, Jan. 1975.

Great Britain and Ireland

1788. Alderson, Brian. "Bibliography and children's books." Library,
5th series, 32:203-13, Sept. 1977.

1789. Andreae, Gesiena. The dawn of juvenile literature in England.
Amsterdam, H. J. Paris, 1925. 122p.

1790. Carrington, Noel. "Children's picture book in England."
Wilson library bulletin 22:146-48, Oct. 1947.

1791. Crouch, Marcus S. Treasure seekers and borrowers: children's
books in Britain 1900-1960. London, Library Association, 1962. 160p.

1792. Darton, Frederick J. Children's books in England; five centuries
of social life. 2d ed. Cambridge, University Press, 1966. 367p.

1793. Davis, Dorothy R. The Carolyn Sherwin Bailey historical collec-
tion of children's books: a catalogue. New Haven, Southern Connecticut
State College, 1967. 232p. illus.

 The titles were published between 1657 and 1930 in England
 and America.

1794. Field, Louise. The child and his book; some account of the
history and progress of children's literature in England. 2d ed.
London, W. Gardner, Darton, 1895. 358p.

1795. Green, Roger L. "The golden age of children's books." (In
English Association. Essays and studies. London, 1962. vol. 15, p.59-
73.)

1796. Macfall, Haldane. "English illustrators of juvenile books."
Good housekeeping 51:523-31, Nov. 1910.

1797. McLean, Ruari. "Children's books up to 1850." (In Victorian
book design and colour printing. London, Faber and Faber, 1963.
p.38-45.)

1798. Morris, Charles H. The illustration of children's books. London,
Library Association, 1957. 18p.

1799. Muir, Percival H. "Catnachery, chapbooks and children's books."
(In Victorian illustrated books. London, Batsford, 1971. p.12-24.)

1800. _____. English children's books, 1600 to 1900. London,
Batsford, 1954. 255p.

1801. National Book League, London. The Francis Williams bequest; an
exhibition of illustrated books 1967-1971; selected by John Harthan
et al. London, 1972. 51p. illus.

1802. Ryder, John. Artists of a certain line; a selection of illustra-
tors for children's books. London, Bodley Head, 1960. 125p.

1803. _____. "Children's book illustration in Britain." Graphis
31:30-37. 1975-76.

1804. _____. "Children's books in England." Graphis 27:220-27.
1971-72.

1805. Share, Bernard. "Children's book illustration in Ireland."
Bookbird 10:70-71. 1972.

1806. Smith, Janet A. Children's illustrated books. London, Collins, 1948. 49p. 32 illus. in black and white. 4 plates in color.

1807. Stanley-Wrench, Margaret. "Children's book illustration in Britain." Design 49:11, 21, May 1948.

1808. Taylor, Judy and Ryder, John. "Children's book illustration in England." Graphis 23:232-41. 1967.

1809. Thomas, David. "Children's book illustration in England." Penrose annual 56:67-74. 1962.

1810. Whalley, Joyce I. Cobwebs to catch flies; illustrated books for nursery and schoolroom 1700-1900. Berkeley, Univ. of California Press, 1975. 163p. illus. plates.

India and Pakistan

1811. Gangopadhyāya, Aśa. Bāmlā śiśu-śahityera kramabikāśa, 1800-1900. Calcutta, D. M. Library Publisher, 1961. 333p.

1812. Mahmud, Satnam. A century of children's literature in West Pakistan. Honolulu, Univ. of Hawaii, East-West Center, 1964. 82p. (Typewritten manuscript.)

Italy

1813. Caspar, Franz. "The children's picture book today: Italy." Graphis 27:301-03. 1971-72.

1814. Faeti, Antonio. Guardare le figure. Gli illustratori italiani dei libri per l'infanzia. Turin, G. Einaudi, 1972. 413p. illus.

1815. Hawkes, Louise R. Before and after Pinocchio; a study of Italian children's books. Paris, Puppet Press, 1933. 207p.

1816. Sachetti, Lina. Storia della letteratura per ragazzi. 3d ed. Florence, Le Monnier, 1966. 470p.

Japan

1817. Chiba Shōzō et al. Shinsen nihon jidō bungaku. new ed. Tokyo, Komine Shoten, 1959. 2 vols.

1818. Hürlimann, Bettina. "Notes on Japanese picture-books." Graphis 23:242-49. 1967. 27:268-73. 1971-72.

1819. Matsui, Tadashi. "Japanese picture book in past and present." Graphis 31:76-83. 1975-76.

1820. Nishihara, Keiichi. Nihon jidō bunshōshi. Tokyo, Tokai Shuppansha, 1952.

1821. Ramseger, Ingeborg. "Contemporary Japanese books for children."
Gebrauchsgraphik novum 44:42-53, Sept. 1973.

1822. Torigoe, Shin. Nihon jidō bungaku annai. Tokyo, Rironsha, 1963.
204p.

1823. Watanabe, Shigeo. "Japanese and American picture books ... simi-
larities and differences." Michigan librarian 37:11-14, Winter 1971.

Netherlands

1824. Daalder, Dirk L. Wormcruyt met suycker. Amsterdam, De Arbeider-
spers, 1950. 298p.

1825. Riemens-Reurslag, Johanna. Het jeugdboek in de loop der eeuwen.
's-Gravenhage, Van Stockum and Zoon, 1949. 255p.

Norway

1826. Casper, Franz. "The children's picture book today: Scandinavia."
Graphis 27:306-12. 1971-72.

1827. Hagemann, Sonja. Barnelitteratur i Norge 1850-1914. Oslo, H.
Ashehoug, 1970. 302p. illus.

Poland

1828. Kaniowska-Lewanska, Izabella. Literatura dla dzieci i mlodziezy
od poczakków do roku 1864. Warsaw, Pantswowe Zaklady Wydawnictw
Szkolnych, 1960. 190p.

1829. Kuliczkowska, Krystyna. Literatura dla dzieci i mlodziezy w
latach 1864-1914. Warsaw, Panstwowe Zaktady Wydawnictw Szkolnych, 1965.
260p.

1830. Lenica, Jan. "Polish posters and children's books." Graphis
5:248-57. 1949.

1831. MacCann, Donnarae. "Something old, something new: children's
picture books in Poland." Wilson library bulletin 52:776-82, June 1978.

1832. Piotrowski, Mieczyslaw. "Polish illustrators and the children's
book." Graphis 31:84-93. 1975-76.

1833. Rusinek, Kazimierz. Polska ilustraçja ksiazkowa. Warsaw,
Wydawnictwa Artystyczne i Filmowe, 1964. 164p.

1834. Rychlicki, Zbigniew. "Children's book illustration in Poland."
Graphis 27:274-83. 1971-72.

1835. Siemaszková, Olga. "Thoughts on children's books in Poland."
Graphis 23:250-61. 1967.

1836. Wroblewska, Danuta. "Polnische Kinderbücher." Gebrauchsgraphik
10:14-25, July 1969.

Russia

1837. Alekseeva, Olga V. Dekskaia literatura. Moscow, 1957. 333p.

1838. Babushkina, Antonina P. Istoria russkoi detskoi literatury.
Moscow, 1948. 479p.

1839. Caspar, Franz. "The children's picture-book today: Russia."
Graphis 27:296-97. 1971-72.

1840. Deutsch, Babette. "Illustrations for children's books in Russia."
Creative art 9:223-27, Sept. 1931.

1841. Evans, Ernestine. "Russian children and their books." Asia 31:
686-91, 736-37, Nov. 1931.

1842. Gankina, Ella. Russkie knudozhniki detskoi knigi. Moscow, 1963.
276p. illus.

1842a. Grechishnikova, A. D. Sovetskaia detskaia literatura. Moscow,
1953. 249p.

Sweden

1843. Caspar, Franz. "The children's picture book today: Scandinavia."
Graphis 27:306-12. 1971-72.

1844. Hellman, Gunnar. Några svenska sagokonstnärer. Stockholm,
Lindqvist, 1949. 78p. illus.

1845. Klingberg, Göte. Svensk barn- och ungdomslitteratur 1591-1839;
en pedagogikhistorisk och bibliografisk översikt. Stockholm, Natur och
Kultur, 1964. 413p.

1846. De technar för barn; portratt av tolv svenska barnboksillustratorer.
Red. Carl-Agnar Lövgren. Lund, Bibliothekjänst, 1976. 112p. illus.

1847. Zweigbergk, Eva von. Barnboken i Sverige 1750-1950. Stockholm,
Rabén and Sjögren, 1965. 520p. (Summary in English.)

Switzerland

1848. Hoenig, Rudolf C. "Thoughts on the children's book in
Switzerland." Graphis 27:242-57. 1971-72.

1949. Kraut, Dora. Die Jugendbücher in der deutschen Schweiz bis 1850.
Bern, Schweizer Bibliophilen Gesellschaft, 1945. 89p.

1850. Schatzmann, Jürg. "Tradition and internationalism in the Swiss
children's book." Graphis 31:60-75. 1975-76.

The United States

Reference Works

1851. Davis, Dorothy. <u>The Carolyn Sherwin Bailey historical collection of children's books: a catalogue.</u> New Haven, Southern Connecticut State College, 1967. 232p. illus.

1852. Hoffman, Miriam. <u>Authors and illustrators of children's books.</u> N.Y., Bowker, 1972. 471p.

1853. Kingman, Lee, ed. <u>Newbery and Caldecott Medal books 1956-1965.</u> Boston, Horn Book, 1965. 300p. illus.

1854. _____. <u>Newbery and Caldecott Medal books, 1966-1975.</u> Boston, Horn Book, 1975. 321p. illus.

1855. _____ et al., eds. <u>Illustrators of children's books 1957-1966.</u> Boston, Horn Book, 1968. 295p.

1856. Mahony, Bertha E. et al. <u>Illustrators of children's books 1744-1945.</u> Boston, Horn Book, 1947. 527p.

1857. Miller, Bertha E. and Field, Elinor W. <u>Caldecott Medal books 1938-1957.</u> Boston, Horn Book, 1957. 329p. illus.

1858. Montreville, Doris de and Crawford, Elizabeth. <u>Fourth book of junior authors and illustrators.</u> N.Y., H. W. Wilson, 1978. 370p.

1859. Rosenbach, Abraham S. W. <u>Early American children's books with bibliographical descriptions of the books in his private collection.</u> Portland, Me., Southworth Press, 1933. 354p. illus. plates.

1860. Viguers, Ruth H. et al. <u>Illustrators of children's books.</u> <u>Supplement, 1946-1956.</u> Boston, Horn Book, 1958. 299p.

1861. Ward, Martha E. and Marquand, Dorothy. <u>Illustrators of books for young people.</u> Metuchen, N.J., Scarecrow Press, 1970. 166p.

Early History to 1900

1862. Bader, Barbara. <u>American picture books from Noah's ark to the beast within.</u> N.Y., Macmillan, 1976. 615p.

1863. Earle, Alice M. "Story and picture books." (In <u>Child-life in colonial days.</u> N.Y., Macmillan, 1899. p.264-304.)

1864. Halsey, Rosalie V. <u>Forgotten books of the American nursery; a history of the development of the American story-book.</u> Boston, Goodspeed, 1911. 244p. illus.

1865. Howard, Helen C. "Trends in the illustration of American children's books, 1770-1860." Master's essay, Columbia Univ., 1942.

1866. Kiefer, Monica. American children through their books 1700-1835. Phila., Univ. of Pennsylvania Press, 1948. 248p. facs.

1867. Pitz, Henry C. "Pictures for children." (In 200 years of American illustration. N.Y., Random House, 1977. p.59-65.)

1868. Whalley, Joyce I. Cobwebs to catch flies; illustrated books for nursery and schoolroom 1700-1900. Berkeley, Univ. of Calif. Press, 1975. 163p. illus. plates.

20th Century

1869. American Institute of Graphic Arts. Children's book show 1965/1966. N.Y., 1967. 16p.

1870. _____. Children's books 1967/1968. N.Y., 1969. 79p.

1871. _____. AIGA children's books 1971/72--N.Y., 1973- (a biennial.)

1872. Children's Book Council, N.Y. Children's book showcase. N.Y., 1972- illus. (annual exhibit catalog.)

1873. Bennett, Paul A. "American children's books in a changing world." Penrose annual 56:75-81. 1962.

1874. Chappell, Warren. "Illustrations today in children's books." Horn book 17:445-55, Nov. 1941.

1875. Freeman, G. La Verne and Freeman, Ruth S. The child and his picture book. Chicago, Northwestern Univ. Press, 1933. 102p.

1876. Glick, Milton. "Children's book illustrations." Publishers' weekly 130:1590-92, Oct. 17, 1936.

1877. Holscher, E. "Amerikanische Kinderbücher." Gebrauchsgraphik 17:2-12, July 1940.

1878. Horton, Marion. "Current trends in the illustration of children's books." California Librarian 23:81-87, Apr. 1962.

1879. Klemin, Diana. The art of art for children's books; a contemporary survey. N.Y., Potter, 1966. 128p.

1880. MacCann, Donnarae and Richard, Olga. "Outstanding contemporary illustrators." (In The child's first books. N.Y., H. W. Wilson, 1973. p.47-72.)

1881. Martin, Helen. Children's preferences in book illustration. Western Reserve University bulletin 34, no. 10, July 15, 1931. 58p.

1882. Munro, Eleanor C. "Children's book illustration." Art news 53:41-48, Dec. 1954.

1883. Nordstrom, Ursula. "Some thoughts on children's books in the United States." Graphis 27:198-219. 1971-72.

1884. Quist, Harlin. "Children's book production in the United States." Graphis 23:272-93. 1967.

1885. Rutgers University. Art Gallery. Contemporary American illustrators of children's books. Exhibition catalog 6 Oct.-17 Nov. 1974. With an essay by A. Hyatt Major. New Brunswick, N.J., 1974. 72p. 32 illus.

1886. Turner, Pearl. "Critical analysis of picture books by American author-illustrators." Thesis, Texas State College for Women, Denton, 1951. 65p.

1887. Warnock, Lucile. "Illustration of children's books." Elementary English review 15:161-65, May 1938.

1888. Watanabe, Shigeo. "Japanese and American picture books ... similarities and differences." Michigan librarian 37:11-14, Winter 1971.

1889. Waugh, Dorothy. "Design in children's books." Horn book 16:116-28, Mar. 1940.

Other Countries

1890. Anderson, Hugh. The singing roads; a guide to Australian children's authors and illustrators. 3d ed. Surry Hills [N.S.S.] Wentworth Press, 1970-

1891. Berdiales, Germán. El cuento infantil rioplatense. Santa Fe, Castellvi, 1958. 59p.

1892. Bergson, Gershon. Shloshah dorot be-sifrut ha-yeladim. Tel Aviv, Yesod, 1966. 268p.

1893. Caspar, Franz. "The children's book today: Hungary." Graphis 27:298-300. 1971-72.

1894. Castilla Barrios, Olga. Breve bosquejo de la literatura infantil colombiana. Bogotá, Aedita, 1954. 371p.

 A thesis for Pontificia Universidad Catolica Javeriana.

1895. Lemieux, Louise. Pleins feux sur la littérature de jeunesse au Canada français. [Montreal] Lemeac, 1972. 337p.

1896. Noesen, Paul. Geschichte der Luxemberger Jugendliteratur. Luxemburg, Verlag der L.K.A., 1951. 101p.

1897. Parish, Helen R. "Children's books in Latin America." Horn book 24:214-23, 257-62, 363-66, May-Oct. 1948.

1898. Ramseger, Ingeborg. "Persian children's books of today." Novum Gebrauchsgraphik 44:44-51, Feb. 1973.

1899. Trejo, Blanca L. La literatura infantil en Mexico. Mexico, Información Crítica-Orientación, 1950. 262p.

SCIENCE AND TECHNOLOGY

General Works

1900. Frewin, Anthony. One hundred years of science fiction illustration 1840-1940. London, Jupiter Books, 1974. 128p.

1901. Hamilton, Edward A. "Scientific illustration for the general public." Graphis 29, no. 165:58-77. 1973-74.

1902. Peck, Paul. "Scientific illustration in the twentieth century." Graphis 29, no. 165:38-57. 1973-74.

Manuals and Other Writings on Technique

1903. Clarke, Carl D. Illustration; its technique and application to the sciences. Butler, Md., Standard Arts Press, 1949. 252p.

 A longer edition was published in 1940 by John D. Lucas in Baltimore.

1904. Gibby, Joseph C. Technical illustrations: procedure and practice. 3d ed. Chicago, American Technical Society, 1970. 352p.

1905. Giesecke, Frederick E. et al. Technical drawing. 5th ed. Rev. by Henry C. Spencer and Ivan L. Hall. N.Y., Macmillan, 1967. 882p.

1906. Grant, Hiram E. Engineering drawing. N.Y., McGraw-Hill, 1962. 177p.

1907. Husnot, Tranquille. Le dessin d'histoire naturelle sur papier, pierre lithographique, bois et divers papiers pour photogravures. Cahan, Athis (Orne), 1900. 79p. illus.

1908. Katz, Hyman H. Technical sketching and visualization for engineers. N.Y., Macmillan, 1949. 163p.

1909. Levavasseur, L. Perspectives et vues éclatées. Paris, Dunod, 1969. 244p.

1910. Luzadder, Warren J. Graphics for engineers. Englewood Cliffs, N.J., Prentice-Hall, 1957. 597p. illus.

1911. _____. Fundamentals of engineering drawing for technical students and professional draftsmen. 5th ed. Englewood Cliffs, N.J., Prentice-Hall, 1965. 726p.

1912. Magnan, George A. <u>Using technical art; an industry guide</u>. N.Y., Wiley-Interscience, 1970. 237p.

1913. Morris, George E. <u>Technical illustrating</u>. Englewood Cliffs, N.J., Prentice-Hall, 1975. 244p.

1914. Papp, Charles S. <u>Manual of scientific illustration</u>. 3d ed. Sacramento, Calif., American Visual Aids Books, 1976. 336p.

 First edition has title: <u>Introduction to scientific illustration</u> (1963).

1915. Pyeatt, A. D. <u>Technical illustration</u>. new ed. Brooklyn, N.Y., Higgins Ink Co., 1960. 113p.

1916. Rainbird, George. "Making of colour plate books." <u>Private library</u> 5:47-49, July 1964.

1917. Ridgway, John L. <u>Scientific illustration</u>. Stanford University, Calif., Stanford Univ. Press, 1938. 173p.

1918. Staniland, Lancelot N. <u>The principles of line illustration, with emphasis on the requirements of biological and other scientific workers</u>. London, Burke, 1952. 212p.

1919. Thomas, R. A. <u>Technical illustration</u>. N.Y., McGraw-Hill, 1968. 203p.

Botany

History and Art of Illustration

1920. Archer, Mildred. <u>Natural history drawings in the India Office Library</u>. London, H. M. Stationery Office, 1962. 116p. and 25 plates.

1921. Auer, Alois. <u>Die Entdeckung des Naturselbstdruckes</u>. Vienna, K. K. Hof- und Staatsdruckerei, 1854. 75p.

1922. Bishop, Alison. "The art of botanical illustration." <u>Boston Public Library quarterly</u> 5:56-59, Jan. 1953.

1923. Blunt, Wilfrid and Stearn, William T. <u>The art of botanical illustration</u>. London, Collins, 1950. 304p. 3d ed., 1955.

1924. _____ and _____. "The decline of the woodcut." (In <u>The art of botanical illustration</u>. 3d ed. London, Collins, 1955. p.57-74.)

1925. _____ and _____. "The early etchers and metal engravers." (In <u>The art of botanical illustration</u>. 3d ed. London, Collins, 1955. p.85-104.)

1926. _____ and _____. "Epilogue: five hundred years of botanical illustration." (In <u>The art of botanical illustration</u>. 3d ed. London, Collins, 1955. p.262-67.)

1927. Blunt, Wilfrid and Stearn, William T. "Some botanical books of
the late seventeenth and early eighteenth centuries." (In The art of
botanical illustration. 3d ed. London, Collins, 1955. p.132-42.)

1928. Burbridge, Frederick. The art of botanical drawing. 2d ed.
London, Winsor and Newton, 1873. 63p. illus. plates.

1929. Day, Lewis D. Nature in ornament; an inquiry into the natural
element in ornamental design and a survey of the ornamental treatment of
natural forms. London, B. T. Batsford, 1896. 260p.

1930. Desmond, R. G. C. "Plant illustration in British books and
periodicals of the nineteenth century." M.A. thesis, University College,
London, 1972.

1931. Hardie, Martin. "Nature printing." (In English coloured books.
London, Methuen, 1906. p.221-33.)

1932. Harvard University Library. Houghton Library. Early botanical
books; an exhibit celebrating the centennial of the Arnold Arboretum
1872-1972, May 21, 1972-June 9, 1972. Cambridge, 1972. 52p. illus.

1933. Hill, Adrian. On drawing and painting trees. London, Pitman,
1951. 184p.

1934. Hunt Botanical Library. Catalogue: a selection of 20th century
art and illustration; presented at the xith International Botanical
Congress, Aug. 1969. Comp. by George H. M. Lawrence. Pittsburgh, 1969.
168p.

1935. Jackson, Benjamin D. "The history of botanical illustration."
Transactions of the Hertfordshire Natural History Society, series 12,
4:145-56. 1905.

1936. _____. "Botanical illustration from the invention of printing
to the present day." Journal of the Royal Horticultural Society
49:167-77. 1924.

1937. Krause, Ernst. Natur und Kunst. Berlin, 1891. 395p. illus.

1938. Lacy, William A. "The earliest printed illustrations of natural
history." Scientific monthly 13:238-58, Sept. 1921.

1939. Marquand, Allan. "History of plant illustrations to 1850."
Bulletin of the Garden Club of America 7:18-33, Mar. 1941.

1940. Nissen, Claus von. "Botanische Prachtwerke; die Blütezeit der
Pflanzenillustration von 1740 bis 1840." Philobiblon 6:243-56, 335-48.
1933.

1941. _____. Die botanische Buchillustration; ihre Geschichte und
Bibliographie. Stuttgart, Hiersemann, 1951. 2 vols.

1942. _____. "Die Naturwissenschaftliche Abbildung." Gutenberg
Jahrbuch 49:249-66. 1944.

1943. Portmann, Adolf. "Pre-20th century botanical illustration." Graphis 29, no. 165:24-29. 1973/74.

1944. Rohde, Eleanour S. The old English gardening books. London, Minerva Press, 1972. 144p. illus. facs.

1945. Schauer, Georg K. "Glück in der alten Botanik." Imprimatur 1972, p.9-18.

1946. Sotheby Parke Bernet. The magnificant botanical library of the Stiftung für Botanik, Vaduz Liechtenstein. Collected by the late Arpad Plesch. 1975-76. 3 parts.

1947. Treviranus, Ludolph C. Die Anwendung des Holzschnittes zur bildlichen Darstellung der Planzen. Leipzig, 1855. 72p.

1948. Wade, Arthur. Plant illustration from woodcut to process block. Cardiff, National Museum of Wales, 1942. 32p. (exhibit catalog.)

1949. Whalley, Joyce I. "Natural history and science." (In Cobwebs to catch flies; illustrated book for nursery and schoolroom 1700-1900. Berkeley, Univ. of Calif. Press, 1975. p.113-22.)

Flowers

1950. Bartning, Ludwig. Blumenzeichnen Blumenmalen. Ravensburg, Maier, 1950. 140p.

1951. Blunt, Wilfrid and Stearn, William T. "Some flower painters of the late sixteenth century." (In The art of botanical illustration. 3d ed. London, Collins, 1955. p.75-84.)

1952. Coats, Alice M. The book of flowers, four centuries of flower illustration. London, Phaidon, 1973. 208p.

1953. Dunthorne, Gordon. Flower and fruit prints of the 18th and early 19th centuries, their history, makers, and uses. Washington, D.C., The Author, 1938. 275p.

1954. Gottscho, Samuel H. "The golden age of wild flower illustration in America; a brief survey of some of the popular guides of the seventies and eighties." New York Botanical Garden journal 50:145-52, July 1949.

1955. Johnson, Esther B. The technique of flower painting in oil, water-color, and pastel. London, Pitman, 1951. 131p. illus. plates.

1956. Loir-Mongazon, Arthur. Fleurs et peinture de fleurs. Paris, Gervais, 1882-84. 3 fascicles.

1957. National Book League, London. Flower books and their illustrators. An exhibition arranged ... by Wilfrid Blunt. London, Cambridge Univ. Press, 1950. 58p. colored illus.

1958. Sitwell, Sacheverell and Blunt, Wilfrid. Great flower books, 1700-1900; a bibliographic record of two centuries; the bibliography edited by Patrick M. Synge. London, Collins, 1956. 94p. illus. plates (some in color).

1959. Sowerby, James. A botanical drawing book. 2d ed. London, 1791. 11 leaves. 10 colored plates.

1960. Temple,Vere. How to draw wild flowers. London, Studio, 1942. 62p.

1961. Thomas, Alan G. "Herbals and colour-plate flower books." (In Great books and book collectors. N.Y., Putnam, 1975. p.126-51.)

Zoology

1962. Anker, Jean. Bird books and bird art. Copenhagen, Levin and Munksgaard, 1938. 251p. plates.

1963. Baur, Otto. Bestiarum humanum, Mensch-Tier-Vergleich in Kunst und Karikatur. Munich, H. Moos, 1974. 164p. illus.

 A revision of the author's thesis, Univ. of Cologne, 1973.

1964. Berry, Ana M. Animals in art. London, Chatto and Windus, 1929. 83p. 32 plates.

1965. Cetto, Anna M., ed. Animal drawings from the 12th to the 19th century. London, Faber, 1936. 56 plates on 28 leaves.

1966. Guilmain, Jacques. "Zoomorphic decoration and the problem of the sources of mozarabic illumination." Speculum 35:17-38, Jan. 1960.

1967. Handrick, Willy. Tiere in Malerei und Zeichnung. Leipzig, Seemann, 1956. 79p. 16 plates.

1968. James, Montague R. "The bestiary." History n.s. 16:1-11, Apr. 1931.

1969. Lysaght, Averil M. The book of birds; five centuries of bird illustration. London, Phaidon, 1975. 208p. plates.

1970. Klingender, Francis D. Animals in art and thought to the end of the middle ages. Ed. by Evelyn Antal and John Harthan. Cambridge, Massachusetts Institute of Technology Press, 1971. 580p.

1971. McCulloch, Florence. Medieval Latin and French bestiaries. Studies in Romance languages and literatures, no. 38. Chapel Hill, Univ. of North Carolina Press, 1960. 210p. illus.

1972. Nissen, Claus von. Die zoologische Buchillustration. Ihre Bibliographie und Geschichte. Stuttgart, Hieresemann, 1966-

1973. _____. Die illustrierten Vogelbücher; ihre Geschichte und Bibliographie. Stuttgart, Hiersemann, 1953. 222p. illus.

1974. Nissen, Claus von. Schöne Fischbücher; kurze Geschichte der ichthyolgischen illustration. Bibliographie fischkundlicher Abbildungswerke. Stuttgart, L. Hempe, 1951. 108p.

1975. _____. "Tierzeichnen in Indien." (In Zoologische Buchillustration. vol. 2, lieferung 14, p.410-12 and 4 plates. 1976.)

1976. Oxford University. Bodleian Library. Zoological illustration. Oxford, 1951. 8p. 24 plates. (Bodleian picture books, no. 4.)

1977. Paley, Marilyn B. "Trends in publishing adult illustrated bird books in the United States 1900-1969." Research paper, Long Island Univ., 1969. 218p.

1978. Peterson, Roger T. "Illustrating nature books." Nature magazine 43:388, 390, Aug. 1950.

1979. Piper, Reinhardt. Das Tier in der Kunst. Munich, 1922. 302p. 240 illus. plates.

1980. Portmann, Adolf. "Zoological illustration (to 19th century)." Graphis 29, no. 165:10-17. 1973/74. illus.

1981. Ronsil, René. L'art français dans le livre d'oiseaux. Paris, 1957. 136p. illus. plates. (Mémoires de la Société Ornithologique de France et de l'Union Française, no. 6.)

1982. Rotterdam. Museum Boymansvan Beuningen. Het dier in de prentkunst; grafiek uit de 15de tot de 17de eeuw (The animal in graphic art from the 15th-17th centuries). 9 Feb.-16 Apr. 1974. By L. D. Ihle. Rotterdam, 1974. 60p. 38 illus. (exhibit catalog.)

1983. Sitwell, Sacheverell et al. Fine bird books 1700-1900. London, Collins and Van Nostrand, 1953. 120p. illus. col. plates.

1984. Strachan, Walter J. "Modern French bestiaries." Private library 3:171-91, Winter 1970.

1985. Vallat, Francois. Histoire de l'illustration dans l'anatomie vétérinaire française. Bayeux, Imprimerie Bayeusaine, 1973. 157p. illus.

 Prepared as a thesis for the School of Veterinary Medicine, University of Lyon, 1973.

1986. Verneuil, Maurice. L'animal dans la décoration. Paris, Levy, 1897. 2p. 60 col. plates.

1987. Vinycomb, John. Fictitious and symbolic creatures in art. London, Chapman and Hall, 1906. 276p. illus.

1988. Walravens, Hartmut. "Zoologische Illustration in China and Japan.' (In Nissen, Claus. Die zoologische Buchillustration. vol. 2, lieferung, no. 14, p.413-32. 1976.)

1989. Wohlfert, Theodor. "Schmetterlinge in der Illustration." (In Nissen, Claus. Die zoologische Buchillustration. vol. 2, lieferung no. 13, p.306-26. 1975.)

MEDICINE

1990. Ballard, James F. "Medieval manuscripts and early printed books illustrating the evolution of the medical books from 1250 to 1550." Bulletin of the Medical Library Association 23:173-88, Jan. 1935.

1991. Barberi, Francesco. "Antiche illustrazione mediche." Accademie e biblioteche d'Italia 41:241-66. 1973.

1992. Berger, Pierre, ed. L'étrange beauté des planches médicales du temps passé. Lausanne, Publi SA, 1973. 51p. illus.

1993. Blumberg, Joe M. "A century of medical illustration." Military medicine 130:13-22, Jan. 1965.

The period covered is 1860-1960 in the United States.

1994. Crummer, Leroy. A catalogue, manuscripts and medical books printed before 1640 in the library of Leroy Crummer, Omaha, Nebraska. Omaha, 1927. 93p. plates.

1995. Choulant, Johann L. History and bibliography of anatomical illustration in its relation to anatomic science and the graphic arts. Chicago, Univ. of Chicago Press, 1920. 435p.

1996. Doray, Victor. "Medical illustration: yesterday, today, tomorrow." Canadian Medical Association journal June 8, 1968, p.1097-1105.

1997. Garrison, L. "History of illustrations in psychiatry." British journal of photography 117:880-83. 1970.

1998. Gernsheim, A. "Medical photography in the nineteenth century." Medical and biological illustration 11:85-92, 146-56. 1961.

1999. Grape-Albers, Heide. Spätantike Bilder aus der Welt des Arztes: medizinische Bilderhandschriften der Spätantike und ihre mittelalterliche überlieferung. Wiesbaden, G. Pressler, 1977. 203p. illus.

Based on thesis at the University of Vienna.

2000. Gudger, E. W. "Some early illustrations of comparative osteology." Annals of medical history n.s. 1:334-55. 1929.

2001. Hahn, André et al. Histoire de la médecine et du livre médical à la lumière des collections de la Bibliothèque de la Faculté de Médecine de Paris. Paris, Olivier Perrin, 1962. 430p.

2002. Herrlinger, Robert and Putscher, Marielene. Geschichte der medizinischen Abbildung. Munich, H. Moos, 1967-72. 2 vols.

2003. _____. History of medical illustration from antiquity to A.D. 1600. Tr. from the German by G. Fulton-Smith. London, Pitman, 1970. 178p.

2004. Jones, T. S. "The evolution of medical illustration." (In University of Illinois. College of Medicine. Essays ... in honor of David J. Davis. Chicago, 1965. p.158-67.)

2005. Kiell, Norman. "Medicine and art, 1934-1964: a bibliography." Journal of the history of medicine 21:147-72, Apr. 1966.

2006. Ledoux-Lebard, René. "La gravure en couleurs dans l'illustration des ouvrages médicaux depuis les origines jusqu'à 1800." Bulletin de la Société Française d'Histoire de la Médicine 10:218-25. 1911. 11:171-93. 1912.

2007. Lefanu, William. "Some English illustrated medical books." Book collector 21:59-64, Spring 1972.

2008. Loechel, William E. Medical illustration. Springfield, Ill., C. C. Thomas, 1964. 341p.

2009. MacKinney, Loren C. Medical illustration in medieval manuscripts. London, 1965. 263p. (Publication of the Wellcome Historical Medical Library, n.s. 5.)

2010. _____. "Medical illustrations in medieval manuscripts of the Vatican Library." Manuscripta 3:18, 76-88. 1959.

2011. _____. "Medieval medical miniatures in central and east European collections." Manuscripta 5:131-50. 1961.

2012. McLarty, Margaret C. Illustrating medicine and surgery. Baltimore, Williams and Wilkins, 1960. 158p.

2013. Mann, G. "Medizinisch-naturwissenschaftliche Buchillustration in Deutschland." Sitzungsberichte Gesellschaft zur Befoerderung der Gesamten Naturwissenschaften zu Marburg 86, No. 1-2:3-48. 1964.

2014. Nakumura, Julia V. and Massy, M. "A brief note of medical illustration." (In Your future in medical illustration: art and photography. N.Y., Richards Rosen Press, 1971. p.80-93.)

2015. Nesmith, Fisher H. "Ornament and symbolism in early medical books." Journal of the American Medical Association 12:109-14, Apr. 6, 1970.

2016. Netter, Frank H. The CIBA collection of medical illustrations; a compilation of pathological and anatomical paintings. Summit, N.J., Ciba Pharmaceutical Products, 1953-74. 6 vols.

2017. _____. "Medical illustration; its history, significance and practice." Bulletin of the New York Academy of Medicine 33:357-68, May 1957.

2018. Osler, William. Incunabula medica; a study of the earliest printed medical books, 1467-1480. London, Printed for the Bibliographical Society at the Oxford University Press, 1923. 140p.

2019. Pagel, J. L. "Zur Geschichte der medizinischen Illustrationen in Altertum und Mittelalter." (In Katalog zur Ausstellung der Geschichte der Medizin in Kunst und Kunsthandwerk, zur Zröffnung des Kaiserin-Friedrich-Hauses, i Marz 1906. Stuttgart, 1906. p.149-57.)

2020. Perrin, Olivier. "Histoire de l'illustration de la médecine. A la recherche du héros anatomique." Médecine de France no. 246:25-50. 1973.

2021. Portmann, Adolf. "Pre-twentieth century scientific art." Graphis 29, no. 165:10-17. 1973/74. illus.

2022. Putscher, Marielene. "Changes in medical illustration in the first half of the seventeenth century." Proceedings of the 23d International Congress of the history of medicine, London, 1974, p.911-13.

2023. _____ . Geschichte der medizinischen Abbildung, von 1600 bis zur Gegenwart. Munich, H. Moos, 1972. 207p.

2024. Staniland, Lancelot. The principles of line illustration. London, Burke, 1952. 212p.

2025. Stein, Philemon. Med; medical engravings of the 19th century. N.Y., Universe Books, 1974. 111p. illus.

2026. Sudhoff, Carl. Ein Beitrag zur Geschichte der Anatomie im Mittelalter, speziell der anatomischen Graphik. Leipzig, J. A. Barth, 1908. 94p. illus. plates.

2027. _____ . Tradition und Naturbeobachtung in den Illustrationen medizinischer Handschriften und Frühdrucke vornehmlich des 15. Jahrhunderts. Leipzig, J. A. Barth, 1907. 92p. illus. plates.

2028. Thomas, K. Bryn. "The great anatomical altases." Proceedings of the Royal Society of Medicine 67:223-32, Mar. 1974.

2029. Thornton, John L. "Medical books of the nineteenth century." (In Medical books, libraries and collectors. London, Andre Deutsch, 1966. p.146-92.)

2030. Vogt, Helmut. Das Bild des Kranken; die Darstellung ausserer Veranderungen durch innere Leiden und ihrer Heilmassnahmen von der Renaissance bis in unsere Zeit. Munich, J. F. Lehmann, 1969. 384p. 500 pictures in text.

2031. Wells, Ellen B. "Graphic technique of medical illustration in the 18th century." Journal of biocommunication 3:24-27, Aug. 1976.

2032. _____ . "Medical illustration and book decoration in the 18th century." Medical and biological illustration 20:78-84, Apr. 1970.

2033. Zweifel, Francis W. A handbook of biological illustration.
Chicago, Univ. of Chicago Press, 1961. 131p.

Herbals

2034. Ahumada, Juan C. Herbarios medicos primitivos. Buenos Aires,
1942. 62p. illus. facs.

2035. Anderson, Frank. An illustrated history of the herbals. N.Y.,
Columbia Univ. Press, 1977. 270p.

2036. Arber, Agnes. "Colouring of sixteenth-century herbals." Nature
145:803-04, May 25, 1940.

2037. _____ . Herbals, their origin and evolution; a chapter in
the history of botany 1470-1670. 2d ed. Cambridge, University Press,
1938. 253p. illus. plates.

2038. Barlow, Horace M. Old English herbals 1525-1640. London,
J. Bale, 1913. 42p.

2039. Becher, Karl. A catalog of early herbals, mostly from the well-
known library of Dr. K. Becher, Karlsbad, with an introduction by
Dr. Arnold C. Klebs. Lugano, 1925. 24, 61p. illus.

2040. Bethe, Erich. "Botanik und ihre medizinische Verwendung."
(In Buch und Bild im Altertum. Amsterdam, A. M. Hakkert, 1964. p.28-
40.)

2041. Blunt, Wilfrid. "The first printed herbals." (In The art of
botanical illustration. 3d ed. London, Collins, 1955. p.31-44.)

2042. Freeman, Mary B. Herbals for the medieval household. N.Y.,
New York Metropolitan Museum, 1943. 71 illus.

2043. Hatton, Richard G. The craftsman's plant-book: or figures of
plants selected from the herbals of the sixteenth century. London,
Chapman and Hall, 1909. 539p.

2044. Herbals of five centuries; 50 original leaves from German, French,
Dutch, English, Italian, and Swiss herbals, with an introduction and
bibliography by Claus Nissen. Zurich, L'Art Ancien, 1958. 89p. and
box of 50 plates (some in color).

2045. Marcus, Margaret F. "The herbal as art." Bulletin of the Medical
Library Association 32:376-84. 1944.

2046. Rohde, E. S. The old English herbals. London, Longmans, Green,
1922. 243p. 17 plates.

2047. Schmid, Alfred. Über alte Krauterbücher. Bern, Leipzig, 1939.
75p. plates.

2048. Thomas, Alan G. "Herbals and colour-plate flower books."
(In Great books and book collectors. N.Y., Putnam, 1975. p.126-51.)

MUSIC

2049. Banach, Andrzej. <u>Lekeja z nut</u>. Krakow, PWM, 1971. 327p. illus.

2050. Davidsson, Ake. <u>Catalogue critique et descriptif des imprimés de musique des xvi^e et xvii^e siècles conservés dans les bibliothèques suédoises</u>. Upsala, Almqvist and Wiksells, 1952. 471p. 5 plates.

2051. Davison, Nancy R. <u>American sheet music illustration; reflections of the 19th century; a guide to an exhibition in the Museum of Art</u> [University of Michigan] Oct. 12-Nov. 18. Ann Arbor, William L. Clements Library, 1973. 24p.

2052. Fraenkel, Gottfried S., ed. <u>Decorative music title pages; 201 examples from 1500 to 1800</u>. N.Y., Dover, 1968. 230p. illus. 201 plates. facs.

2053. Gamble, William. <u>Music engraving and printing</u>. London, Pitman, 1923. 266p.

2054. Grand-Carteret, John. <u>Les titres illustrés et l'image en service de la musique</u>. Turin, Bocca Frères, 1904. 296p.

2055. Hoberg, Martin. <u>Die Gesangbuchillustration des 16 Jahrhunderts</u>. Strassburg, J. H. E. Heitz, 1933. 118p. (Studien zur deutschen Kunstgeschichte, Hft 296.)

2056. Imeson, William E. <u>Illustrated music titles and their delineators</u>. London, Privately printed, 1912. 46p.

2057. Kidson, Frank. "Some illustrated music books of the seventeenth and eighteenth centuries." <u>Music antiquary</u>, July 1912, p.195-208.

2058. King, A. Hyatt. "English pictorial music title-pages 1820-1885; their style, evolution and importance." <u>Library</u>, series 5, 4:262-72 and 4 plates. Mar. 1950.

2059. _____. "Some Victorian illustrated music titles." <u>Penrose annual</u>, 1952, p.43-45.

2060. Kinkeldey, Otto. "Music and music printing in incunabula." <u>Papers of the Bibliographical Society of America</u> 26:89-118. 1932.

2061. Komma, Karl M. <u>Musikgeschichte in Bildern</u>. Stuttgart, A. Kröner, 1961. 332p.

2062. Mourey, Gabriel. "The illustration of music." <u>International studio</u> 6:86-98. 1899.

2063. Newman, George. "Music engraving." Typographica no. 4:22-29.
1951.

2064. Pearsall, Ronald. Victorian sheet music covers. Detroit, Gale
Research, 1972. 116p.

2065. Robert, Henri. Traité de gravure de musique sur planches d'étain
et des divers procédés de simili gravure de musique; Précédé de l'histoire
du signe de l'impression et de la gravure de musique. 2d ed. Paris,
1926. 151p.

2066. Ross, Ted. The art of music engraving and processing. Miami,
Hansen Books, 1970. 278p.

2067. Valdruche, Eugène. Iconographie des titres de musique aux xviiie
et xixe siècles. Lille, 1912. 27p. (Tirage à part du Bulletin de la
Société archéologique historique et artistique "Le vieux papier".)

2068. Whalley, Joyce I. "Music." (In Cobwebs to catch flies; illus-
trated book for nursery and schoolroom, 1700-1900. p.127-29.)

2069. Zur Westen, Walter von. Musiktitel aus vier Jahrhunderten;
Festschrift anlässlich der 75 jährigen Bestehens der Firma C. G. Roder.
Leipzig, 1921. 116p. 97 facsimile illus.

GEOGRAPHY AND HISTORY

2070. Baer, Leo. Die illustrierten historienbücher des 15. Jahrhunderts. Strassburg, Heitz, 1903. 216p.

2071. Bagrow, Leo. "The century of atlases." (In History of cartography. rev. and enlarged by R. A. Skelton. Cambridge, Harvard Univ. Press, 1964. p.179-92.)

2072. _____. History of cartography. Rev. and enlarged by R. A. Skelton. London, C. A. Watts, 1964. 312p. illus. colored plates.

2073. Baltimore. Museum of Art. The world encompassed; an exhibition of maps held at the Baltimore Museum of Art, Oct. 7 to Nov. 23, 1952. Baltimore, Trustees of the Walters Art Gallery, 1952. 125p. 60 plates.

2074. Baynton-Williams, Roger. "Frontispieces." (In Investing in maps. N.Y., C. N. Potter, 1969. p.146-49.)

2075. _____. Investing in maps. N.Y., C. N. Potter, 1969. 160p. illus.

2076. Bellaire, Alfred. Decorative illustrative letters used in atlases. London, Map Collectors' Circle, 1969. 7p. and 40 plates. (Map collectors' series, no. 52.)

2077. Braun, Georg and Hogenberg, Franz. Old European cities; thirty-two sixteenth century city maps and texts from the Civitatis orbis terrarum. With a description by Ruthardt Oehme. rev. ed. London, Thames and Hudson, 1965. 128p.

2078. Bricker, Charles. Landmarks of mapmaking; an illustrated survey of maps and mapmakers. Maps chosen and displayed by R. V. Tooley. Oxford, Phaidon, 1976. 276p. illus. maps.

> First published in 1968. Appeared also in 1969 under the title A history of cartography: 2500 years of maps and mapmakers.

2079. Child, Heather. Decorative maps. London, Studio, 1956. 96p. illus. facs.

2080. Dilke, O. A. W. "Illustrations from Roman surveyors' manuals." Imago mundi 21:9-29. 1967.

2081. _____. "Maps in the treatises of Roman land surveyors." Geographical journal 127:417-26, Dec. 1961.

2082. Fletcher, Ifan K. "Literature of splendid occasions in English history." Library, series 5, 1:184-96, Dec. 1946.

2083. George, Wilma. Animals and maps. London, Secker and Warburg, 1969. 235p. illus.

2084. Grenacher, Franz. "The woodcut map." Imago mundi 24:31-41. 1970.

2085. Grosjean, Georges and Kinauer, Rudolf. Kartenkunst und Karten-technik vom Altertum bis zum Barock. Bern, Hallwag, 1970. 144p.

2086. Harms, Hans. Künstler des Kartenbildes: Biographien und Porträts. Oldenburg, 1962. 245p. illus.

2087. Humphreys, Arthur L. Old decorative maps and charts. N.Y., Minton Balch, 1926. 51p. 79 plates.

 Revised by Raleigh Skelton in 1952 and published by Staples
 Press in London.

2088. Koppe, C. "Wesen und Bedeutung der graphischen Kunsts für den Illustrations--und Kartendruck." Himmel und Erde 10:193-211, 268-82. 1898.

2089. Le Gear, Clara E. and Ristow, Walter W. "Sixteenth-century atlases presented by Melville Eastham." (In Ristow, Walter W., ed. A la carte; selected papers on maps and atlases. Washington, D.C., Library of Congress, 1972. p.51-61. illus.)

2090. Lelewel, Joachim. Géographie du moyen âge. Brussels, V. and J. Pilliet, 1850-52. 4 vols in 2 and atlas of 50 plates.

2091. Libault, André. Histoire de la cartographie. Paris, Chaix, 1959. 86p. illus.

2092. Lister, Raymond. Antique maps and their cartographers. London, G. Bell, 1970. 128p. illus.

2093. _____. How to identify old maps and globes with a list of cartographers, engravers, publishers, and printers concerned with printed maps and globes c.1500 to c.1850. Hamden, Conn., Archon Books, 1965. 256p. illus. facs.

2094. Lynam, Edward. The mapmaker's art; essays on the history of maps. London, Batchworth Press, 1953. 140p. illus.

2095. _____. "Period ornament, writing, and symbols on maps 1250-1800." Geographical magazine 18:323-26, Dec. 1945.

2096. Miller, Konrad, ed. Mappaemundi: die ältesten Weltkarten. Stuttgart, Roth'sche, 1895-98. plates.

2097. "Modern maps in the ancient manner." Country life (American)
48:34-38, Sept. 1925.

Includes colored maps of Rhode Island, Long Island, and
Plymouth Colony.

2098. Muller, Frederik (firm). Remarkable maps of the xvth, xvith, and
xviith centuries reproduced in their original size. Amsterdam, 1894-97.
6 vols. in 1. Issued in portfolio.

2099. Nordenskiöld, Nils A. E. friherre. Facsimile atlas to the early
history of cartography, with reproductions of the most important maps
printed in the xv and xvi centuries. Tr. from the Swedish original by
Johan A. Ekelöf and Clements R. Markham. Stockholm, 1889. 141p. 51
plates. 170 maps (some in color).

Reproduced by Kraus Reprint Corp. in N.Y. in 1961. The
Swedish original was finished in 1889.

2100. Paris. Bibliothèque Nationale. Le livre dans la vie quotidienne.
Paris, 1975. 179p. plates.

2101. _____. Dépt. des Cartes et Plans. La terre et son image;
100 chefs-d'oeuvre de la cartographie, de Marco Polo à la Pérouse ...
Catalogue par Edmond Pognon et al. Paris, 1971. 1 vol. unpaged. illus.

2102. Portmann, Adolf. "Early works of cartography and astronomy."
Graphis 29, no. 165:18-23. 1973-74.

2103. Skelton, Raleigh A. "Colour in mapmaking." Geographical magazine
32:544-53, Apr. 1960.

2104. _____. "Decoration and design in maps before 1700." Graphis
7:400-13. 1951.

2105. _____. Decorative printed maps of the 15th to 18th centuries.
London, Staples Press, 1952. 80p. 84 plates.

2106. _____. "Early atlases." Geographical magazine 32:529-43,
Apr. 1960.

2107. _____. Explorers' maps. N.Y., F. Praeger, 1958. 337p. illus.

A reprint with revisions of 14 articles in Geographical
magazine between July 1953 and Aug. 1956.

2108. Tooley, Ronald V. A dictionary of mapmakers, including cartog-
raphers, geographers, publishers, engravers, etc., from the earliest
times to 1900. London, Map Collectors' Circle, 1964/65-

Ten parts of the dictionary appeared in the Map Collectors'
Series between 1964 and 1975: series no. 16, 28, 40, 50, 67,
78, 91, 99, 100, and 110.

2109. _____. Title pages from the 16th to 19th century. London,
Map Collectors' Circle, 1975. 80 plates (Map collectors' series, no.
107.)

2110. Twyman, Michael. Lithography 1800-1850; the technique of drawing on stone in England and France and their application in works of topography. London, Oxford Univ. Press, 1970. 302p. plates.

2111. Van de Gohm, Richard. Antique maps for the collector. Edinburgh, John Bartholomew, 1972. 157p. illus.

2112. Walton, Perry. "Decorative maps and their makers." Country life 46:35-39, Sept. 1924.

 Contains three maps by William Blaeu and one by F. de Wit
 of Amsterdam.

2113. Wieder, Frederik C., ed. Monumenta cartographica; reproductions of unique and rare maps, plans and views in the actual size of the originals, accompanied by cartographical monographs. The Hague, 1925-1933. 4 vols. plates. maps.

2114. Woodward, David, ed. Five centuries of map printing. Chicago, Univ. of Chicago Press, 1975. 177p. maps. plates.

AUTHOR INDEX
The numbers in this index refer to entry numbers, not page numbers.

Dawes, Leonard G., 1239

Day, Lewis D., 1929

Delaborde, Henri, 1171

Delafons, Allan, 903

Délaissé, L. M., 437, 1291

Delamotte, Freeman G., 136

Delaware Art Museum, Wilmington, 1586, 1630

Delen, Adrien J., 249, 640, 641, 1292-94

Deleplanque, Jacques, 781

Delteil, Loÿs, 518, 542

Delvoye, Charles, 394

De Lyée de Belleau, 1343

De Mare, Eric, 998

Demus, Otto, 395

Denis, Ferdinand, 424

Der Nersessian, Sirarpie, 1403, 1404, 1407

De Roos, S. H., 1293a, 1294

Desmond, R. G. C., 1930

Deubner, L., 904

Deusch, Werner R., 788

Deutsch, Babette, 1840

Devigné, Roger, 832

De Vinne, Theodore L., 98, 264

Devreesse, Robert, 1066

De Vries, R. W. P., 1295

De Wald, Ernest T., 1073

Dilke, Emilia F., 789

Dilke, O. A. W., 2080, 2081

Dimand, M. S., 1146

Dimitrov-Rudar, 1759

Diringer, David, 343-45, 396, 1067-69

Doderer, Klaus, 857, 1775, 1776

Dodwell, Charles R., 416, 858, 928, 1443

Dolmetsch, Joan, 1558

Domínguez Bordona, Jesús, 1444-49

Donati, Lamberto, 330, 346, 470, 1172-74

Doray, Victor, 1996

Dostál, Eugen, 682

Douglas, Robert K., 665, 1240

Dow, George F., 1559

Doyen, Camillo, 184

Dreppard, Carl W., 1536, 1560

Drobná, Zoroslava, 683, 684

Duchartre, Pierre L., 1406

Dufrenne, Suzy, 397, 398

Duft, Johannes, 929

Dunikowska, Irena, 305

Dunthorne, Gordon, 1953

Duplessis, Georges, 726-28, 966, 1175, 1296

Dupont, Jacques, 745, 930

Durán, Drego, 1271

Durand, Marion, 1709, 1736, 1770

Duret, Theodore, 1254

Köster, Herman L., 1782

Kolarić, Miodrag, 1649

Komma, Karl M., 2061

Kondakov, Nikodim P., 403

Konow, Jurgen von, 119

Koopman, Harry L., 482

Kopera, Feliks, 1377

Koppe, C., 2088

Korostin, A. F., 1412, 1413

Kraiker, Wilhelm, 1074

Krais, Felix, 586

Kraus, H. P. (firm), 355, 356, 1388, 1455

Krause, Ernst, 1937

Kraut, Dora, 1849

Kristeller, Paul, 256, 1179

Krueger, Otto F., 194

Kühnel, Ernst, 1155, 1156

Künnemann, Horst, 1783

Künstle, Karl, 50

Küp, Karl, 869

Kuliczkowska, Krystyna, 1829

Kumlien, Akke, 1476

Kunstler, Charles, 829

Kunze, Horst, 868

Kuo, Wei-ch'i, 671

Kurth, Julius, 672, 1250

Kurz, Martin, 1389, 1456

Kutschmann, Theodor, 870

Květ, Jan., 688, 696

Labarre, A., 443

Labarte, Jules, 427

Laborde, Léon de, 288

Lacassin, Francis, 311

Lacy, William A., 1938

Lagerström, Hugo, 1477

Lalanne, Maxime, 169

Laliberté, Norman, 148

Lam, Stanislaw, 1379, 1380

Lamb, Lynton, 120

Lambert, F. C., 68, 552

Lambert, Frederick, 1050

Lamprecht, Carl G., 428

Lanckorońska, Maria, 622, 795, 885

Landsberger, Franz, 1088

Landwehr, John, 645, 1306-09

Lang, Lothar, 912

Lang, Oskar, 890

Langlois, Eustache H., 429

Laran, Jean, 257

Larkin, David, 1051

Larned, William T., 1633

Latimer, Louise P., 38

Latzarus, Marie T., 1772

Lauer, Philippe, 767

Lauter, Adalbert, 504

Newman, George, 2063

N.Y. Historical Society, 1512

N.Y. Museum of Art, 607

Newton, Lesley, 1745

New York Public Library, 71

Nichols, Frederick D., 1601

Nicholson, David, 215

Nielsen, Lauritz M., 701, 702

Nishihara, Keiichi, 1820

Nissen, Claus von, 1940–42, 1972–75, 2044

Nixon, H. M., 105

Noble, Frederick, 238

Noesen, Paul, 1896

Nordenfalk, Carl, 72, 363, 419, 420, 756

Nordenskiöld, Nils A. E. friherre, 2099

Nordstrom, C. O., 1094

Nordstrom, Ursula, 1883

Novak, Arthur, 690

Oakeshott, Walter, 947

Oberhuber, Konrad, 1181

O'Conor, David, 76

Oehler, R., 622, 885

Okudaira, Hideo, 1253

Olcott, Charles S., 609

Olds, Clifton C., 490

Olingdahl, Gote, 1479

Olschak, Blanche C., 1135

Olschki, Leo S., 491

Olson, Eleanor, 1136

Omont, Henri A., 364, 1077

Orcutt, William D., 1189, 1637

Osiakovski, S., 1417

Osler, William, 2018

Ottley, William Y., 492

Ovink, G. W., 1301

Ozzola, Leandro, 1212

Pace, Claire, 717

Pächt, Otto, 73, 365, 951, 1190

Pagel, J. L., 2019

Pakhomov, Viktor V., 1418

Pal, Pratapaditya, 1136

Palais des Beaux Arts, Brussels, 887, 902

Paley, Marilyn B., 1977

Palmer, Cecil, 278

Panofsky, Erwin, 757, 1317

Papillon, Jean M., 153, 275

Papp, Charles S., 1914

Paret, Oscar, 366, 493

Parish, Helen R., 1897

Parker, Barbara N., 1557, 1571

Passavant, Johann D., 40, 495

Passeron, Roger, 819, 840

Paulson, Ronald, 1014

SUBJECT INDEX

The numbers in this index refer to entry numbers, not page numbers.

ABOUT THE COMPILER

VITO J. BRENNI has taught library science at Duquesne University and the State University College at Plattsburg, New York. His earlier books include *American English: A Bibliography*, *William Dean Howells: A Bibliography*, and *Essays in Bibliography*.